Arrivals and Sailings:

The Making of George Wyllie

Arrivals and Sailings:

The Making of George Wyllie

LOUISE WYLLIE AND JAN PATIENCE

First published in Great Britain in 2016 by Polygon, an imprint of
Birlinn Ltd
West Newington House
10 Newington Road
Edinburgh
EH9 1QS

www.polygonbooks.co.uk

ISBN 978 1 84697 306 2

British Library Cataloguing-in-Publication Data
A catalogue record for this book is available on request from the
British Library.

The publishers acknowledge investment from Creative Scotland
towards the publication of this volume.

Project management by Alison Rae

Design by Teresa Monachino

Printed in Latvia by Livonia Print

For The Burds

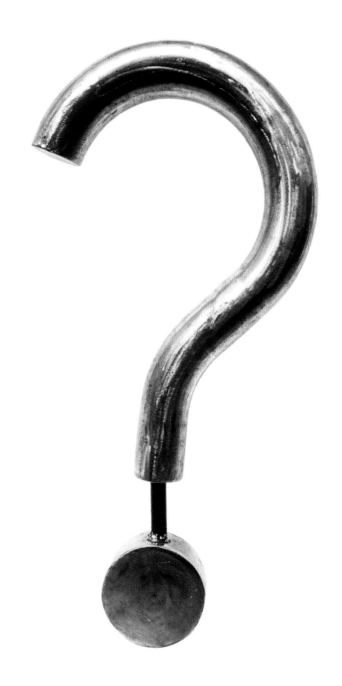

Foreword

If I had to sum up the character of George Wyllie, one of Scotland's most well loved artists, it would be this: I have never met such a talented man more serious about his mischievousness.

The joy in George was irrepressible. Joy in everything he saw, and the joy of anticipation in how he might transmit that to the rest of the world.

I first became aware of George's work as an art student in Glasgow in the 1970s when we started to notice delightful, witty and exuberant sculptures appearing in cheerful drinking establishments like La Bonne Auberge and Charlie Parker's bar in Royal Exchange Square. Who was producing these wrought-iron perfections, full of movement, life and humour? We adored them. We wanted to copy them. They were speaking of other cultures and other places, but they somehow beautifully captured the spirit of Glasgow and of youth. Whimsical, yes, but with a rock solid heart.

Of course it was George, an artist who had no formal training as such, but whose long distinguished career took him to becoming an MBE and revered and recognised by the most formal of our cultural institutions.

Perhaps it was that lack of being shaped by the formality of art tuition that allowed him such free rein in his work. There was no sense of self-censoring. No fear that the 'art world' wouldn't take him seriously. No desire to be closeted in a gallery away from the general public. He just did what he did, and he did it for everyone.

He hung giant straw trains from cranes, placed iron question marks all over cities, put willow bikes in ponds, and made the paper boat of childhood into an emblem of such grace, beauty and poignancy it still gives me a lump in my throat when I see images of it today.

This delightful book is the most wonderful explanation of who the artist and the man George Ralston Wyllie really was and where he came from. It describes not only the person, but the world he grew up in which has all but disappeared.

George's work stitches itself permanently into the soul, and to me, like many others lucky enough to have lived in a country where his work was always present somewhere, he represented the light and the happiness of being alive, summing up a part of our culture that is precious beyond words.

The only drawback with reading this chronicle of his life and achievements is that you will be heartbroken once again that he's no longer with us. At least we had him on loan.

Muriel Gray

Opposite: *George Wyllie's first major exhibition in 1976 at the Collins Gallery in Glasgow was called Scul?ture. 'The question mark deliberately replaced the 'p' to signify doubt and apprehension', he explained later. The question mark would go on to become his trademark..*

Prequel

February 1851, Bosherston, South Pembrokeshire, Wales

As the wind started to pick up, Antonio clawed at the limestone rock beneath his feet in an attempt to keep his balance. He could feel the squalls of icy rain soaking right through to his waistcoat. The basket of wool was full enough for him to head home.

The mile-long walk along the coastal clifftop path from Bosherston had sapped his strength today. It had been a long winter. Spring was just around the corner – he could see that in the few green shoots further down on the dunes – but today it was as if winter had come back with a vengeance.

He was getting too old for this business of rooting around for wool on cliffs, he thought. But Margaret needed wool to spin because the chapman was coming to the door next week. And she wanted to make a cap for young George. She fussed over that boy too much.

As a young seaman, Antonio had always been fit. His shipmates teased him because he couldn't sit still. But not now. Today the old mariner bones were creaking.

He liked to think up here on the cliffs, even with a gale raging around him. It reminded him of his homeland, and his thoughts would drift back to his childhood in Corsica. He recalled the warm summer breezes and the cold northwest winds of the mistral as if it were yesterday. What he'd give to smell that sharp fragrance of the maquis again; the scent of mint and lavender in high summer carried on a fresh sea breeze.

He'd encountered many seas and many winds on his voyages around the world with the Royal Navy and the merchant ships. If Margaret only knew the half of it . . .

Just at that moment, a sharp gust of wind caught the basket of wool on Antonio's back, causing him to lose his footing. For a couple of seconds, he felt as if he was floating. It wasn't a bad feeling. The air caught his feet and gently lifted him off the cliffs. It was as though he was part of the weather – in perfect equilibrium . . .

The next morning, at first light, Margaret rushed out along the path from Bosherston in search of her husband. It was his shoes she found first – lying where he'd left them the night before in order to get a firm footing before he'd clambered down the rocks in search of wool.

She found Antonio's lifeless body lying on Broad Haven Sands.

Antonio Charrette was sixty-six years old. It was an ignominious end to the old mariner's life, one during which he'd cheated death many times – man and boy.

He had fought tenaciously for Great Britain, his adopted country, during the long and bloody years of the Napoleonic Wars (1799 to 1815). His Corsican parents signed him up as a twelve-year-old Boy Second Class in the Royal Navy in 1797. It was their way of keeping him safe from the turbulence on the island as it ricocheted violently between French and British rule.

In that first year, Antonio spent endless hours learning splicing and knotting and being sent up the rigging. He learned his seamanship by total immersion.

Just months after he joined up, in October 1797, Antonio received two medals for bravery in action while serving aboard HMS *Veteran* during the Battle of Camperdown, off the coast of Holland, and later at the Battle of Copenhagen. Subsequent voyages aboard Royal Navy ships took him back and forth from Britain to the West Indies as a convoy escort on board HMS *Scorpion* and HMS *Laurel*, protecting British ships carrying sugar

and tobacco back to Britain from Barbados, Martinique and Saint Lucia.

Not only was he imprisoned for a year at Port Louis by the French during the Seven Years' War, he was at the heart of the most bitterly fought conflict of this long war, the Battle of Grand Port off the coast of Mauritius.

Twice during this Invasion of Île de France (as Mauritius was then known), in which the British fleet suffered heavy casualties, he received medals for gallantry. The first was given on 1 May 1810 after HMS *Néréide* was battered into submission by the French. Out of a crew of 254 men aboard the ship, only fifty-one survived its capture and destruction at the hands of the French frigate *Cannonière*. Antonio was one of the few sailors in the Royal Navy who could swim thanks to a childhood spent playing on beaches and inland pools. Of the fifty-one men, sixteen were awarded medals for bravery. Antonio Charrette was one. A second medal followed after he joined sister ship HMS *Iphigenia*.

Together with fellow survivors, Antonio was returned to Portsmouth aboard HMS *Royal William*, flagship to *Admiral Saunders*. There were only thirteen Admirals in the Royal Navy at that point and not all went to sea; a man might go through his entire career without serving on a flagship. Antonio was summarily discharged in 1811 under an order 'relating to foreigners in the Royal Navy'.

Despite being sent packing by the Royal Navy, Antonio spent the next fifteen years at sea, mainly in merchant shipping. According to subsequent family folklore, Antonio was a pirate. This may well have been the case as it is difficult to distinguish between privateers, pirates, corsairs or buccaneers, many of whom sailed without genuine commissions.

In 1826 at the age of forty-one, Antonio met and married Margaret Dally in Bristol, a Welsh woman, who was nineteen years his junior. He continued to spend periods away at sea as a merchant seaman, but the couple went on to have six children. At the age of fifty-six, he sailed on the *Carena* from Liverpool to Montreal and even worked as a cook on a previous ship *Wm & Elizabeth*. This may well have been where the 'pirate' story came from as, in the 1800s, privateering was an accepted part of naval warfare.

It was a hand-to-mouth existence for the Charrettes, with at least two of their children born in Bosherston's East End Poorhouse, which was not a workhouse but was operated by the parish as an almshouse for families who needed assistance in times of financial hardship. Latterly they lived in a cottage owned by the Trinity Board, a charity which looked after the welfare of mariners.

A news report in the *Pembrokeshire Herald* in late February 1851 recorded his death in these stark terms:

> FATAL ACCIDENT – An old seaman, a pensioner from The Trinity Board, formerly living in a small cottage in the parish of Bosherston, left his home on Thursday afternoon last. Not returning during the night, his wife became much alarmed, and early on Friday morning went in search of him. She found his shoes on top of the cliff. The poor woman then proceeded to the sands beneath, where she discovered her husband, lying quite dead on Broad Haven sands. It is supposed the old man was in search of wool, and by some means missed his footing, and fell over the cliff. An inquest was held on Saturday last, before John Stokes, Esquire, the coroner, when a verdict of accidental death was returned.

Tenacity was Antonio Charrette's middle name. The sea was in his veins. These two characteristics would run through his bloodline like a fine Corsican wine. Antonio's great-great-grandson was the renowned Scottish artist, George Ralston Wyllie.

1 Push the Boat Out

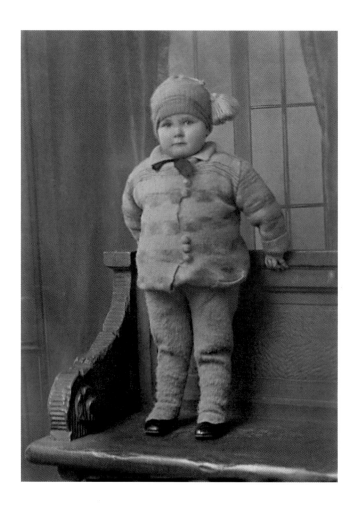

In the wee sma' hours of the very last day of 1921, as wind and rain battered the windows of a red sandstone four-in-a-block-style terraced house in Glasgow's East End, George Ralston Wyllie made his entrance into the world.

Just a few miles away from the Wyllie home in Shettleston, boats on the River Clyde strained on their moorings as the watermark inched up to record high tide levels after days of relentless rain.

When wee Ralston (he would be known by his middle name from the outset) gave his first cry at 3.45 a.m., Harriet 'Harry' Wyllie, great-granddaughter of Corsican mariner, Antonio Charrette, gasped with relief. In the kitchen next to their bedroom, as the local midwife went about her business, making sure the baby was cleaned up and presentable, Andy Wyllie waited anxiously to be called through to see his newborn son. Luckily, he didn't have to go to work the next day as all the factories were closed for the New Year holiday.

The new baby was the third George Ralston Wyllie, and he shared the name with Andy's father and his younger brother. Later that night, Harry nursed her baby boy and mapped out a bright future for him. Harry couldn't stop looking at Ralston, frequently checking his every breath and stroking his cheek.

As midnight came and went, and 1921 turned into 1922, outside in George Street she could hear first-footers going from house to house, bringing in the New Year with neighbours. Yes, hope was hard, as her mother always told her, but there was something extra special about having a new baby as the world focused on the hope and expectation of a new year.

Above: *Ralston, aged around two, when the family still lived in Shettleston, where he was born on 31 December 1921.*

Ralston was not Harry's first baby. The couple's first child, a girl called Ellen (after Harry's mother, Ellen Charrette), had been born fifteen months earlier on 3 October 1920. When she was five weeks old, Ellen came down with what Harry thought at first was a bad cold. Unfortunately, it was much, much worse than just a cold. At the age of just five weeks, baby Ellen was admitted to the City of Glasgow's fever hospital, Belvidere, which was sited close to Celtic FC's football ground at Parkhead. After fifteen days, at 5.28 a.m. on the morning of 28 November 1920, she drew her last breath. Her death was certified by Dr Agnes P. Routledge. The cause was cerebrospinal fever, or meningitis; every mother's dread, it was a disease which was killing over one hundred people every year at Belvidere.

Ellen was buried at Glasgow's Necropolis cemetery on an eerily mild morning in early December. The loss of her daughter was very hard to bear for Harry. After the birth of their second son, Banks, in 1924, the couple tried to adopt Andy's niece, a little girl called Nan, who was his brother Walter's daughter.

Nan Wyllie's mother, Jean, died in 1926, when Nan was just two years old, and the toddler was cared for her by her two grandmothers. She often stayed with uncle Andy and aunt Harry, with Ralston and Banks regarding her as a sister. Their uncle Walter had other ideas though and inexplicably took Nan off to England, severing all contact with his family.

It would have been a bitter disappointment to Harry, but the wellbeing of Ralston and Banks became her all-consuming passion. Ralston would tell people later in life that he had been 'disadvantaged by a happy childhood' and 'had nothing to rail against'. His parents' tender loving care and innate sense of fun – and ambition – lay at the centre of that childhood.

Andy and Harry Wyllie were married in Barrowfield United Free Church, Rutherglen, on 28 August 1919 by Revd J. Lindsay Robertson, who would go on to baptise all three Wyllie children. The witnesses were Andy's younger brother Charles, and Harry's younger sister Louisa Mills.

Andy was twenty-nine at the time and working as an engineer's clerk with James Bennie & Sons, a heavy engineering firm based in Polmadie, Glasgow, which supplied heavy machine tools to companies such as the Govan-based shipbuilders Harland & Wolff. His twenty-four-year-old bride was employed as a telephonist at the time of her marriage. Andy was the type of man who was everyone's friend, despite doing the unpopular job of setting the rates for piecemeal work in James Bennie & Sons. He was a cheerful man, and a hard worker, which endeared him both to management and the shop-floor workers.

He had joined the masons in 1913 after a spell in the Territorial Army, and the connections he made as a lifetime member of Lodge Progress No. 873 in Glasgow helped to advance his career. By the end of his life, he would rise to the role of Right Worshipful Master, the person who leads and conducts all business within the Lodge.

The couple met in Inverkip, a small village on the Clyde coast that would later feature in the lives of both the Wyllie and Mills families. Not only did the families live within a short walk of one another in Glasgow – the Wyllies in the Calton area of the city next to Glasgow Green, and the Mills in nearby Tollcross – later they would end up living fifty yards apart in Inverkip.

The Great War loomed large over this generation's lives. Andy was twenty-four when war broke out in 1914. A few years earlier, in March 1909, at the age of eighteen, he had been enlisted to serve with Glasgow-based Territorial Force, the 5th Battalion Scottish Rifles. Although he was a reservist until September 1913, he was not called up in 1916, when conscription became mandatory, because his work in the munitions supply chain was considered essential war work.

The Wyllies

The Wyllie family did not escape the draft: all four young brothers, Charles (b.1892, George (b.1893, Walter (b.1897) and James (b.1901) served in the Great War. James, known as Jimmy, was killed in action. In the Glasgow area alone, around 18,000 people – mostly men – died in active service, and by the time the couple married, the city was in a state of mass recovery, as people and businesses tried to get on with their lives.

Andy Wyllie's family were conscientious workers. They had been living in Glasgow in the shadow of the mighty River Clyde since the beginning of the nineteenth century, when many workers flocked to the city for work. His great-great-grandfather James Wyllie, a carpet weaver, married Barrhead-born Barbara Pratt in the Gorbals area of the city in February 1829, and there was much to-ing and fro-ing between outlying villages of Glasgow and further south to Ayrshire, where many family members worked in the weaving industries.

Andy's father, the first George Ralston Wyllie, was always in stable employment as a lithographer with publishing firm Blackie & Son, working at their Glasgow printing works in Rutherglen.

The Mills

In contrast, Harry's family, the Charrette/Mills travelled around a lot. After Antonio Charrette's fatal fall from a Welsh clifftop in 1851, his family of six children scattered to the winds in search of work. Youngest son George having moved to Windmill Farm as a carter at eighteen years old, then moved on to Tenby as a plater. There he met Harriet Clark, a dressmaker, who was the only child of a single mother. She was brought up by her grandfather an old mariner who lived in Frog Street Tenby. Frog Street was where young George was also living and was also where they met. They were married

in Tenby and had five children. George became a steel smelter and steel contractor and in 1881 he and his family moved to Cambuslang, just outside Glasgow. There they found their first accommodation at Hallside Village, built to house workers from the new steel mill. Harriet now in her late thirties and forties went on to have a further five children. The Charrette family led a peripatetic life, with George's work in the steel industry taking him back and forth between Sheffield, Tipton in Staffordshire, and Glasgow.

His daughter, Ellen, met and married steel smelter Joseph Mills in Tipton in 1884. In 1885, they moved back to Cambuslang where Joseph found work in the booming steel industry. Their eldest daughter, Emily, was born that year, and they went on to have eight more children, including Ralston's mother, Harry, their fourth youngest child.

By the time of Harry's birth in 1895, in Dumbarton, north of Glasgow, the couple had moved from Cambuslang, to Sheffield and back to Dumbarton, where Joseph worked for a spell as a foreman steel smelter. The three children born after Emily were all born in Brightside-Bierlow, near Sheffield, while the five youngest Mills children were all born in Dumbarton.

Not long after the end of the First World War, Gran and Grandpa Mills were on the move again – this time across the Atlantic to Saskatchewan in Canada, with their three youngest children, Louisa, David and son Harry, in tow. Joseph, aged fifty-eight, had secured a position as a civil servant, and they went to join daughter Ellen, who was already living in Saskatchewan. Louisa had married a man called Sidney Graysher who

*Top: Ralston and Banks at the seaside. Like many Glaswegian families, the Wyllies spent their summer holidays 'doon the watter' on the Clyde. **Bottom:** Ralston, aged around five, aboard a paddle steamer on one of those holidays.*

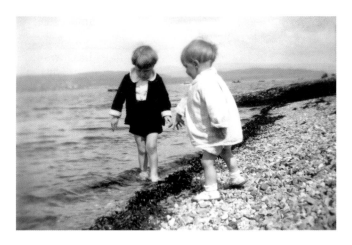

went on to become a very wealthy man on the back of the expansion of railways in Canada. Joseph shuttled between Canada and Scotland until his death in 1947, with his wife pre-deceasing him by twelve years. Both are buried in Inverkip Cemetery. Their daughter, Harry Wyllie, had very itchy feet and made several moves with Andy and her boys. She always moved in an upwardly mobile direction during Ralston and Banks' childhood years and beyond.

On the Move

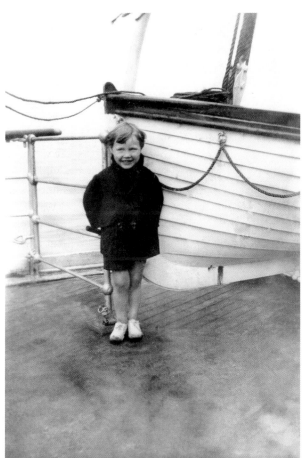

By the time Banks came along in 1924, the family had flitted to a two-bedroom flat at 10 Lismore Street in Craigton (now renamed Drymen Street), an area in the South Side of Glasgow close to Bellahouston Park. This move to the 'leafy suburbs' would have been considered a good move in these days, when the issue of overcrowding was still a major concern in Glasgow. In 1921, more than 270,000 people (twenty-eight per cent of the city's population) were living in accommodation in which there were more than three occupants per room. Lismore Street was close to the wide open spaces of Bellahouston Park and just a short tram ride away from Paisley. When they moved there, the flat was a new-build on the ground floor of a terraced house just across the road from Craigton Public School.

New estates were springing up all around this district, just a walk away from Govan and the River Clyde. By the time Ralston was at primary school, his father was working for the Scottish Machine Tool Corporation in Govan and he used to take a shortcut to the works along the nearby railway line, a dangerous commute by anyone's standards. Later, suffering from rheumatoid arthritis, he bought a bicycle, and his family would push him off at Craigton and hope he made it to Govan in one piece.

In Harry's eyes, Craigton was just the place to bring up her boys. Craigton Public School was a smart red sandstone building which had opened in 1911 with just 173 pupils. When five-year-old Ralston first stepped through its doors on 10 January 1927, it must have seemed huge, with its sweeping stairway up to the two floors of classrooms, giant echoing assembly hall and glass cupola.

In 1927, the school had the biggest roll in its history, with 959 pupils (including twenty pupils who were classified as 'mentally defective' and taught in a separate classroom from the rest of the pupils). Ralston's class teacher was a Miss Winifred Graham and there were fifty-two pupils in her class, Infants One.

Headmaster David Blair noted in the school logbook on the day Ralston started school that 'attendance was poor' due to 'several cases of mumps'.

In these pre-antibiotic days, infectious diseases such as scarlet fever, measles, German measles and mumps were rife in overcrowded Glasgow schools. Harry, after the experience of losing baby Ellen to meningitis, was a nervous mother, who fretted if her boys caught so much as a cold. In 1931, by which time Banks was also at Craigton Public School, two 'modern drinking fountains' had been installed in both the senior and junior playgrounds, which would have cut the risk of infection spreading.

At Home

Ralston was a quick learner and a sociable lad. The Wyllie household was always filled with reading matter. Even as a very young boy, Ralston was always reading. Grandpa Wyllie's job as a printer at Blackie's ensured a ready supply of annuals and storybooks with titles like *Blackie's Boys Annual*, *Blackie's Boys Story Book* and *The Boy's Budget*. There was always something to read, be it the *Daily Record*, featuring Uncle Rex (a column designed for younger readers), or the *Daily Express* with its Rupert the Bear cartoons. Ralston was also an avid reader of *Hobbies Weekly* magazine, a popular weekly craft magazine of the day. Every issue was packed with instructions on how to make toys, household objects and furniture. *The Children's Newspaper* by Arthur Mee was another favourite. Ralston and Banks also devoured the boys' adventure comics of the day: *The Rover*, *The Skipper* and *The Wizard*.

Although he loved comics of all description when he was a boy, as a father himself many years later, Ralston used to hate his daughters reading comics. During his own childhood, all these illustrated books and comics fired his imagination with tales of foreign travels and adventures, not to mention plentiful advice on how to make carts, planes, boats and kites. From a very young age, Harry would tell anyone who would listen that 'our Ralston is good with his hands'.

At weekends, Andy would take Ralston and Banks to nearby parks, such as Bellahouston and Barshaw Park in Paisley. A small slim man with a Charlie Chaplin-style moustache, Andy was always singing, whistling, and making up wee rhymes or songs, so he made any outing fun. A favourite song he would sing to his boys was the Harry Lauder classic, 'Bella, The Belle O' Dunoon'. He was a great one for reciting little poems and ditties, including one which always made the boys laugh, called 'Wee Jimmy Stodger'.

The boys sailed toy yachts on the ponds at these local parks, most of which Ralston had made himself, with the help of Andy or Grandpa Wyllie. Ralston was always making things. He was barely out of short trousers (or a short kilt, one of his mother's favourite modes of attire for him) when he started making his own boats and bogies. (A bogie was a handmade cart with pram wheels and a box frame constructed of bits and pieces of found wood.) When Ralston was still a little boy, he made a mini-galleon just like the one his great-great-grandfather, Antonio Charrette, would have sailed in when he was in the British Royal Navy. He called it *The Merry George*.

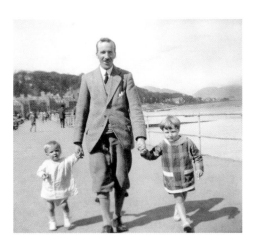

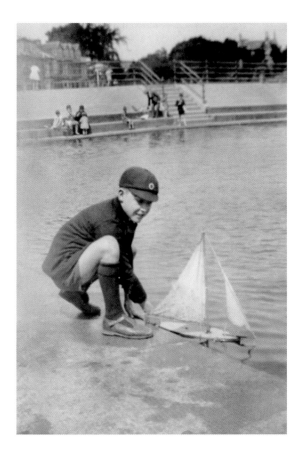

Ralston was well known in the area for his building skills and used to joke later in life that he was 'the best bogie-builder in Cardonald'.

At the centre of all the activity in the Wyllie home was Harry. Harry was a vivacious woman. Always beautifully turned out, not exactly stout, she was short, stocky and well upholstered thanks to wearing whale-boned corsets. She had a round face, which, according to family legend, came from the Charrette side of the family.

As she went about her business, cooking pots of lentil soup and making Scottish staples such as mince and tatties, clootie dumpling and the boys' favourite, coffee buns, she would sing popular songs of the day, such as 'Stay Out Of The South', made popular by American comedienne and singer Sophie Tucker, known as 'The Last of the Red Hot Mamas'. The Wyllies' living room was dominated by a large wind-up gramophone with a large green horn and it was always in use whether there were visitors or not, with Al Jolson being a favourite. The wireless was also well used. When Ralston and Banks came home from school, they'd sit with one of Harry's homemade coffee buns or Empire biscuits listening to the BBC Home Service. Particular favourites were Auntie Kathleen (Kathleen Garscadden) on *Children's Hour* and BBC Dance Orchestra bandleaders Jack Payne and Henry Hall.

Both Andy and Harry could vamp it up on the piano, which sat in a corner of the living room. Songs, jokes, music and laughter were always on the menu at Harry and Andy Wyllie's house. Andy was also a dab hand on the mouth organ, or 'mouthie'.

When Ralston and Banks were small, before Gran and Grandpa Wyllie moved down to Inverkip, Andy

Top: Andy with Banks and Ralston c.1925 walking Gourock 'prom'. *Bottom:* Ralston, aged around six, sails a toy yacht in a pond near the family home.

and Harry took them on 'the yellow tram' every Sunday to tea at their grandparents' top-floor tenement flat beside Glasgow Green. Sitting on horsehair chairs which prickled the backs of their legs, the boys would eat a hearty Sunday lunch of gammon, followed by a sponge cake from Pinkerton's the bakers in Bridgeton, before being heading out to Glasgow Green.

Glasgow Green was a hive of activity, and on Sunday afternoons *the* place where Glaswegians went for a weekend walkabout experience. The People's Palace was a museum which had opened in 1898 with the intention of providing a centre of recreation for the people then living in one of the most overcrowded areas of the city. It lay at the centre of the Green, and the boys used to love roaming around it and the adjoining Winter Gardens with its swaying palm trees and exotic plants. Half a century later, Ralston made artworks which were displayed in the People's Palace, including a stainless-steel palm tree and a zany machine called the All British Slap and Tickle Machine.

Harry was a strict – but fair – maternal presence. Possibly because of her experience of losing her baby daughter, she lavished great attention on dressing both lads up to the nines, in red blazers and red hats. Family photographs reveal Ralston in full mini-Highland regalia, complete with an extravagant feather in his 'toorie' hat. She had an eye for detailing in clothes, and once the boys were a bit older, ran a small knitwear business in Glasgow city centre with a friend. Later still, she tried her hand at running a coal business, but both enterprises petered out. She was also fond of painting on china. Sadly, she made just one oil painting, a very accomplished work of art, which hung in every house the family moved to. The family called it *Fruit*.

During the Glasgow Fair, the Wyllie family always had an annual holiday 'doon the watter', as a trip down the River Clyde was called by Glaswegians in the days before cheap foreign travel took them off to warmer climes. Dunoon on the Firth of Clyde was a favourite place to visit, and the family travelled from Glasgow by train to Gourock to catch the boat. When they reached Dunoon, they would rent a room from a resident, looking to make some money from the hordes of visitors who descended on the town. The family also visited Wales many times during Ralston's childhood.

At Gourock, Andy would take his sons up for a look at the railway engine, where they'd have a chat to the driver. If the driver let off some steam for Ralston and Banks, it was the highlight of their day. The Wyllies also travelled to Wales on several occasions when the boys were young. There were also frequent visits to the many Glasgow variety theatres of the day, such as the Empire, the Alhambra, the King's, the Royal and the Princess theatres. As a family, they paid regular visits to the pictures. Their favourite 'fleapit' was the Mosspark Picture House, with Saturday matinee cowboy films – especially starring 1930s star Tom Mix – a favourite with both boys. Years later, when Ralston visited America, he made an art installation based around his boyhood era.

By the time Ralston was ten, the family had moved round the corner to a slightly bigger home at 22 Morar Road. Around this time, while out playing with some pals, Ralston jumped off a washhouse wall after spotting a local policeman and thinking he was going to tell them off for trespassing. It was an eight-foot drop, and Ralston landed so badly he broke his right leg. The policeman came to Ralston's rescue and the boy was rushed to the Royal Hospital for Sick Children at Yorkhill.

The leg break – at his shinbone – was so bad that doctors at the hospital considered amputation. Luckily, they managed to save the leg by inserting a steel plate, but Ralston was confined to a wheelchair for many months. After several weeks in hospital, during which time his parents and Banks visited him faithfully, he was allowed home. His leg would give Ralston 'gyp' for the rest of his life. To help pass the time, Harry bought him a ukulele and taught him how to play it. Around this time, encouraged by his father, his passion for the songs

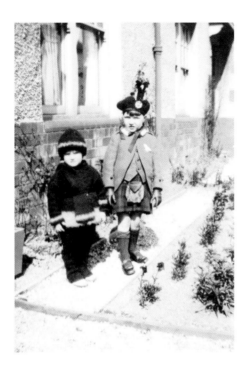

of George Formby developed – as well as a lifelong love affair with his 'uke'.

As Ralston came to the end of his time at primary school, like all Scottish children of that age, he and his fellow pupils sat what was known as a qualifying examination. Between the two World Wars, most children who passed the 'qualy', as it was known, went on to post-primary courses lasting two to three years. A minority went on to longer courses that lasted five or six years and led to a leaving certificate or, more prestigiously, a university education.

At Craigton, Ralston was taken under the wing of a young teacher called Neil Alexander, whom he later recalled as wearing brown shoes and blue suits. A self-made Glaswegian from humble beginnings, Mr Alexander viewed education as a route to a better life and recognised a cleverness that could lead Ralston on to bigger and better things. Mr Alexander put forward Ralston to sit a bursary examination for the exclusive Glasgow boys' secondary, Allan Glen's School. Andy had remained in employment through the tough years of the Depression, unlike two of his brothers who lost their jobs in the early 1930s. But even so, paying school fees would not have been an option.

In June 1933, they learned that Ralston had succeeded in securing a bursary for Allan Glen's. Two other boys from Craigton, James (Jimmy) Elliot and Dan MacDonald, were also awarded places. Harry was delighted. Her bright-eyed boy had surgeon's hands, she used to say. In her eyes, Ralston was on his way to a professional career.

Top: Banks and Ralston, c. 1926, pose in their Sunday best.
Bottom: Although she was a talented amateur artist who painted on china, George's mother Harry only ever she made one oil painting, which hung in every house the family moved to. The family called it Fruit.

Disadvantaged by Happy Childhood, Continued

Ralston joined class 1B of Allan Glen's on 1 September 1933. The school, on Cathedral Street close to the city centre, had been set up in 1853 in memory of Allan Glen, a successful Glasgow joiner, property owner and philanthropist. Glen's original aim was to 'give a good practical education and preparation for trades or businesses, to between forty to fifty boys, the sons of tradesmen or persons in the industrial classes of society'. The school eventually closed in 1989.

His fees were paid by the Auldhouse Scholarship Trust, which originally helped apprentices by supplying them with a 'shirt and stout boots' to assist them at the end of their apprenticeship to get employment as tradesmen. In 1933, the funds had been diverted to provide education to those who could benefit from it, from families who were unable to fund their schooling.

To get to school, Ralston took the number 32 tram which took him all the way from the family home at 93 Walkerburn Road in Cardonald – the Wyllies had moved *again* to a larger property a mile and a half away from Craigton – almost directly to Allan Glen's door. A fellow pupil, who entered class 1A a year later in 1934, was one Derek Jules Gaspard Ulric Niven van den Bogaerde, who would go on to become famous as matinee idol Dirk Bogarde.

In his memoir, *A Postillion Struck by Lightning*, Bogarde, who had a Scottish mother and had been sent to live with relatives in Bishopbriggs to get a 'good Scottish education', recalled his first taste of Allan Glen's in horrified tones that described a school resembling 'a

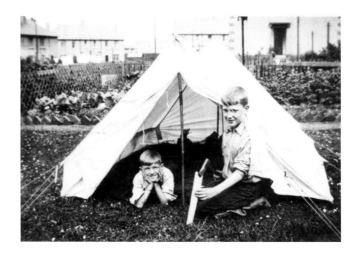

Top: Ralston's class at Craigton Primary c.1930. He is fifth from the right in the second back row. Mr (Neil) Alexander stands at the far left of the same row. *Bottom:* Ralston (right) and Banks camp it up in the early 1930s.

cross between a lunatic asylum and a cotton mill'.

The school's motto was 'Cum Scienta Humanitas' ('With knowledge, culture'), and it specialised in turning out captains of industry, physicians, academics, diplomats and architects, notably Charles Rennie Mackintosh, a pupil there in the 1870s.

On Allan Glen's instructions, it had been written into the school's constitution that the teaching of Greek was forbidden, as was the giving of religious instruction. The headmaster in Ralston's era was Dr James Steel, known as 'Jumbo' to the boys in his charge. He was a progressive sort with a strong belief in the development of individuality and originality. In English classes, boys were encouraged in speechmaking to make them confident individuals. He also ensured every boy had a training in the school's workshops.

Scottish Daily Express journalist P.A. Grimley visited the school while Ralston was a pupil and was impressed by its practical approach to education. 'In these school workshops,' he wrote, 'boys were standing at forges or sitting at tables forming chunks of copper and brass into beautiful ash trays, bowls, candlesticks and sugar basins . . . In the section devoted to art-craft, where the greatest advance has been made in recent years in the school, pupils were shaping clay into various designs ranging from insipid inkwells to glossy simpering shepherdesses.'

While at Allan Glen's, Ralston and his fellow pupils would often gather in the playground to watch the giant locomotives which had been built at the nearby Springburn Locomotive Works (part of the North British Locomotive Company) being transported through the streets of Glasgow to the giant Stobcross Crane at Finnieston Quay. There, on the banks of the Clyde, the locomotives would be loaded onto ships and carried off to countries all over the world.

The spectacle of these huge feats of engineering moving slowly through the streets burned its way into the young Ralston's imagination and years later, he would use this visual prompt as the basis of his major artwork, *Straw Locomotive*. His *Straw Loco*, as it was known, hung from the crane for three months in the summer of 1987 before being paraded through the streets of Glasgow to the site of the former Springburn Locomotive Works, where it was ceremoniously burned.

Ralston's love of transportation in all its forms – trains, trams, planes, boats and bogies – was a constant theme in his childhood. Be it travelling on them, making them or listening to Grandpa Mill's stories of the railroads in Canada and America, on which various uncles had worked in the early part of the century, Ralston was obsessed by all methods of transportation.

He started keeping a diary – an on-off habit he kept up for the next thirteen years – on 30 December 1935. There was clearly great excitement when a longed-for billiard table arrived on Hogmanay in time for his fourteenth birthday. He must have been itching to play, but the next day –New Year's Day – the whole family headed to Inverkip to visit Gran and Grandpa Wyllie, who had moved there permanently.

Years later, Ralston would recall travelling to Inverkip on his own by train. Once he reached Inverkip, he'd walk down a steep hill from the station towards the main street where both sets of grandparents lived. At home, he shared a room with Banks, and was always excited at the prospect of staying in his own room at his grandparents' home. Even more enthralling, a weekend at Inverkip always entailed lots of pottering around boats and the beach. Ralston often went with Grandpa Wyllie to the Inverkip Yacht Club, which had a little jetty at the bottom of the cliff, where the Inverkip Cenotaph now stands. Grandpa – the first George Ralston Wyllie – was the club's commodore for several years and instilled in young Ralston a deep love of sailing and the sea.

Grandpa and Grandma Mills moved to Inverkip in the early 1930s when they returned from Canada, and lived just a few doors away from the Wyllie grandparents.

Harry's sister Emily moved to the end of the village in a house overlooking the sea. Inverkip, the Clyde coast and family were all inextricably linked in Ralston's mind.

At the beginning of 1936, as we know from Ralston's diary entries, the family all paid a visit to Uncle Joe (Harry's older brother) in Tollcross on the evening of 2 January. The next day, the family headed to the Glasgow Empire to see Tommy Morgan in *Babes in the Wood*. Ralston also reports that on 3 January, 'grandpa went home'.

This passing entry about his maternal grandfather, Joseph Mills, represents a big sea change in the family's life as Granny Mills, Harry's mother Ellen, died in Inverkip on 6 December 1935, at the age of sixty-nine. Her death certificate states she died from 'chronic nephritis', or inflammation of the kidneys.

After the death of his wife, Grandpa Mills didn't hang about waiting to meet his maker; instead, he returned to Saskatchewan in Canada, where daughter Ellen and husband William Laird were still living. Later in 1936, we know from Border Control records, he travelled to the US to visit his youngest daughter Louisa and her tycoon husband Sydney Graysher in Illinois. Meanwhile, back at Walkerburn Road, Ralston whiled away the final hours of the Christmas and New Year holiday on his new billiard table, working on his model aeroplane Puss Moth, and going to the pictures.

Back to school on the Monday and another panto in the evening – this time at Glasgow's Alhambra Theatre to see *Cinderella* with Jay Saurier – and on the Tuesday after school, it was a visit to the Campbells and then off to the Marionette Club, a touring German puppet show which was a popular draw at the time.

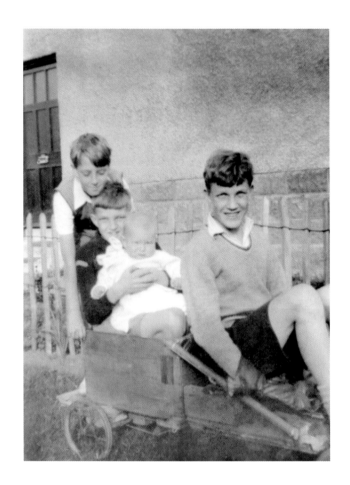

Above: Ralston, master bogie-builder (front) with Banks (holding unknown baby) and a friend.

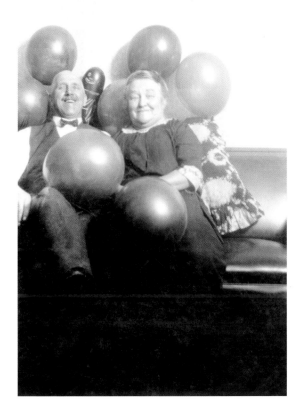

As a youth, Ralston spent all his pocket money on uke strings, lathes and saws. He was *always* busy. After drawing his own designs, he would set out to make models that actually worked. In his 1936 diary, he mentions the death of the king at 11.55 p.m. on 21 January, but he is more focused on finishing his Flying Flea model, making wheels for Puss Moth or fashioning a Flickergraph wireless station. Other pastimes included fixing his bike, making a kite, constructing a model galleon, painting a picture, building a bogie and playing the uke.

Fun was always at the centre of the Wyllie family activities. Both sets of grandparents were heavily involved in Ralston and Banks' carefree childhood years. One family photograph shows Gran and Grandpa Mills surrounded by huge balloons in a living room, laughing fit to burst. Another shows Grandpa Wyllie sitting in the garden at Craigton on a deckchair beside a makeshift tipi sporting an American-Indian headdress, complete with feathers.

As well as overseeing drawing and painting at the kitchen table, and helping Ralston to make music, Harry also taught both boys how to dance. Banks was badly injured in a road traffic accident when he was still at primary school, and to help build up his strength, she sent him to ballet lessons. This was to lead to a lifetime love of performance, and he even made a career out of it during the years of the Second World War by being part of wartime entertainment troupe ENSA (Entertainments National Service Association).

Above: Harry's parents, Joseph and Ellen Mills.

Both sons were involved in the Boy Scouts and attended the local troop in Cardonald every Friday night. Ralston was also in the troop's dance band, which met to practise every Tuesday night. Making music and making *things* took up almost all Ralston's spare time. He was inspired by his teachers in Allan Glen's workshops and a craft class held in school every Thursday, which he always looked forward to, noting it in his diary each week. He also liked drawing, particularly aeroplanes. He excelled at Technical Drawing, which he used to do on first and second periods every Wednesday, routinely achieving full marks for his drawings.

Never the sportiest of boys after the bad leg fracture a few years earlier, Ralston struggled with the emphasis placed on physical prowess at Allan Glen's. Classes ended early on a Wednesday so that the boys could head out by tram car to Bishopbriggs to play rugby.

Cricket, rowing, sailing and tennis also featured in the sporting timetable. There were also plenty of visits to the swimming baths, but despite his lifelong love of sailing and the sea, Ralston never learned to swim properly; it was a constant thorn in his side. Although he was in the drama club at school, Ralston's name doesn't appear in any of the school magazines during the three-year period he attended Allan Glen's. A fellow pupil in his year, Bill Smith, who later became Dr William Smith, a distinguished ophthalmic surgeon, must surely have been the year's hero, as his name appears in around twenty places in the school magazine.

As the summer term came to a close in the school year of 1935/36, Ralston records in his diary on 25 June: 'School. Away early. Went to J Brown's yard for exam.'

He didn't note the outcome of this exam at the John Brown & Company shipyard in Clydebank, but the next day would be fourteen-year-old Ralston's last day at Allan Glen's. His diary entry reads: 'School. Away early. Holidays begin. Bogey.'

In a document dated 22 June 1936, headmaster James Steel wrote this reference:

> This is to certify that George R. Wyllie has been a pupil of this school since September 1933, and is at present completing the third year of his secondary course. The subjects of his curriculum are English, Mathematics, Latin, Art, Physics, Chemistry, Technical Drawing and Workshop Practice. Wyllie is a boy of some ability and of excellent conduct and character.

In another letter dated 24 June (the day before his exam at John Brown's), he also secured a reference from his Craigton teacher, Neil Alexander, who wrote this about his one-time pupil:

> This is to certify that George R. Wyllie was a pupil under me for two years during which time I found him to be a boy of excellent character and outstanding ability – a boy whom I could safely recommend to anyone.

According to his diary, Ralston's summer of 1936 was spent tinkering with his bogie, building a model aeroplane, sailing his yacht in the pond at Barshaw Park in Paisley, cycling, playing tennis, climbing trees, playing his uke with friends and going to the pictures. Whatever ideas he had about leaving school, by 1 September he was back, albeit at a new school, and one closer to home.

A Good but Elusive Education

On that day, Ralston records in his diary: 'Back to school (Bella) (cuss it).' The 'Bella' Ralston refers to is

Bellahouston Academy, a brand new – and much bigger – Glasgow Corporation-run school near Ibrox Park, home of Rangers football club. It was a suburban school attended by the sons and daughters of marine engineers, civil servants, engineers and clerks, such as Ralston's dad, Andy.

Ralston settled quickly into school life at Bella, a five-year senior secondary. Banks attended nearby Cardonald School, a three-year junior secondary, from 1936 to1939.

Bella was much closer to Walkerburn Drive, and Ralston, like his younger brother Banks, was able to come home from school for his lunch and be home by 4 p.m. Now aged fourteen, and with his eyes swivelling in the direction of the fairer sex, he particularly liked the fact that there were girls to befriend at Bella.

Ever sociable, Ralston joined the debating society, the school orchestra and the dramatic society.
He particularly liked the last of those, which met every Tuesday under the tutelage of a Mr McIntyre (or 'Pansy' McIntyre as the pupils unkindly referred to him). Mr McIntyre was a part-time actor for the BBC in Glasgow and inspired his young troupe of actors as they worked towards their yearly Christmas show. Ralston played Sir Andrew Aguecheek in a production of Shakespeare's *Twelfth Night*, no doubt bringing to life the comic potential of this classic, nice-but-dim figure of fun.

A schoolfriend called Audrey McArthur (*née* Newell) from Class 4B at Bella wrote to George forty-five years later, after seeing him feature on BBC1's popular current affairs programme *Nationwide*, demonstrating his *All British Slap and Tickle Machine*. Although the sixty-

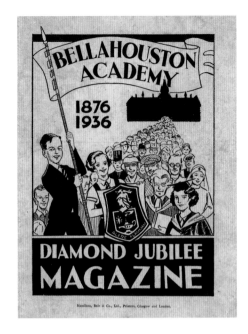

Top: The school magazine from Bellahouston Academy, which Ralston attended from September 1936 until December 1937.
Bottom: An example of Ralston's technical drawing prowess while attending Allan Glen's.

year-old white-haired artist on her TV screen was called 'George' (he started calling himself by his first name in adulthood), Audrey instantly recognised Ralston. The sense of fun in George's ridiculous contraption ('made', he told viewers, 'to keep laughter alive in the city') sparked a host of memories for Audrey, by then living on the Isle of Arran. 'You had begun sculpting even then,' she wrote to him, 'but it was sweets you fashioned (from candle wax and salt with a nut or cherry on top) and I was daft enough to eat one – I can taste it yet.' Audrey also recalled that Ralston used to compulsively draw caricatures of staff and pupils alike: 'they all had bandy hairy legs, spiky beards and pimples – females too!' She wondered too if he remembered putting her down a trap door in the classroom and then putting his desk on top of the trap door where she was forced to stay until the bell rang. 'You also arranged a date for me to go to the flicks with Stanley Livingstone (he was too shy) and then you ended up coming too!' Audrey continued. 'You must have been a whizz-kid . . . always wore scarlet stockings and plus fours – playing your ukulele and imitating George Formby & other songs you made up on the spot.'

Audrey was right. Ralston really was a whizz-kid. He never sat still! He was busy building versions of Pussy Moth aeroplane, making cases for his 'model plane stuff', playing the uke, going to Scouts, playing billiards, watching rugby on a Saturday, visiting the Mitchell Library or Kelvingrove Art Gallery in town, going down to Inverkip and attending Cardonald United Free Church and Sunday School most weeks. Like all teenagers, he also spent a lot of time with his pals, and even formed a small band in which he played the ukulele-banjo, just like his hero George Formby.

With hormones kicking off alongside pimples (which he regularly complains about in his diary), Ralston met his first girlfriend Helen Caulfield; it was a courtship that would last three years. This slim, fiery redhead was more than a match for Ralston. Their time together consisted of visits to the pictures (Helen always chose the film) and walks to a café in Cardonald where they would eat ice cream and talk for hours. In those far-off days of sexual innocence, the physical side of their relationship didn't go much further than tentative investigations by Ralston of the tops of her stockings and occasionally the strap of her brassiere. The courtship came to an end after three years when Ralston asked one night if they could go to see a film about a big band and Helen refused. 'If you don't go to see this film tonight, we're finished,' he told her. They never saw each other again . . .

Girls were just part of the mix for Ralston. Music and socialising with family and friends loomed large, as well as making things. By the end of 1936, he had made a new workbench and a toolbox, and had bought the tools to go in it. This insatiable appetite for creating was to stand him in good stead in later life.

Ralston's schoolwork was competent in most areas, but he always struggled with Latin, a requirement for any pupil progressing to university at that stage. Surprisingly, given his late-flowering career as an artist, he was average at art, gaining fifty-eight out of one hundred in his last set of marks at Bellahouston (compared to sixty-nine in history).

With an eye firmly trained on getting out into the big, wide world of work to escape the torture of conjugating Latin verbs, in December 1937, just a few weeks before his sixteenth birthday, Ralston gained his Leaving Certificate. Very quickly, through his 'uncle' Willie Miller (a family friend), he secured a job as a delivery boy at ship owners and stevedore firm, James Spencer & Company at Yorkhill Quay in Glasgow's West End. This untimely end to his school career would have pained Harry, who still had ambitions of his becoming a surgeon.

In a reference dated 10 February 1938, Bellahouston Academy headmaster Mr P Marshall had this to say about him:

George R. Wyllie completed the latter part of a four year Secondary Course at this school, and his performance here showed a very satisfactory level of attainment. On grounds of ability and character I have no hesitation in recommending him for a post in the public service. On the scientific side he showed both interest and promise.

In another reference dated the same day, English teacher James Learmonth said of Ralston:

He came to my class in fourth form in Bellahouston Sec School in Sep 1936 and was with me throughout the session. Of an agreeable, pleasant disposition, good appearance and frank outlook, he impressed me as a very good type of scholar. He writes well, is an intelligent observer and has a wide range of interests.

Despite the positive references from his teachers, Ralston had had it with school. On 6 December 1937, his working life began when he walked through the doors of James Spencer & Company. At sixteen, life was just beginning for George Ralston Wyllie. Like all young men on the cusp of adulthood, he was heading into uncharted waters, but the life lessons learned during his happily disadvantaged childhood would keep him on the right course.

As he would later say, his early life may have been one long holiday camp, but little did Ralston know his love of music and performing, his fascination with steel and the sea, and his compulsive making of trains, boats and planes would all play a major role in his career as one of Scotland's best-known artists.

Right: *Ralston spent endless hours making models of boats and planes. He made this galleon and named it 'The Merry George'. He kept it all his life..*

2 Setting Sail

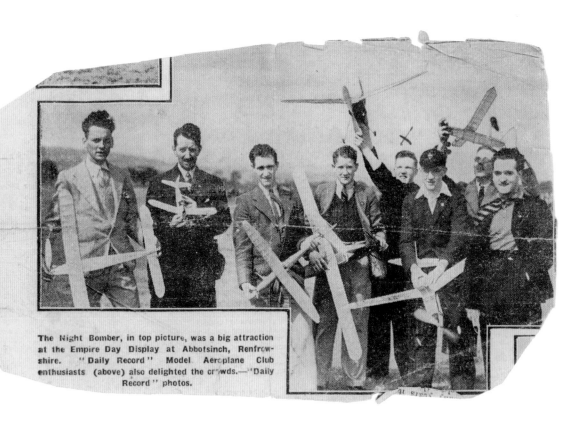

The Night Bomber, in top picture, was a big attraction at the Empire Day Display at Abbotsinch, Renfrewshire. "Daily Record" Model Aeroplane Club enthusiasts (above) also delighted the crowds.—"Daily Record" photos.

Ralston began 1938 with a spring in his step and the world at his feet. In the last few weeks of 1937, he left Bellahouston Secondary (with no Highers – a disappointment to his mother), started working life as an office junior, and on the last day of the year, turned sixteen. The offices of his first employer, ship owner and stevedore company, James Spencer & Company were based at 165 Finnieston Street, just a short walk from the River Clyde, then a bustling port thronged with ships loading and unloading cargo. As he walked out of Spencer's head office on an errand, Ralston would have seen the mighty Stobcross (Finnieston) Crane, which at that time was working at full tilt, loading Glasgow-built railway engines and carriages onto the ships below so they could be sent to far-flung destinations across the globe.

Almost five decades later, Ralston would use the crane, by then mothballed, as a 'plinth' for one of his most famous artworks, *Straw Locomotive*.

As well as making music on his ukulele, Ralston was still crazy about building and making things. He had an ongoing project to build a life-size dinghy in the back garden of Walkerburn Road, and he was also a member of a model aeroplane club which in May that year took part in the annual Empire Air Day display at Abbotsinch Airfield in Renfrew. Ralston and his fellow modellers were even pictured in the *Daily Record*, showing off their model aeroplanes which the newspaper reported 'delighted the crowds'.

Ralston's job at Spencer's offered him a tantalising glimpse into the world of international shipping. In the late 1930s, having emerged from the Depression years, this part of the Clyde was bustling with ships and crews

Opposite: This cutting from the Daily Record shows Ralston (holding aeroplane aloft, third from right) during an Empire Day Display at Abbotsinch, which became Glasgow Airport.

from all over the world. The vessels came from as far afield as South Africa, Burma, the Mediterranean, North America and across the Irish Sea. There was even a division of the City of Glasgow Police force dedicated to policing the river and all its comings and goings, with Partick Marine Police Station, just a stone's throw away from the docks, even having its own court and cells for miscreant sailors.

Every morning, Ralston was given a pile of letters to deliver to ships relating to the discharge of cargo. Towards the end of his eight-month-long spell in the job, he was even allowed to board the ships to collect reports to take back to the head office on Finnieston Street.

Ralston knew the job at Spencer's was a stopgap between leaving school and learning a proper trade. The work ethic was strong in the Wyllie family: Andy especially never missed a day's work, despite suffering from occasionally debilitating arthritis, and Harry always had some scheme on the go. No doubt with Harry nagging away in the background (she knew her clever son was capable of being more than just a message boy), after a few months at Spencer's, Ralston started looking around for another job. Despite having no formal academic qualifications, he managed to secure an interview in the drawing office of internationally renowned civil engineering firm, Sir William Arroll & Company. The firm were known all over the world as makers of cranes and bridge-building equipment, and for Ralston, designing cranes and bridges for a living would have been a dream job.

Armed with drawings he'd done of the model aeroplanes he'd been building with the Model Aeroplane Flying Club at Abbotsinch, and work from his Technical Drawing classes at Allan Glen's, Ralston impressed his interviewer at Arroll's so much he was offered a job on the spot. However, Ralston's career as a crane-builder was not to be. He went back home to tell his parents about his new job and his normally cheery and mild-mannered father told him to forget it, that it was

an 'airy' job which would leave him vulnerable should another economic slump happen. Andy's brothers had all lost their jobs during the Great Depression of the early 1930s and he didn't want that to happen to his son. To Ralston's horror, his father telephoned the office at Arroll's to say his son would not be taking up the job. That was that.

Never down for long, by July 1938 Ralston had secured a job in the General Post Office (GPO) engineering department. He brought with him the following reference from Spencer's:

> The bearer, George Ralston Wyllie, has been in our employment since 6th December 1937 as a junior. We have found him bright and intelligent and attentive to his duties. He leaves of his own accord.

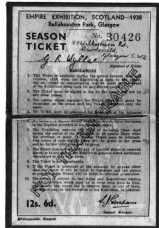

A Safe Job

Designing manholes for the GPO wasn't exactly the exciting job Ralston had dreamed of, but he knew that it would lead to him gaining useful engineering qualifications. It was the kind of job of which his father approved mightily. The Post Office was not going to go under any time soon. As a 'Youth in Training' in the Glasgow Telephone Area, Ralston was required to train in the fitting and maintenance of telephone and telegraph equipment, an area which, in the late 1930s, was expanding rapidly due to the increased demand for telephones in the workplace.

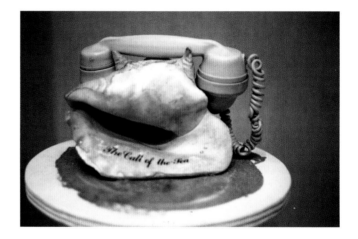

Top: Ralston's season ticket for the Empire Exhibition at Bellahouston Park in 1938. ***Bottom:*** *The sea was calling George. Many years later, he made this artwork,* The Call of the Sea, *which summed up his feelings about a life on the ocean wave.*

In 1938, outside work, one of the highlights of Ralston's year was the Empire Exhibition, which ran from 2 May until 29 October in Glasgow's Bellahouston Park, a twenty-minute walk away from the Wyllie home in Walkerburn Road, Cardonald.

This exhibition was the brainchild of the Scottish National Development Agency and was intended to make a positive statement about Scotland and its place in the Empire. A celebration of engineering, the arts and the Empire, the exhibition was two years in the planning, and all the countries of the Empire participated, apart from India.

Previous major exhibitions in the city had taken place in 1888, 1901 and 1911 at Kelvingrove Park, close to the city centre, but the scope of this ambitious event was such that the organisers required a bigger site, and Bellahouston Park, which lay two miles out of the city centre and had around 175 acres of mostly flat land available, fitted the bill exactly. There was tremendous excitement in the surrounding area as the exhibition began to take shape and new tram lines were laid leading up to the gates of the park. Even more exciting for a transport-mad youth like Ralston, was the new type of tram car designed for the Coronation of King George VI, the Coronation trams that were used on a newly configured route to the park.

The man behind this ambitious exhibition was architect Thomas Tait, a London-based native of Paisley who also designed the Edinburgh-based Scottish Office headquarters, St Andrew's House, which opened in 1939. Tait's scheme for the Empire Exhibition consisted of a futuristic townscape of pavilions and palaces, with the icing on the cake being Tait's Tower, as the 300-foot-high Tower of Empire which rose majestically into the sky above Bellahouston Park was known.

Despite that summer being one of the wettest on record, over twelve million visitors flocked to Bellahouston Park in six months. Ralston was one of hundreds of thousands of people who bought a season ticket for twelve shillings and sixpence. He would head to the park with his friends after work most evenings to take in the sights, sounds and entertainment. Buildings there included a Palace of Arts, a Palace of Engineering, a United Kingdom Government Pavilion, two Scottish Pavilions, two Palaces of Industry, a Women of Empire Pavilion, and separate pavilions from a wide range of industrial firms, government agencies, press and broadcasting organisations, and churches. There was even a concert hall, a cinema, an amusement park and bandstands for open-air dancing.

Ralston would watch displays given by the resident troop of four Canadian Mounted Police officers, or ogle beautiful girls taking part in fashion shows. He particularly liked the fleet of fifty petrol-engine Lister Trucks, which travelled around the ten miles of roads inside the park, each with a driver and a conductor. The trucks had knife-board seating for eight passengers on six routes throughout the exhibition. The public could also climb to the top of Tait's Tower and take in the views all over Glasgow and beyond. The Empire Exhibition and its attendant attractions seared its way into sixteen-year-old Ralston's imagination. Many years later, at similar, large-scale public happenings, including the Glasgow Garden Festival of 1988 and Glasgow's reign as European City of Culture in 1990, he would try to recapture this engagement of the public's collective imagination with his own brand of public art and installations, which relied heavily on a solid grounding in making things which worked, not to mention 'putting on a show'.

When the Empire Exhibition was dismantled in October 1938, it left a big hole in Ralston's life, but there was always something to be getting on with when he got back home from a day's graft learning how to design GPO manholes, including night classes at Allan Glen's Department of Technology. In these 'continuation classes' for the 'Technical Instruction of Workmen in the Engineering Department of the Post Office' Ralston laid

down the foundations of a sound engineering knowledge which he would call on in later life when he started creating sculpture in his forties.

Oozing Around

By 1939 Ralston had a wide circle of friends and was still walking out with his girlfriend Helen ('Ginger') Caulfield. Together with younger brother Banks, he was still occupied several nights a week with the Boy Scouts. Ralston played ukulele in the Scout dance band, while Banks was becoming a key player in the perennially popular annual *Glasgow Gang Show*. The *Gang Show* first took to the stage of the city's Alhambra Theatre in 1936. Both Banks and Ralston appeared in the 1938 show together, with the *Glasgow Bulletin* newspaper describing the show as a 'merry-go-round of mirth', the highlight of which was the entire cast singing *Gang Show* founder, Ralph Reader's 'Crest Of A Wave' signature tune.

Banks would go on to produce the *Glasgow Gang Show* in later life, but the 1938 show was important to both Ralston and Banks as it led to them setting up a dance act called 'The Wyllie Brothers' later that year. Their business card listed their address as '93, Walkerburn Road, Cardonald, Glasgow S.W.2. Tel. Halfway 2268'. Photographs of the pair from this era show them dancing in a variety of costumes, including matching sailor suits and lounge suits.

By the summer of 1939, Ralston had a new passion: the double bass. He had seen one for sale in the

Above: *Ralston plays his banjo behind the scenes of the Glasgow Gang Show c.1938.*

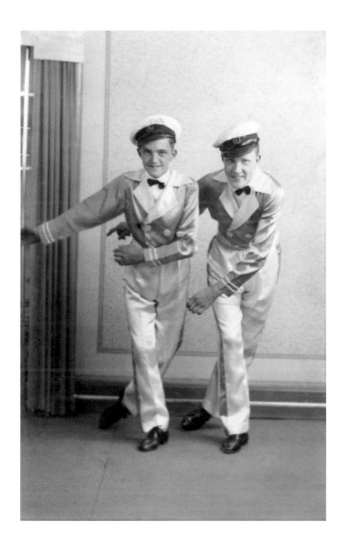

Clydesdale Supply Company in Govan for £7.10s (£440 in today's money) and had persuaded his mother to give him the money for it. From then on, the thump-thump-thump of his double bass became a familiar sound to the many visitors who passed through the Wyllies' new home at 34 Crookston Road in Cardonald. The first tune he mastered, as he recalled many years later, was a jazz standard dating back to the First World War, 'Tiger Rag'. He worked out how to play to it while listening to a recording on the family's green-horned wind-up gramophone player.

Andy and Harry had made the leap from being tenants in a council house to buying their own home in May 1939. They bought this three-bedroom semi-detached property for £600 and for the couple it represented a major upwardly mobile step on the ladder of prosperity. The house was named 'Ralbank', by Harry, a nod to both her beloved sons. That summer, Ralston stepped up a gear in his bid to build a seaworthy dinghy, and this small boat started to take shape in the family's garden.

Engineering At Last

Ralston had only been working with the GPO for a couple of months when Prime Minister Neville Chamberlain declared at 11.15 a.m. on Sunday, 3 September 1939, that Britain was officially at war with Germany. The events in Poland – Hitler's army invading its neighbour – had largely passed by Ralston, who was having his first taste of freedom away from the family home at the time. The GPO had sent Ralston

Above: *'The Wyllie Brothers' take to the stage. They took their tap-dancing act around Glasgow theatres (c.1939).*

on a residential training course to learn the basics of electronics and telephony at Coatfield Lane in the Port of Leith, north of Edinburgh. Through the week, Ralston stayed in a boarding house – filled with bamboo furniture and run by a 'Tartar' of a landlady – on Leith Walk. He returned to Glasgow each weekend, a bag of washing in hand for his mother. He was at home with his family when Chamberlain made his announcement on the wireless. Harry and Andy, who had already lived through the horror of the First World War, would no doubt have feared for both their sons (Banks was only fifteen and too young to be called up and Ralston – at seventeen – was not quite old enough).

To begin with, the war didn't change much for Ralston and his fellow Youths in Training, although one of their number, who was in the Territorial Army, was called up swiftly and left to go to war immediately. At the outbreak of war, all men between the ages of eighteen and forty-one were liable for conscription. Thanks to his GPO job, Ralston was told that when he turned eighteen at the end of the year, he wouldn't be called up.

The period from September 1939 to April 1940 was later dubbed 'The Phoney War' because after the so-called Blitzkrieg on Poland by Germany in September 1939, very little happened. Many young children from Glasgow were evacuated in the first weeks of the war, but by January 1940 around three quarters of them had drifted back. For Ralston, away from home for the first time and experiencing his first taste of freedom, it was an exciting period of discovery, particularly when it came to the opposite sex. Once he and his workmates had finished their classes for the day, they'd hook up with a group of trainee nurses they'd met and go to the outdoor swimming pool in Portobello and, later on, take walks around Leith Links, a large public park close to

Ralston's digs. The whole of Britain was forced into a blackout situation, and Leith was no exception. These evening strolls on dark nights with accommodating (up to a point) nurses opened Ralston's eyes to the possible joys of sex. For a well-brought up boy from the suburbs of Glasgow, usually under the watchful eye of a protective mother, the Leith experience was an eye-opener.

In the boarding house, Ralston also had his first taste of surreal yet simultaneously philosophical and funny classic literature, in the form of a battered copy of Voltaire's French satire *Candide*. The story of the naive young man who is slowly indoctrinated into the ways of the world touched a nerve with the young Ralston. He would reference it many years later in his award-winning, two-handed stage play, *A Day Down a Goldmine*, which was performed throughout the 1980s on stages across Britain.

On Song

Ralston's Leith experience came to an end, and back home in Glasgow with his family by Christmas 1939, he made a New Year's resolution to keep a diary again. He managed to maintain this journal, a Collins Electrical Engineer's Diary, until July 1940. In it he quickly complains about 'having a miserable time at work' (he was based at Glasgow's main telephone exchange at Pitt Street at the time) and charts his success – or lack of it – with walking girls home from dances. He also mentions his new passion for writing songs.

———————————

Opposite: *Ralston was writing songs with an eye on making money if they were used as part of the many variety shows in Glasgow. His songwriting career was cut short by the war.*

The Isle of Phooeytuyou

Now you've heard of Blue Hawaii

And Sweet Leilani too

But there's not an isle

That's got the style

Of the Isle of Phooeytuyou

There's not a place in all the world

With it you could compare

Just listen to my story

And you'll wish that you were there

Inspired by his father's love of writing ditties and poems, not to mention regular family visits to see the stars of Glasgow's vibrant variety scene in theatres all around Glasgow (there were twenty-six at the turn of the twentieth century), Ralston started to compose his own songs. He had a natural ear for music and could both read and write it with ease. These jaunty songs, which still survive, have titles such as 'You've Got To Take Precautions', 'Bessie's On The Buses' and 'My Wee Pea Shooter'.

There was also a practical reason for Ralston wanting to write songs. In the days before television took light entertainment to a mass-market audience, it was potentially a very good earner. Thanks to multiple programme-changes of summer seasons, and radio and 78-rpm recordings, the shelf life of songs was short, leading to an insatiable demand for new material. Success for the leading entertainers of the day, such as Jack Raymond, Tommy Morgan, Dave Willis and Jack Buchanan (who were all on salaries equivalent to today's leading Premiership footballers) depended on keeping their acts fresh and original. Comedians relied on writers like Greenock Maths teacher Bill MacDonnell, who according to his own diligently kept records, between 1941 and 1953 sold a total of 725 items made up of 'gag-set, compere gags, rhymes, rhyme sheets, parodies, medleys, rewrites' (source: *Scottish Showbusiness, Music Hall, Variety and Pantomime*, Frank Bruce). What these entertainers needed was novel and up-to-date material with a local, community-focused angle. For Ralston, fascinated and immersed as he was in the variety scene of the day, it was a perfect fit.

On 5 January, the morning after a visit to see bowler-hatted mustachioed comedian Dave Willis perform in *Goldilocks and the Three Bears* at the Theatre Royal ('Not so hot. Pretty disappointing', he records in his diary of the comic's panto performance), Ralston started working feverishly on a song, despite having a poisoned finger, which he tells his diary was the reason for his poor writing . . .

The diary entry for that day reads: 'Slept most of morning but started song before dinner. Went to "Wullie Wastell" in afternoon (very good). Carried on with song again. G.B. called but didn't stay long. Finished song. Got it typed up by Grace Logan and sent it to J.E. Raymond. (quick work!) Name of song:- My Little Balaclava Helmet.'

The J.E. Raymond whom Ralston mentions was comedian Jack E. Raymond, a big star performer on the Scottish variety scene at the time. Raymond, who was born in 1898, caught the tail end of the crossover from variety into television, when he starred in Scottish Television's fondly remembered comedy show *The One O'Clock Gang* in the early 1960s. At the start of 1940, Raymond was aged forty and star of *Wullie Wastell*, the pantomime Ralston and the family saw on 5 January at the Royal Princess's Theatre in the Gorbals (now the Citizens' Theatre). The Princess's pantos were famous for their extravagantly absurd and surreal scripts and spectacular chorus numbers. For many years, Raymond and co-star George West were the knockabout double-act who charmed audiences at the famous theatre. The Princess's pantos were also famous for having thirteen letters in the name of every production.

Inspired that day by seeing the surreal antics of Raymond and his co-stars in *Wullie Wastell*, and tapping his feet to all the musical numbers, Ralston rushed home to finish his song. A jaunty ditty, with two verses and four choruses, it takes the war, which may have been phoney but was on everyone's mind, as its subject matter.

My Little Balaclava Helmet

VERSE I:

Since I've joined the army, I am a soldier bold,
But though it's very chilly, I do not feel the cold
I've a Balaclava helmet,
The best one that's in France, And as for all the
 German ones,
They don't stand half a chance.

CHORUS I:

In my little Balaclava helmet
The girls all smile and wink their eyes at me.
And every little French girl always tells me,
I am a sight for all sore eyes to see.
My mother made it for me with vigour and with
zeal,
Its design is complicated, its secret I'll reveal.
She started knitting socks for me, but couldn't turn
 the heel!
That's how I got my little Balaclava helmet.

CHORUS II:

In my little Balaclava helmet
It's a rare thing if your hair is kind of thin,
And some say when I'm in my helmet,
I'm like a haggis with a white spot on its skin,
It protects me from the splinters when the bombs
 and shells are bursting
And from what I consider, an even more worse
thing,
For I can't hear the sergeant when he's doing all his
 cursing!
When I'm in my little Balaclava helmet.

VERSE II:

I'm the envy of each soldier in the army of today,
It's a nifty piece of knitting, a nit-wit's work they
say,
It's garter stitch and cable stitch
And purl and plain as well,
There's even a trace of drop stitch
For I can see just where it fell.

CHORUS III:

In my little Balaclava helmet
To any soldier it would be a boon,
It was borrowed by a sergeant in the Air Force
To cover up his big barrage balloon,
As a duster or a hanky, it's really quite a good thing,
The cook once took a loan of it to make a
 Christmas pudding,
It kept the raisins in alright, but the rest was all
 protruding!
Through my little Balaclava helmet.

CHORUS IV:

In my little Balaclava helmet
I'm camouflaged as though I wasn't there,
A pilot of our bombers once told me,
I look like a big dumpling from the air.
In a German push I once saw Hitler in the rear,
Urging on his Nazis from a bomb-proof shelter near,
The big attack was furious, the reason was I fear –
He wants my little Balaclava helmet!

Exactly a week after sending Raymond his neatly typed-out song, Ralston was overjoyed to receive this handwritten reply:

Wellfield Avenue
Giffnock
Glasgow

January 11th 1940

Dear Ralston

Thanks ever so much for your letter and song enclosed. Sorry not to have replied sooner but I think you'll understand just how busy the last few weeks have been. The song I think is very good indeed and so topical of course. I can't use it in the panto now we've started Mr McKelvie [panto director Harry McKelvie] does not favour changes but it will probably come in handy on some future occasion. The difficulty about learning the melody is that you are working the day and I am at night, maybe you could come along to the Princess one evening and I could hear it in the interval.
Drop me a line or phone one morning before 12 noon saying which night is suitable for you. The next few Sundays are taken up with friends and charity shows for Jock's Box etc.

I'd like to hear the melody because I think you're onto a winner in the song and I do like the theme. That's all for now, please convey my kind regards to Mother and Dad in which Mrs R joins.

With all good wishes to you for 1940.

Sincerely yours
Jack E. Raymond

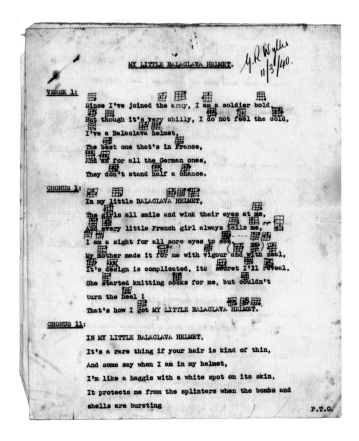

From this response, it appears there was some social link between Harry and Andy and Jack Raymond and his wife. Ralston was not backwards at coming forwards and he'd soon set up a meeting for 17 January, backstage at the Princess's Theatre at 6 p.m. That night, he records in his diary: 'He [Raymond] liked lines and said he'd speak to Mr Kingsley (Rex) of Sunday Mail to see about Jock's Box Concerts.'

Ralston's twin interests of songwriting and dancing must have merged in this conversation with Raymond as the reference to *Jock's Box* related to his dance act with Banks. *Jock's Box* was a peripatetic variety concert which raised funds for servicemen and their families. It was backed by one of the most popular sports journalists of the day, Rex of the *Sunday Mail*, whose real name was R.E (Bob) Kingsley. Kingsley, who had extensive contacts in the entertainment world from his time writing about the stars of the day for the *Sunday Mail*, had also established Rex Blind Parties in 1937 to provide commentaries for the visually impaired at football matches. We know the journalist got in touch with Ralston not long after this because on 31 January, Ralston writes in his diary that he 'received word from Mr Kingsley 'Rex' of Sunday Mail to go to Larkhall for Jock's Box concert on Sunday'. For the rest of the week, Ralston expresses his frustration about Banks not being 'co-operative'. When the two boys finally performed in Larkhall, a small town some fourteen miles southeast of Glasgow, later that week, their song and dance act wasn't up to scratch. 'I consider we did not do as well as we might have,' writes Ralston disconsolately in his diary on 4 February. On a more positive note, he adds: 'Played uke coming home on the bus and quite a nice tone was had by all.'

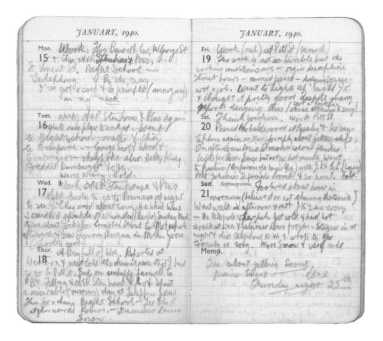

Opposite: The lyrics and music for 'My Little Balaclava Helmet' (written in 1940). **Right:** *Ralston kept diaries from 1936 until 1949. In the early years, he recorded a lot of everyday detail. Some of his diaries were sadly lost.*

Setting Sail

On 21 January, Ralston records in his diary that he 'wrote to Geo Formby re song'. It wasn't unusual for him to contact publications or famous people. In the family archive is a letter written to George from *Hobbies Weekly*, a popular weekly magazine devoted to making things. In it, the editor of the magazine writes that he 'has pleasure in accepting for publication the matter indicated below and hopes to use it in due course. Payment will be made at our usual rates at the end of the month during which the article appears.' The article in question is called 'A Sea Fishing Line'. Ralston must have been beside himself with excitement when a letter appeared on the mat just four days later. Unfortunately, it was a rejection from George Formby, then the UK's highest-paid entertainer, who clearly ran an efficient office. 'Got a letter from G Formby containing a lousy "no"!' Ralston complains in his journal. He wasn't having a good run. The previous night he noted in the diary that 'J Brown phoned to say she couldn't come to dance because she had a cold'. The 'J Brown' in question was a beautiful sixteen-year-old aspiring performer from Rutherglen called Janet Brown. In later life, Brown became best known for her impressions of UK Prime Minister Margaret Thatcher, but she'd previously enjoyed a stellar career in film in the 1940s and later on television. The two young people clearly had a shared admiration for Formby. As well as appearing in films such as *Spare a Copper* and *George in Civvy*

AN A.T.S. ENTERTAINER WHO IS GOING TO FRANCE.
Private Janet Brown comes from Glasgow she is one of three A.T.S. girls who are going to France to entertain the troops—the advance party of a group of twenty. In this picture Subaltern Isabel Birmingham is putting the finishing touches to one of Private Brown's dresses

Right: Through working in theatres around Glasgow with Banks Ralston met a young Janet Brown, who went on to find fame, particularly in the 1980s for her impersonations of Prime Minister Margaret Thatcher.

Street, Formby regularly graced Glasgow stages with his lovable daftie act, which took the form of him singing and playing his ukulele to tunes such as 'Leaning On A Lamp Post' and 'When I'm Cleaning Windows'.

Brown writes in her 1986 autobiography, *Prime Mimicker*, that as a young girl, her parents gave her a ukulele 'to practise a George Formby impression'. Despite being rejected by Janet (or Jenny as she was known to family and friends), Ralston would talk fondly of her for the rest of his life, and there's no doubt there was a strong connection between them. A couple of years later in January 1943, during a spell of leave from the Royal Navy, he notes in his diary that 'he went up to Jan Brown's for tea. Met her folks and fooled around a lot with uke.' He writes a few days later that he went to the pictures to see a comedy called *Between Us Girls* with Jan, followed by tea at the New Savoy.

There weren't enough hours in the day for Ralston. As well as his work at the GPO, which often involved weekend work, he had night classes, band practice, double bass lessons, outings with pals, songwriting and boat-building (learned from *Hobbies Weekly*) to fit in. According to his diary, he had various appointments and phone calls with Jack Raymond about his songs during the first few months of 1940. By the end of February he had worked out a piano score for it. Also, in the first six months of the year, the dance act he had with Banks started to take off as they travelled around various pop-up talent shows, held at the time in cinemas between the two feature films. This meant the boys had to create routines and rehearse. One entry in the diary states that Jack Raymond was taking an interest in the Wyllie Brothers. On 5 February (the day after the disastrous Larkhall concert), Ralston notes that he 'called JE Raymond who suggested more comedy in the

act'. The fourteenth of February saw the boys heading to the city's Metropole Theatre on Stockwell Street to take part in a talent competition. They even reached the semi-finals, which were held two nights later. They didn't make it to the finals, but Ralston put the experience to good use.

He writes in his journal: 'Went to semi finals at Met and nearly got into finals. Met Frank Parr and Norma Meadows who advised me to publish my song. Got a lot of autographs on the drum of my uke.' (Although Ralston refers to it as a ukulele, it was actually ukulele-banjo.)

By the end of February, according to Ralston's diary, the boys were performing every night for a whole week at the Metropole Theatre. In mid-April, they were booked for a week at Paisley Theatre, with Ralston complaining at the end of the week-long run that he only 'got £1 for his troubles'. By this stage, Ralston was also seeing a girl called Babs Young, but she had to play second fiddle to his ambition to make it big on the stage. Saturday, 13 April: 'had to break off date with Babs as got to see Jack Anthony about song'. Jack Anthony was a big star, so doubtless Babs took the rejection on the chin. It's not known what the outcome of this meeting with Anthony was, but Ralston kept in contact with him. A letter dated 23 December 1940 exists in the Wyllie family archive from Anthony in which he writes:

Dear Mr Wyllie

In reply to your letter of 7th instant with enclosure of music.

As pantomime has already started I am sorry I cannot use this material, but should you have any other songs in the near future I should be pleased to give them a trial.

Yours faithfully
Jack

No doubt with their mother pushing from the wings, in May 1940, the Wyllie Brothers made a bid for stardom on the *Britain's Got Talent* of its day, *The Carroll Levis' Radio Discoveries Show*. This talent show, in which the public vote counted, became a huge hit on the BBC Home Service, from the late 1930s until the mid-1940s. Levis, a Canadian impresario, came to Britain in 1935, and while writing continuity links for the BBC launched *Carroll Levis' Discoveries* on offshore commercial station Radio Luxembourg. The format was simple. Levis toured the provincial theatres of Great Britain looking for 'the next big thing' in entertainment. The act that received a combination of the loudest clap and the highest number of postal votes from listeners would go through to the next round. Transferring the show to the BBC ensured a captive audience and over eight million listeners tuned in at the height of its popularity.

Levis' catchphrase was 'We take the unknowns of today and turn them into the stars of tomorrow'. Ralston and Banks were desperate to get in on a piece of this action. Names who emerged through Levis' 'talent factory' and appeared in his hugely popular touring show included Nicholas Parsons (then working as an apprentice engineer in the shipyards of Clydebank when he went for his audition in 1941) and Lenny the Lion ventriloquist Terry Hall. More than two decades later, the Canadian Svengali presented a television version of *Discoveries*. In 1959, a young beat combo from Liverpool called Johnny and the Moondogs reached the semi-finals in Manchester, but didn't make it to the all-important final. They later found success as the Beatles.

The Carroll Levis bandwagon was in Glasgow in May 1940. Ralston notes in his diary on 8 May: 'Went for audition for Carrol Levi's & fixed up for Saturday's matinee'. Unfortunately, the boys' performance at the Empire Theatre on the corner of Sauchiehall Street and West Nile Street (a famous stage which played host to greats such as Fats Waller, Jack Benny, Bob Hope and Frank Sinatra, to name but a few) was a damp squib.

Ralston records that he 'went to Empire. OK – if there had been an audience.' Never down for long, Ralston then went skating with some pals, including a girl called Isa whom he saw home. He got home to Cardonald late, he writes, 'and got a row'.

It could be that dance acts were too visual for radio, but Ralston and Banks didn't make it through to the next round of *Discoveries*. Their brush with stardom did, however, reinforce in both boys a sense of showmanship which had always been in their family. It was Banks who started getting regular gigs on stage. Ralston notes in his diary of 8 May that Banks had been offered regular work with the *Half Past Eight Show*. This fizzy blend of music, laughter and song – a bit like a seaside summer show – had been running in Glasgow's King's Theatre since 1933. The show started at 8.30 p.m. and was changed weekly, attracting huge crowds. Still only sixteen, Banks would go on to perform with the Entertainments National Service Association (ENSA had been set up in 1939 to provide entertainment for British Armed Forces during the Second World War). Once he turned eighteen, Banks would go on to tour Britain as part of an act called Banks and the Benson Sisters during the war years.

The war did not impinge greatly on Ralston's life until the autumn of 1940. In his diary, which abruptly stops after a camping trip with pals to Loch Lomond at the end of July, he records minutiae about working life, working on building the boat with his friend 'JK', trips to ice rinks at Paisley and Crossmyloof, as well as opaque references to girls ('nursie, nursie' being one code he used, which probably harks back to his formative experiences with nurses in Leith the previous year) and continual references to working on new songs.

Together with most of his fellow trainees, once he had passed the City and Guilds course in telephony in June, Ralston joined No 1 (Glasgow) Zone Home Guard, which was the GPO's own Home Guard. For over a year, they would form part of a squad that travelled all

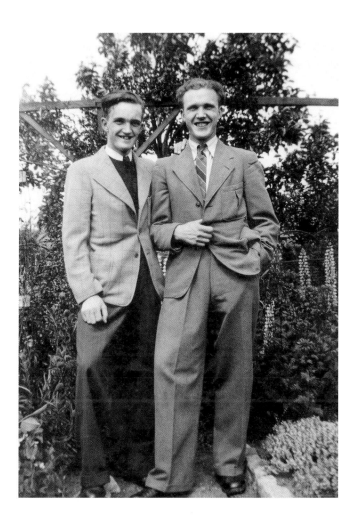

over Scotland setting up radio location centres for the RAF to track bombers flying into Britain's coastlines. As this was regarded as vital war work, Ralston and his workmates were temporarily exempt from conscription.

This essential work took Ralston away from the day-to-day grind in Glasgow and all over Scotland. It meant he was absent from Glasgow during the Clydebank Blitz of 13 March 1941, when 236 German planes were sent to bomb naval targets such as the Admiralty oil storage farm at Dalnottar and the John Brown Shipyard at Clydebank. It must have been a constant worry for the Wyllie family, who lived close to the River Clyde, but happily no one in their family was injured. The bombs were scattered across Glasgow and of the 1,300 people who died, only 500 lived in the intended target area of Clydebank.

Ralston's squad spent a lengthy period of time in Drumossie, outside Inverness. Other trips took them to Aberdeenshire and further north to Orkney. In each location, he stayed in digs with his workmates. During these trips, he worked on his songs, and practised the uke and his double bass, which went everywhere with him. He also started picking up gigs of an evening with dance bands whose bass players were off serving in the war. He had his first ever gig in Govan Town Hall when he was just nineteen. Ralston loved playing in bands, and his parents were fairly tolerant of the late nights and disruption which his coming and going would bring to the home. During this period, Ralston was still trying to get his songs picked up and used in big productions. In October 1941, he wrote to Dave Willis, who was on the road at the time, enclosing a number called 'Bessie's On The Buses' for consideration.

Above: Banks and Ralston in the early 1940s before they went to war; Ralston to the Royal Navy and Banks to the Entertainments National Service Association.

Willis' manager responded twice:

DAVE WILLIS
PHONE IBROX 58

King's Theatre
Edinburgh

18th October 1941

Dear Sir

Mr Willis thank your for your letter to hand, and wishes me to inform you that he will be pleased to read your numbers, and if you have anything in the catchy chorus line (words that can be thrown on a song sheet for the audience to sing) he would be pleased to consider them for Pantomime.

Yours faithfully
Leslie Conway
Manager for Dave Willis

and

Empire. Inverness
Reply to . . . 16 Beech Avenue
Dumbreck
Glasgow

5th Nov. 1941

Dear Mr Wyllie

Mr Willis thanks your for yours to hand, and wishes me to inform you that he has read the numbers, and the one he likes for a sheet number is 'Bessie in the Buses', the others are of no use to him, as he does not want anything referring to the war.

Could you shorten the 'Bessie' number, something like this to make a sheet number for Panto.
This is only an idea of what he means:-
 So Bessie's on the Buses, Bessie's on the Buses,
Yes, my Bessie is a bus conductress now,
Up and down the stairs, gathering in the fares,
Bonny Bessie's busy bustling,
Like a bumble bee she's hustling
(Another line here)
Cos my Bessie's working on the buses now.
 Something like that, making a nippy easily sung sheet song.

Yours faithfully
Leslie Conway
Manager for Dave Willis

Careless Talk Costs Lives

Possibly because of the British government's propaganda campaign that 'Careless Talk Costs Lives', Ralston stopped keeping a diary around the time he started travelling around Scotland with the squad of fellow GPO engineers. One of the posters at the time even showed a cartoon of Hitler sitting on telephone wires listening in to conversations on the line – a bit too close to home for Ralston and his workmates.

As the GPO squad's war work came to an end in the summer of 1942, so did Ralston's reason for *not* being called up. Aged twenty and in rude health, he was exactly the type of man needed by his country. One morning in September 1942, his 'papers' arrived on the mat at Crookston Road. With his telephony experience, Ralston was a natural fit for the Royal Corps of Signals, an army regiment traditionally first into any military action, providing battlefield communications and information systems essential to all operations. A close relationship existed between the General Post Office

Engineering Department and the Royal Corps of Signals, but for some reason, Ralston was told he'd be joining the Fleet Air Arm.

A branch of the British Navy, the Fleet Air Arm was responsible for the operation of naval aircraft, and by 1942, it was, quite literally, firing on all cylinders due to a lack of RAF personnel after hundreds of servicemen were killed and injured during the Battle of Britain in 1940. It is estimated that between 10 July and the end of October 1940, the RAF lost around 1,023 aircraft. This caused a severe shortage of air and ground crews, which meant that the Fleet Air Arm was called upon to step up to the mark with air crews and ground staff. It needed men with Ralston's experience in telecommunications, but somehow, when he presented himself for an initial appraisal, he talked his way *out* of the Fleet Air Arm and *into* the Royal Navy.

His early working experience of being around sailors on the big ships docked on the River Clyde had whetted his appetite for a life on the ocean wave. History doesn't record how Ralston managed to convince the authorities that he should join the Royal Navy, but Ralston had always been a good talker. His parents were delighted with this outcome. In their opinion, the Navy was a much safer option for their boy. By that stage too, younger brother Banks had turned eighteen, but because of poor health following a bad car accident, his father had used his contacts to secure him a job as an armature winder (someone who locates and repairs, or replaces, broken parts of electric motors) in the shipyards in Govan. His contribution to the war effort was to take time out to entertain the troops as part of ENSA.

On 23 September 1942, waved off by his mother and father, Ralston boarded a train from St Enoch Railway Station in Glasgow bound for London Euston. Apart from a few childhood holidays in Wales, it was the first time he'd been south of the border. He had been detailed to report to a barracks in Gosport, a naval town close to Portsmouth on England's south coast, for training –

or square-bashing. His job title was Electrical Artificer, which carried the rank of Petty Officer. His job would entail maintaining and repairing electrical apparatus, instruments and torpedoes. Sparks were about to fly for George Ralston Wyllie – in all directions.

3 All at Sea

Although Ralston was within smelling distance of the sea in Gosport, it would be another eighteen months before he set sail and witnessed conflict first-hand. As far as his parents were concerned, being confined to the shore was the best place to be. There's no doubt that Harry fretted about the fact that the city of Portsmouth and the surrounding towns, as the home of the Royal Navy, were a constant target for enemy bombing. Just one month before Ralston was called up, it was widely reported that there had been a renewed bombing offensive on Portsmouth and the surrounding area by the Luftwaffe after a year-long gap. Although not on the scale of the initial bombing in 1940, this continued on and off until July 1944, terrorising the people who lived there, particularly those living and working around the city's huge dockyards. By the end of the war, the heart was bombed out of Portsmouth's historic centre, but the people picked themselves up and got on with it. There was nothing else for it.

Ralston had four years' experience in electrical engineering behind him thanks to his much loathed job with the GPO, but the Royal Navy still needed to make sure each and every one of its personnel knew one end of a torpedo from another. His training schedule began at View Barracks in Gosport, where along with a squad of fellow Royal Navy rookies, Ralston was put through basic military training and instruction in naval history. His Royal Navy records show that from 23 September 1942 until 26 March 1943 he was based at HMS Victory 2, a land-based naval training establishment located at the dockyard in what was known as 'Old' Portsmouth.

Away from home for the first time for an extended period of time, Ralston was in his element. He enjoyed the banter with fellow trainee sailors, and although his leg troubled him from time to time (a hangover from falling off the wall as a boy), he didn't even mind the relentless drill of marching and square-bashing. He had brought his double bass and trusty uke with him, and was never shy about performing. It was around this time he started to introduce himself to new friends as 'George'. Beyond Scotland, he found people seemed to struggle with the name Ralston. It may have been his strong Glasgow accent and the way he rolled his Rs when he told people his name, but after a few weeks in England, it just seemed easier to introduce himself to new people by his other name of George. Most of the lads in the navy called him 'Jock', the usual moniker for a Scot abroad. His family and closest friends would continue to call him Ralston for the rest of his life, but from this period onwards, he told new people he met that his name was George.

Love is in the Air . . .

Just three weeks after leaving Glasgow, George spotted a notice on the wall of the View Barracks' mess room. A dance was to be held on the evening of Thursday, 22 October, in the drill hall, where he and his fellow recruits did their square-bashing through the day. Always keen to hear a dance band, as he put on his uniform that night and slicked back his unruly mop of blond curly hair, little did he know he was about to meet his 'first mate'. When George and his pals walked into the hall, they all headed for one side of the room and stood against the wall boards and bars, eyeing up the gaggle of girls who lined up on the other side of the hall. One particular girl caught George's eye. Petite, slim and softly pretty with light brown curly hair which touched her collar, as was the fashion at the time, she was glancing nervously around the room, smoothing out the skirt of her dress when her eyes met his. Without hesitation, he walked over and asked her to dance. She shyly agreed, and for the rest of the night no one else existed for either of them in the smoky drill hall. They danced one dance after another, and as they waltzed around the hall, she told him her name was Daphne. She had only just turned eighteen and lived in Gosport with her parents,

older brother John, who was serving in the RAF, and elder sister Joan, who worked in a laundry at the old docks in nearby Portsmouth. She had just started her first job herself in an accountant's office at the docks. It could be terrifying, she told him, now that the Germans had started dropping bombs again. At the end of the night, George asked Daphne if he could walk her home. Daphne agreed and the pair set off to walk the two miles to her home at Gosport's Brockhurst Road.

As the young couple approached the front gate, Daphne's father William (Will) Watts, a former abattoir superintendent turned food inspector for the Admiralty, appeared out of the darkness, not best pleased that the baby of the Watts family (she was called 'Babes' by all the family) was consorting with an unknown Scottish sailor without his knowing anything about it. Daphne told her dad that this young stranger had recently arrived from Glasgow and was missing his mum's home cooking. Although Will was annoyed about Daphne coming home with a young sailor she'd only just met, this seemed to touch a nerve, especially given his job with the Admiralty. George was summarily dismissed, albeit with an invitation to return for Sunday lunch a few days later. It was wartime, after all, and these men were doing their bit for King and Country. Later on in their courtship, Daphne told George that her father read her the riot act that first night for going out with sailors and not telling him and her mother. But the die was cast after that first dance in the View Barracks Drill Hall in Gosport. Daphne was George's and George was Daphne's.

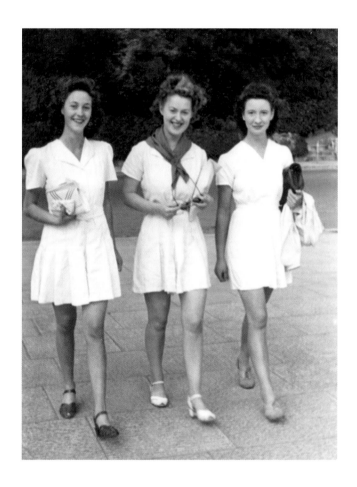

Above: *From right to left, Daphne Watts, Marion Telford (who married Daphne's brother John) and Joan Watts (who married Marion's brother Norman).*

From then on, even though he shuttled about from one shore-based centre to another during his naval training period, George's internal compass was always set to where Daphne was living. Although her family nickname was Babes, Daphne would always be Daph to George. She in turn called him Ralston. Daphne's parents were welcoming of this personable young Scotsman, but protective of their little girl. Despite the watchful parental eye always being trained on their activities, from that moment on, the young couple saw each other as often as they could, with George becoming almost like a second son to Will and Daphne's mother Winifred (known as Wynn). George loved his food and, although rationing was at its height, Will was always able to procure decent meat and fresh fruit and vegetables, thanks to his job. George and Daphne got to know each other slowly, with George making a point of seeing her as often as he could get away from the barracks. Opportunities to go beyond kissing and cuddling were few and far between for the couple, although George records in his journal in coded language various attempts to try . . .

These were different days for young couples, and although there was clearly a strong physical attraction between the two of them, sex was strictly off limits in their courting days. George started keeping a diary again at the start of 1943 and on 2 January – after a brief trip back to Glasgow to celebrate his twenty-first birthday with the family, he writes: 'Phoned Daph in morning and dined with her family at 1pm. Stayed at home with her during afternoon and considerable ground gained with no resistance. All the same, we're pretty sincere.'

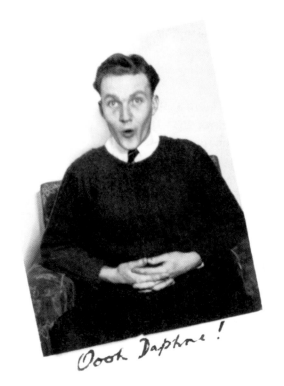

Oooh Daphne !

Above: Oooh Daphne! Ralston, in typically playful mood, in a photograph sent to Daphne during their two-year-long courtship.

The next day, 'after scrubbing out chief's office' and attending a church parade, he confesses in his diary that he 'skipped out with pass & saw Daph. Over at her house resistance was met with but all ended very beautifully and I really like her an awful lot.' By the end of February, during a weekend stay with the Watts, he writes: 'I'm sure very much in love'.

They did do a lot of what George told Daphne was called 'winching' (stepping out in the early days of a courtship) back in Glasgow. At the weekend, the couple would catch trains out into the country with the thinking being that trains on the move were hard for enemy bombers to hit. A favourite haunt was Horndean, eight miles or so north of Portsmouth, where they would go on walks around Horndean Woods. They'd also take the train to Shoreham, a small seaside town in West Sussex, where Daphne's grandmother lived. Most nights, if he could wangle a pass, he'd escape from barracks and head to Daphne's house, where there was always a warm welcome. Every night, before he headed back to base, there would be a protracted 'porch scene with Daph', which he usually recorded in his diary. George left the Royal Navy Barracks in Gosport at the end of March 1943. As he records in his diary on his second last night in Gosport, 25 March, he has mixed feelings about this leave-taking. 'I'm really "sad" about going away on Sat,' he writes. The next day, after having spent the night at the Watts' house and returned for a final night in the barracks, he writes: 'we part very lovingly & I return strangely happy to R.N.B [Royal Naval Barracks], becos' I'm pleased to have someone like Daph.'

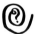

The second stage of George's training saw him being sent for three months to study at Northampton Square Polytechnic in London, close to the Angel tube station in Islington, living in nearby 'billets', as the navy accommodation was termed. In London at the 'poly', George and his fellow trainees were lectured on the latest developments in electronics and the practical side of maintaining and repairing electrical apparatus, instruments and torpedoes on board a naval vessel involved in active service. Although he missed Daph, George loved London, which was a buzzing place to be during the years of the Second World War, despite the hardships brought about by the Blitz and ongoing day-to-day privations created by rationing and wartime. He regularly visited his aunt Emily, his mother's sister, who lived in London with her family, and he liked to have this home-from-home to escape to in the big city. The creative side of his life seemed to flourish too alongside his love life. As well as getting paid for gigs a-plenty in the evenings around the various dance halls of London, he writes in his diary frequently about cartoons he's been doing. He also talks about pictures he's taken, reflecting a growing interest in photography.

Music was at the heart of his London life. One of the places George regularly visited to hear big band music was the Queensberry All-Services Club on Old Compton Street, a huge venue which could accommodate up to 2,500 people. Glenn Miller and his band played there in 1944 to great acclaim. He also writes in his diary in late May 1943 about a visit with the 'boys' to the Coloured People's Club, a new establishment on Frith Street, Soho, which specialised in 'Real Swing in the authentic manner'. 'Have double bass, will travel' was George's motto, and in London, the prevailing taste for American-inspired jazz appealed to him greatly. He managed to talk himself into playing with several bands during his brief spells in the capital. It was a good source of income too. Apart from playing at dances in the polytechnic, he records in his diary that on one Friday night in May 1943, he played a gig at the Rainbow Corner Red Cross Club, Piccadilly Circus, a famous haunt for US servicemen during the war, and received £1 for his trouble. It wasn't always dance music on the

Daphne

Charles Letts's

POCKET
DIARY
1943

Charles Petts & C°

DIARY HOUSE
LONDON

GLASGOW - EASTER.

Dawdle around house till Wyn
comes down & then Daph

24 Sat
Cyril, Nan & Frances & I go
walk over Gleniffer braes.
Very nice & muddy. Home & home
about 1.30 pm. In afternoon
Daph & I go up town. Watch &
dawdle & finally end up at
Royal to see "International Circus"
— not bad. Home not too late
& to bed quite early.

Dawdle around house in Sun

25 Sun — Easter Day. S. Mark morn Daph & I
making hay. She conveys to
me that I'm a "nark" & in a
way it's quite true — tho' I got
completely. We intended going
to Balmaha — but weather bad.
End up by going to Hot Glasgow
which were shut & then to Ranken
Glen. Daph feeling cold. Back
via Paisley & then blethin with
folks — play records & like a stik
etc. & so to bed at 12.45 am

Up early to catch 10am to Euston with
Wyn. Farewell to Mum & Oscar

26 Mon — Easter Monday. Bank Holiday
Daph. Pop Banks & Wena at station.
The quickest & by far the nicest
run I have ever had on this or
most trains. Daph is in a "delicious"
mood & I feel fine towards her &
today I felt like starting to do
something really effective towards the
future with someones guidance.
Train arrives early & Daph & I
hurry to Waterloo for her to catch

27 Tues — Last Quarter. 8.51 a.m. catch
Back at Poly again. 7.27 to Pompey.
Turning & believe. I don't half tell
To Predie of Essin the party &
at night. Write when I get back
to folks. Cheered to billets I write
up somewhat. to Daph quite
Some yesterdays a letter. Post
but still wish this & back to
yet was armistice billets & so to
cos one never knows bed — feeling
what Daph & I might wrapies ovry
do — this one

musical menu. One entry in his diary for 20 April 1943 says he had a hectic night playing at the Pride of Erin Social Club, which catered for the many Irish folk exiled in London. 'Had a hectic night,' he writes, 'between G string bursting forcing a return to billets for new string.' One of the fellow musicians he met in London was a very young Johnny Dankworth. He kept in touch with both Dankworth and his wife Cleo Laine for many years. Dankworth, who was some five years younger than George, was a precocious talent on the alto saxophone, then just becoming 'the' instrument in dance circles.

By Easter that year, at the end of April, things were getting serious enough with Daphne for her to pay her first ever visit to the Wyllie family home in Glasgow. George doesn't record in his diary what his mother thought of his new English girlfriend, but meeting Harry for the first time must have been a nerve-wracking experience for Daphne, who was shy with strangers. Any girl her precious son brought home would have been thoroughly grilled by Harry, who knew that for Ralston to bring a girl home all the way from Gosport, it had to be serious. On what was a whirlwind day, George notes Daph arriving at St Enoch's Station in Glasgow on Good Friday off the overnight train. From there, he takes her back to Crookston Road for the formal introductions to his parents before heading back 'up town' for a 'daunder around'. In the afternoon there was a 'walk down by Cart' (the path by the River Cart was a popular beauty spot in Crookston) during which he notes his beloved 'is super-passionate', followed by tea with the family and then a trip to the Aldwych cinema on Paisley Road West to see *The Glass Key*, a thriller starring Alan Ladd and Veronica Lake ('not bad', notes George in his journal. He always made a point of recording what film or show

Opposite: By 1943, Ralston and Daphne's courtship was well underway. Ralston recorded a lot of his feelings in his diaries.

he had seen and giving a quick crit). Back home for supper, visitors appear, but as 'Daph and I pretty tired', the young lovers head to bed – Daph in the spare room, of course. After a busy weekend, George and Daph returned south on Easter Monday, with George noting at the end of the day in his diary that his girl is in a 'delicious mood'. He goes on: 'I feel fine towards her & today I feel like starting to do something really effective towards the future with someone's guidance.'

Trained to Engineer Everything

When George was based in London, the couple saw each other most weekends, with George staying over at Daph's house where her watchful parents oversaw their every move. They both wrote to each other, either by letter or postcard, every day, a habit which they would continue until well after the war ended. Their letters were newsy, filled with the day-to-day details of each other's family and life against a backdrop of the Blitz. There was a real energy surrounding the lives of ordinary people during the war. The accountants' office in which Daph worked at the docks was bombed and it moved further down the coast to Fareham, midway between Portsmouth and Southampton. She had also enlisted for the fire service and she would do night shifts that involved shovelling up fire bombs. It was dangerous work but exciting and energising, especially for young people caught up in the live-for-the-moment adrenaline-fuelled work it entailed.

Although London was still a target for Hitler's bombing raids, the scale was not as intense as it had been in 1940. As George logs in his diary on several occasions throughout his stay in London, the sound of sirens going all night was common. In Portsmouth and surrounding areas, the good citizens of this historic naval town took it all on the chin. The historic centre had taken a real battering on 10 and 11 January 1941

On Leave

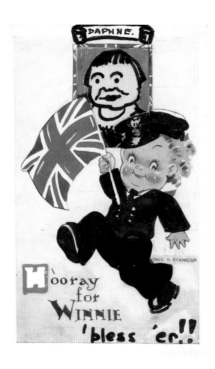

We've put away our troubles —
and packed up Joy in here

THE NEWS BULLETIN
"To-day's Channel crossing"

"Handsomely Receding" - That's me!

Street view, Custom in China.

"I LIKE'S OO!

D. WATTS.

'wot - a naughty girl you are

So you sent a wool-chit to your fiancee too?

when the famous Guildhall was hit by incendiary bombs. Around 1,000 civilians were killed and hundreds of houses destroyed in that raid. Bombing continued until well into 1944 but not on the same epic scale. Most of the large navy vessels didn't use Portsmouth for fear of attack from the air, which possible saved its people from further death and destruction. Against this backdrop, as they got to know each other, it became clear that Daph was more than a match for her Ralston, who could be strong-willed when it came to making decisions about what they did and when they did it.

By the end of June 1943, having passed his end-of-term test with a mark of sixty per cent, it was time for George to move on to the next stage of training in Devonport, Devon, a move, as his diary confirms, he wasn't happy about. Mainly because it was a five-hour journey down the south coast of England away from Gosport and his beloved Daph. Before and after he arrives in Devonport, his diary makes several mentions of the fact that he is lobbying his superiors for a stint in Brighton at another Admiralty training establishment based at the famous girls' school, Roedean. With Brighton being just forty-four miles from Gosport, this option would have suited George and Daph very well. The Navy's temporary training school at Roedean, HMS *Vernon*, was home to over 30,000 sailors during its time as a training centre for torpedoes and mines and for the electrical branches of the Royal Navy. George *would* eventually be sent to Roedean, but not until the following year, so he had to make do with being billeted to HMS *Defiance*, a floating torpedo school, which has been described as 'three old tubs lashed together with gangways between' (source: *WW2 People's War*, BBC archive, Len Mason). The 'tubs' in question were three elderly ships called HMS *Andromeda*, HMS *Inconstant* and HMS *Vulcan*. It was here that George would learn all the 'high-powered' stuff which would enable him to be part of a team on a warship involved in combat. It also gave him a taste of what life on board an actual ship

would be like as it involved living in close quarters with fellow sailors. It had all the facilities one might expect from a ship which was a temporary home to many, including a gymnasium and a cinema. On his first night aboard HMS *Defiance*, he writes in his diary that there is a 'very crowded mess'.

On day two aboard HMS *Defiance* George notes again that he has requested a transfer, but he's kept busy doing odd jobs in the workshop through the day while at night he stayed aboard and attended a ship's concert, which he declared 'very funny'. He also records that he saw 'fellas about band'. On the curriculum in Devonport, officers instructed theoretical knowledge while practical work was done by chiefs (non-commissioned officers). George and his shipmates studied electrical principles, the inner workings of torpedoes, sound-powered telephones, depth chargers, machine shop practice, trimming gyros, fitting skills and fire-fighting. In the early days at Devonport, he spent a lot of time in workshops, making things such as handles and telephone brackets, which George describes as 'hard graft'. Torpedoes and their constituent parts had to be stripped and rebuilt for practice. After the initial settling-in period, there was an intensive period spent studying the Whitehead Torpedo, nicknamed the 'Devil's Device'. This lethal anti-ship and anti-submarine weapon was considered the Royal Navy's ace in its warfare pack and judging by remarks about the Whitehead lessons, George and his fellow trainees clearly enjoyed getting to grips with how it worked. While sailors were billeted on board HMS *Defiance*, it was relatively easy to leave the training ship. The sailors could either talk a *Defiance* crew-member into rowing them across to a landing stage at nearby Wilcove then walk a couple of miles into Torpoint to get a chain ferry to Devonport, or take a ferry to the Flagstaff steps in Devonport Dockyard. When George and his shipmates went into Plymouth, they stayed in Salvation Army accommodation rather than return to the boat.

George and Daph didn't have to wait long before being reunited. Just ten days after being sent to Devonport, George took a train to Paddington Station in London, where he met Daph and they travelled together to Scotland for a week-long holiday with his folks. The young couple arrived in Glasgow and immediately took a walk up town, followed by a session at the Locarno Ballroom on Sauchiehall Street and then a trip to the Pavilion Theatre with Andy and Harry to see top comic Tommy Morgan. And that was just on day one . . . In the days which followed, George showed Daph as many sights as he could cram in, while introducing her to as many members of his family and extended network of friends as possible. They went to the shows (fairground) on Glasgow Green, rowed on the River Clyde, visited his grandparents in Inverkip, went to Largs and took a sail from Balloch to Rowardennan on Loch Lomond. They even managed to see Daph's brother John in Dumbarton, where he was stationed with the RAF, the night before they headed back south.

George was stationed at Devonport for nine months. He progressed well in his studies, routinely getting marks above eighty per cent. No doubt, back home in Glasgow, his parents were relieved at every passing month their boy stayed on home soil. As long as he was still training, he was largely out of harm – and Hitler's way. For George, Devonport was a damp squib after London's Lyon's Tea Rooms, crowded dance halls and endless opportunities to 'have a bash' on his double bass in front of a big crowd. Not to mention being paid

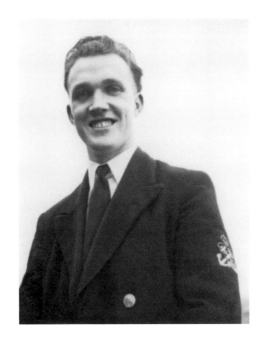

Previous spread: *A selection of customised postcards sent during Ralston and Daphne's years spent apart, from 1942 to 1946.*
Right: *Ralston and Daphne sent many photographs back and forth during their courtship and the early years of their marriage. Daphne is pictured here in Scottish attire in the back garden of Crookston Road.*

for his trouble . . . But he knuckled down to a routine at HMS *Defiance* in both work and play. There was nothing else for it. He had always been able to occupy himself, and in his down-time he played with the ship's band (before long he was playing in the Ship's Concert), worked out orchestrations for band numbers, did some drawing, played darts in the mess, went to the cinema, blethered a lot with shipmates, and made fishing lines. The food was good on board HMS *Defiance* and George loved his grub – or 'big eats', as he routinely referred to a decent meal. His parents religiously sent him Glasgow newspapers every week, such as the *Weekly News* and the *Bulletin Weekly*, which he devoured eagerly. He was also a regular attendee at the Free Church Services in the Barracks at Devonport if he was at the base on a Sunday. Daph came to visit on the odd weekend and they would stay (in separate rooms) in a Plymouth guesthouse and take in the sights. Mostly though, he got alternate weekends off and would hightail it to Fareham to pick up Daph before heading back to the Watts' home in Gosport for some home comforts.

By the end of September, there are veiled references in his diary to rings, so it's clear things were getting very serious in George and Daph's relationship as they prepared to celebrate their first anniversary as a couple. At the end of a flying visit to Glasgow to see his parents, he records in his diary how he hinted to his father as he prepared to board the train back to Plymouth that marriage was on the cards. 'Kind of "pop the question" to Pop at station,' he writes. In late October, he notes in his diary that 'engagement spondulicks now £9'. Then, on a flying visit to Gosport to see Daph in the first

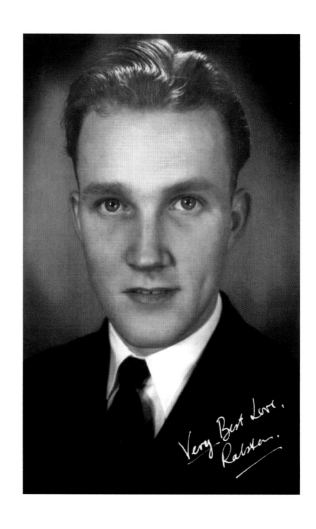

Above: A wartime photograph sent by Ralston to Daphne, which she kept by her bed.

weekend of November, he tries hard to find the right moment to 'pop the question to Mr Watts' to ask for his daughter's hand in marriage 'but no opportunities'. George Ralston Wyllie wasn't often lost for words, but the prospect of asking his future father-in-law if he could marry his treasured daughter was clearly an intimidating one. He writes in his diary that he finally managed to spit it out on Sunday, 5 December, a full month after he first tried. 'AND – I popped the question to Mr Watts – wotta job,' he confides in his journal. He also records that Daph now had her engagement ring, which cost him £22 (£900 in today's money).

Setting Sail

Despite George's best intentions of returning to Pompey (as the city of Portsmouth is known by its sailor population) for the next stage of his naval training, by 1 April 1944 he was settling himself into HMS *Vernon*, the shore-based school at Roedean, Brighton. On the plus side, it wasn't too far away from Daphne, and Brighton was much more lively than Plymouth had been. Within a week, he had even picked up a gig playing at the city's Corn Exchange – for which he was paid £1 (around £40 in today's money). It was also much easier for Daph to visit him, and vice versa, but this happy state of affairs was short-lived. After almost five years at war, the tide was beginning to turn for the Allies and a massive invasion of German-occupied Europe by land, sea and air, codenamed Operation Overlord, was being orchestrated by US Army General, Dwight D. Eisenhower. With some three million personnel involved, it would turn out to be one of the biggest and most complex military operations the world had ever seen. It would also be the largest seaborne invasion in history, with 7,000 ships taking part. Originally planned to take place on 1 May, the operation was postponed by a month to allow time to gather more troops and

equipment. The timing was important to allow for the right weather and tidal conditions, and a full moon.

For George, it meant that after almost two years in the Royal Navy, he was about to set sail. At last. On 8 May, he was detailed to join HMS *Argonaut*, a light cruiser (one of eleven Dido-class vessels), which had been in service since August 1942. The ship's motto was 'Audax Ominia Perpeti' (bold to endure), reflecting the Greek myth about Jason, ancient king of the Argonauts, and his quest for a golden fleece. Its red and gold crest depicted this legend with the warrior on board a boat dressed in golden armour and holding a golden fleece in his right hand and a golden shield in his left. As an electrical artificer, George served under the ship's gunnery officer maintaining the electrics in the ship's engine room. It was largely a 'watching' role, on standby in case anything went wrong. The modern equivalent would be an information technology, or systems manager, role. He was one of a crew of 550, made up of regulars and hostilities-only Royal Navy and Royal Marine Officers. The man in charge of the ship was Eric Longley-Cook, who had been its captain two years earlier when it was torpedoed on both sides while providing reinforcements for Allies in the fight against Field Marshal Rommel's Army in North Africa. There was even a ship's cat, a tabby called Minnie, with immaculate white paws and breast, who joined the *Argonaut* just before George.

After a hasty farewell in Brighton to Daph, which involved a snatched, romantic two-mile walk along the coastal path from Roedean to the village of Rottingdean ('dilly & dally & "Farewell" – very nice too,' he writes on 7 May), George travelled on the overnight 'draft train' to Scotland to join the *Argonaut*. He managed a quick detour to see his folks in Glasgow (noting in the diary that brother Banks wasn't there), before jumping on another train to Greenock, where the *Argonaut* was berthed. With a fresh crew – many of them rookies like George – joining a few old hands, the ship sailed to Scapa Flow in the Orkney Islands for general working-

up and manoeuvres. From this point, for a month or so, entries in George's diary become unusually scant and perfunctory. Locations and names are barely mentioned, although it's clear George has amended the diary in a different-coloured pen at a later date, adding locations such as Flotta, a small island which lies in Scapa Flow, Orkney, where he went ashore on 10 May. He notes when he is on duty and how many letters he has written and received. He also begins a tally of letters written to and received from Daph and his folks. All personnel involved in Operation Overlord were vigilant about the need for secrecy as the clock ticked towards the D-Day Landings in Normandy. George was no exception, although he confessed many years later that he kept a secret diary about the whole of the invasion, which he subsequently lost.

The *Argonaut* was just one of a vast flotilla of Royal Navy vessels involved in Operation Overlord, which had been in the planning for years. At Scapa Flow, she took part in what was known in naval parlance as 'running up trials', in which all the crew got to know their job on board the ship. She also took part in speed trials while based off this far northern archipelago of Scotland. From Scapa Flow, the *Argonaut* was deployed to join HM Cruisers *Orion*, *Ajax* and *Emerald* across the Irish Sea at Belfast to form Force K. The *Argonaut* and her crew would be supporting British Force G during the Normandy landings in Bombarding Force K (known as Operation Neptune). The ship and its crew were assigned gun batteries at Vaux-sur-Aure in Normandy in the strategic bombardment plan on 5 June. (Although this date had to be changed to 6 June due to adverse weather conditions.) By 31 May, the *Argonaut* was back in Greenock.

George surprised Andy and Harry by turning up on the doorstep of Crookston Road for a two-night flying visit and his diary temporarily reverts back to chatty mode. Although he had to report back to the ship on the second day, he fitted in some socialising, as well as

a trip to the Aldwych Cinema in nearby Paisley Road West to see *Girl Crazy,* a light-hearted musical starring Judy Garland and Mickey Rooney. He was obviously thinking ahead to filling the down-time aboard the ship and he notes 'bass negotiations' were ongoing, presumably meaning he wanted to take his double bass with him. Given the cramped quarters the men had to sleep in (George's 'mess' or dormitory was a twelve foot by twelve foot square space in which nine men slept), bringing a double bass aboard would have been an issue. George also mentions discussing a wood carving with his friend Jimmy Elliot, which indicates he was looking to do some creative work aboard the ship to pass the time. (He mentions making a wood 'Scottie' in his diary, presumably of the canine variety . . .) In the end, he had to leave his double bass behind, but he did bring his ukulele, which allowed him to while away many hours happily in the months and years to come.

Opposite: *Ralston sent home this picture of him (back row, far left) with his Unit from HMS* Argonaut. *He was with them when they heard the news over the wireless that an atomic bomb had been dropped on the city of Hiroshima.*

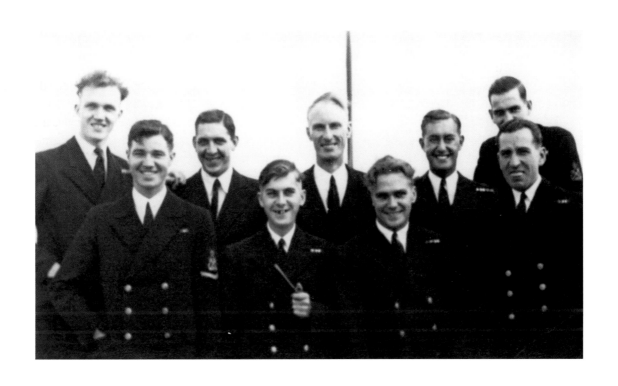

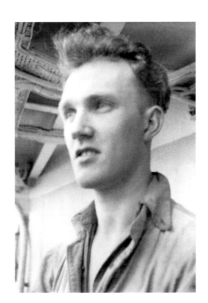

By 2 June, George was back aboard the *Argonaut* on middle watch (from midnight to 4 a.m.), heading south as part of Convoy G12, escorted by HM *Destroyers*, *Grenville* and *Undine*. She sailed back down to Portsmouth through the Bristol Channel, where she was joined by the Dutch gunboat *Flores*. The weather was very bad that day and the entire mission had to be delayed by twenty-four hours. Before sailing into the Solent, the convoy was forced to circle the Bristol Channel several times. The crew were jittery, and one member of the maintenance crew altered the saltwater tanks in the ship which meant saltwater leaked into the drinking water tanks, causing disquiet in the ranks. At Brockhurst Road in Gosport, as Daph would letter tell Ralston in a letter, tanks heading for landing crafts on the Solent parked up outside the Watts' family home. On seeing them, her mother and Daph went out with cups of tea for a chat with the soldiers.

On the evening of 5 June, the die was cast. It was now or never. Captain Longley-Cook gathered the ship's company around him and told them that tomorrow was *the* day. The order had just come through from General Eisenhower, who gave the biggest amphibious invasion in history the green light with three simple words: 'OK, let's go.' As part of Bombarding Force K (Gold), the *Argonaut* led the initial phase of the sea-based assault on 'Gold' beach, the middle one of five landing beaches. To the west were the US beaches, codenamed 'Utah' and 'Omaha', and to the east, 'Juno' and 'Sword'. Juno was a landing beach for Canadian forces while Gold and Sword were British. The invasion was about to begin, and it was a key moment in the war for which both the Allies and the Germans had long prepared. The German commander in charge of halting this invasion was Field Marshal Erwin Rommel. It was his firm belief that his army could only succeed if they defeated the Allies on the beaches of Normandy on D-Day. Just two months earlier, he had observed that the day, when it came, would be 'the longest day' – for the Allies as well

as the Germans. An epic endeavour, it would mark the first time in history that a defended stretch of coastline would be stormed from the seaward side. Surprise was a key element. This had been achieved by a combination of factors, including the preceding bad weather and Operation Fortitude, which created the illusion of a mighty army of American forces mustering in the southeast of England some twenty-one miles across the Channel opposite the German 15th Army.

Early on the morning of 6 June 1944, the *Argonaut* swept out of the Solent and joined a vast armada. The people of Portsmouth woke to find the sea around the coastline completely bare. George's ship was just one of 7,000 vessels of all sizes – battleships, cruisers and lighter vessels – heading for the coast of Normandy, in particular a stretch along the sandy shelved beaches of the Normandy resorts, from the base of the Cotentin Peninsula eastwards to the regional capital of Caen and the River Orne. What is not recorded in the *Argonaut*'s annals is the fact that Daph's dad, who worked at the Royal Clarence Victualling Yard in Gosport, had sent out supplies of additional quality meat to the ship because his future son-in-law was aboard. Unfortunately it missed the boat, literally, which had sailed before the little supply boat reached it.

The *Argonaut* was part of Bombarding Force K (Gold) alongside cruisers HMS *Belfast*, HMS *Diadem*, HMS *Orion*, HMS *Emerald* and HMS *Ajax*, one gunboat HNLMS *Flores*, and twelve destroyers: HMS *Ulster*, HMS *Ulysses*, HMS *Grenville*, HMS *Jerius*, HMS *Udine*, HMS *Undaunted*, HMS *Ursa*, HMS *Urania*, HMS *Urchin*, HMS *Cattistock*, HMS *Pytchley* and ORP *Krakowiak* (Polish). Bombarding Force K (Gold) arrived at the Normandy coast at 3 a.m. and all engines were turned off until daylight. For an hour, an eerie silence hung in the air over the Normandy coastline, which in peacetime was more used to the buzz of holidaymakers than military action. At around 4 a.m., Spitfires and bombers swooped down over the French

coastline, bombarding the batteries along the shore. As dawn broke, the *Belfast* opened fire and the other cruisers followed suit. The third salvo fired by *Diadem* put a German battery out of commission. At that point, the landing craft went ashore, but the operation was shrouded in smoke, so much so that George and his shipmates couldn't see what was happening as these small crafts shuttled backwards and forwards all day, unloading men and equipment. It was the job of the *Argonaut* and her fellow cruisers to cover them while they went ashore. Some of these crafts were sunk during the operation and men were seen floundering in the water. The firing continued all day, and although Allied fighter planes came and went, no German planes were to be seen.

Compared to Bloody Omaha, as the assault on the neighbouring US beach became known, where around 4,000 men were killed or wounded, at Gold, although around 400 men died or were injured, casualty rates were around eighty per cent lower. From his vantage point on the *Argonaut*'s Director Tower (the part from which the guns were directed) George had a bird's eye view of the invasion. As the smoke cleared temporarily, the *Argonaut* crew witnessed Germans soldiers coming out of shelters and running along the coast, as if they were in a shooting gallery. The next phase of the D-Day action saw a fleet of larger invasion craft coming in behind the *Argonaut* and it was her job to cover them while they went ashore.

Wedged between American and British forces, the sound and fury around the *Argonaut* was intense. In his diary that day, George notes tersely: 'Wake early. "D-day" Big Sights. Action stations most of time. Bombard etc etc. At night Act. Station again – near misses etc etc.' The next day was equally intense. 'Up early again,' he writes. 'Nice day. Head down in morn. Frequent "Air Raid Reds". In afternoon get sunburnt. Bombard again. At night see Jerries on run and destroyers like dog after rats. Action stations again

at night.' By the third day, things were calming down, aboard the *Argonaut* at any rate. George writes in his journal: 'Nice day. Forenoon watch. Head down in afternoon. Bombard at night. Evening watch. Write commentary on our doings. Act. Station at night – quietish night with some raids.' By 11 June, the Allies had secured the Contentin Peninsula beyond Cherbourg, but on the land, progress was painfully slow as the German troops mounted fierce resistance. After the intense adrenaline rush at the start of the invasion the strain is obviously starting to get to the crew. George writes: 'Forenoon watch. Do odd job or so on [illegible] & bridge. Draw comic drawing (Argonaut on wheels). Mentioned on BBC. At night Act Stations [abbreviation for action stations]– & write to folks. (13) [13 is a reference to a thirteenth letter to his parents] Missing Daph tremendously these days.' The following day, as he observes, they are sailing back across the Channel to England for additional ammunition supplies, where as he notes ruefully, he is 'so near and yet so far to Daph'.

The *Argonaut* would continue to provide a support role for the entire Normandy mission, and for the next two weeks sailed up and down from the Cherbourg end of the line up to Caen and back again, sending out signals to other ships. The call of 'action stations' and the soundtrack of gunfire became part of the aural furniture for George and his shipmates. The *Argonaut* was generally regarded as a 'lucky ship', and suffered no casualties during the invasion, despite firing a total of 4,359 shells at Vaux-sur-Aure. On 26 June, while sailing along the coast at Caen beside HMS *Belfast*, she was hit on the quarterdeck by a 150mn German artillery shell from a shore battery which failed to explode. It penetrated the wooden quarterdeck and emerged by the starboard side without going off, despite landing next to a magazine. At the end of the invasion, her captain and crew were congratulated by General Miles Dempsey, Officer in Charge of the British Second Army, for the accuracy of her gunnery, especially when the Army was

battling for Caen – and Caen was at the extent of her range, some twelve miles inland. A lucky ship, indeed.

On 25 July, the US 1st Army broke through the weak German forces opposing it and finally moved out of Normandy towards the interior of France. By then, the *Argonaut* – and George – had moved on. In true Wyllie-style, during a brief five-day period of leave at the beginning of July, he and Daph ('exceedingly happy to be together again') took off on a whirlwind trip to Scotland where they surprised his parents by turning up unexpectedly at their front door. The usual social merry-go-round of visiting friends and relatives ensued, not to mention visits to the pictures and the theatre. They go to see comic Dave Willis in *The Half Past Eight Show* at the King's Theatre ('V.G. too,' George writes), and the next day head down to Inverkip to see both grandpas. They are then joined by Banks further down the coast at Wemyss Bay and all three head off to spend a night at the Meigle, a small wooden holiday hut down a winding road, owned by Andy and Harry. There, with the rain battering off the tin roof, the three of them made supper and played pontoon by oil lamplight. 'Very happy – and so to sofa,' George writes in his diary.

By 10 July, George is 'back to it all again', aboard the *Argonaut* with just his double bass for company (he had negotiated to bring it with him this time, foreseeing many long nights which could be filled with 'having a bash on the bass' with fellow naval minstrels). He travelled south by train to London with Daph and bade her a fond farewell at Waterloo Station. 'I do love her very much indeed,' George confides in his diary. His train journey to Plymouth via Bristol to rejoin the *Argonaut*, he notes, was punctuated by the sound of buzz bombs overhead. As the ship and her crew prepared for the next engagement, George had other things in his mind – namely preparations for his wedding. On 14 July, he writes in the diary that he received an 'important' letter from Daph 'about getting married – when!' Clearly, George was very keen on

getting married to Daph, but Allied Command had other ideas about what he should be doing.

By the end of July, the *Argonaut* was on the move again. This time, in 'lovely weather', she sailed down the Mediterranean to Gibraltar, across to Algiers, and further south to Sicily to join Task Force 87 – Camel Gunfire Support Group under the command of the US 8th Fleet. This represented a complex grouping of Allied naval forces which were mustering ahead of Operation Dragoon. During what George describes as a 'Med Cruise' in the diary, the crew were allowed some shore leave to the resort of Mondello, and at the city of Palermo, before heading northwards up the Med again towards the Riviera. During this half-day long visit – the first time George had been on foreign soil – he and a crewmate called Charlie Lisle visited the famous Catacombe dei Cappuccini. These mummified corpses of monks date back to the sixteenth century and must have presented a surreal sight to two young naval officers fresh off the boat from Blighty. They went from there to the beach at Mondello, where they did some 'bathing'. Then, it was time for 'eats' with a British and 'Yank' sailor whom they'd met. For George, more used to his mother's plain Scottish fare, this first taste of exotic foreign food – fresh pasta and juicy tomato sauces laced with garlic – was memorable. Even better, the two men managed to buy fresh fruit – at that point a scarce commodity in wartime Britain – and bring it back on board.

The *Argonaut* was just a tiny cog in the machinery that made up Operation Dragoon. This second amphibious invasion of Southern France is often described as 'the other D-Day' and now stands almost as a footnote in the history of the Second World War, but it played an important part in forcing the German army to retreat from occupied Europe. Largely driven by US military chiefs, British Prime Minister Winston Churchill was not in favour because he felt it would divert military resources which could be put to better use in the Allied

military operations in Italy. The controversial invasion of southern France was approved by Eisenhower over Churchill's objections.

On 11 August, screened by US destroyers, the *Argonaut* sailed from the port of Salerno, just south of Naples in Italy with US battleship *Arkansas* and US cruisers *Tuscaloosa*, *Marblehead* and *Brooklyn*. On 14 August, the Allied fleet met the Camel Convoy SF14 off the coast of Corsica. George had no idea that exactly 165 years earlier, his great-great-grandfather, Corsican mariner Antonio Charrette, had been born just a seagull's flight away on this craggy Mediterranean island. He, too, ended up fighting on foreign shores with the Royal Navy and must have felt the same tight knot of fear as he sailed into unknown territory in defence of his adopted country.

Records of the *Argonaut*'s wartime activities note that on 15 August, having sailed towards the south of France, she fired 394 rounds at batteries between Cannes and Antibes and Île Sainte-Marguerite. Later, she bombarded shore targets in Golfe de Fréjus and found herself 'under some return fire'.

George ran two days' diary entries into one by writing on 14 and 15 August: 'Usual routine. Head down in afternoon. Meet big convoy off Corsica. Night hit action stations. Middle watch . . . to action stations for h-hour in South France Invasion. Great bombing carried out by R.A.F. We bombard at action stations rest of day. Relax at night. Air attack. Not much. Head down in mess.' By the next day, tension is obviously rising aboard the *Argonaut*, as George writes: 'Barney with P.O. Pritchard during dawn Act St. Head down in mess again.

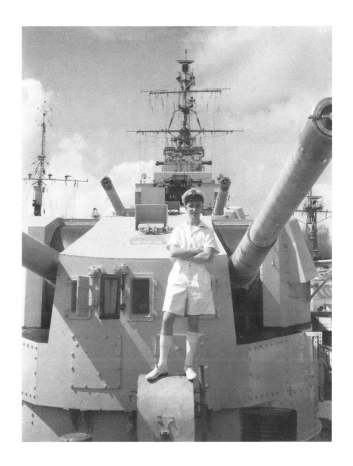

Above: *This was Ralston – or George as he was known to shipmates – posing beside one of the HMS* Argonaut's *big guns.*

(We're off San Raphael).' This second day of Operation Dragoon saw the *Argonaut* bombard troops and vehicles in what was called the Camel area of the invasion.

Despite the behind-the-scenes arguments between British, US and Russian leaders over Operation Dragoon, in the end it was deemed an overwhelming success. It achieved its goals by destroying Hitler's 19th Army, capturing over 100,000 German prisoners, liberating the southern two thirds of France and linking up with the Normandy invasion forces. All within a single month. (Although Churchill went to his grave believing it was a huge mistake that set the stage for Soviet domination of Eastern Europe.) Meanwhile, aboard the *Argonaut*, by 20 August, George is reporting the crew had a 'VERY encouraging speech from the skipper' which signalled a stepping down from Action Stations.

I'd Like to be Married . . .

By 22 August, the *Argonaut* sailed back down to Sicily and docked at Naples. There, George was overwhelmed and overjoyed to receive five Airmail letters from his beloved Daph. The crew were allowed to go ashore and George reported that he bought a bra and shoes (presumably for Daph as such things were hard to come by in England) and had some 'Big Eats'. From the 'boot' of Italy, the *Argonaut* steamed northwards back to Devonport to replenish supplies and give the crew shore leave before they got involved in yet another campaign. Judging by the densely packed, higgledy-piggledy diary entries for that period, George was clearly frustrated about all sorts of things as the ship headed towards Britain: the pressure-pot of life aboard a ship engaged in active service; not seeing Daph; and the pressing business of when he could get married. On 5 September, and by now back at the naval base in Devonport, he writes in his journal that there is great excitement on board the ship because the crew had been given fourteen days' leave. 'Write to Daph & folks. I've got second leave. I'd like to be married on 15th. Latest letters from folks. The one I've waited for. Old Air Mail from Daph. Ashore. Phone Daph. Phone mum. Opposition. Ooze around Plymouth. Very despondent and then to St Andrews club and chapel. Phone folks later and I breakdown somehow?'

Things go from bad to worse, when two days later George receives a letter from Daph. She drops a bombshell by telling him that 'wedding and Engagement off'. George immediately goes to see his senior officer about receiving compassionate leave and early next morning takes a train to Pompey to meet Daph and 'talk it all over' in a flying overnight visit. Although they obviously didn't resolve their differences at this point, the couple spent the day shuttling about Gosport talking to close friends and family. George writes in his diary that he and Daph 'see Mrs Telford and Marion' (Marion was Daphne's sister-in-law). They also had a summit meeting with 'Daph's Pop – not her mum'. In what was a busy day, they saw Daph's brother John and Norman Telford. Daphne's sister, Joan, married Marion's brother, Norman, which made for extremely close family relations in Gosport. This tight-knit, loving family ensured Daphne, who had only just turned twenty, had a lot of support in Gosport. She had only ever travelled outside the south of England a few times and that had been with Ralston to visit his family in Glasgow. With her boyfriend at sea and time on her own to think about the reality of married life with this energetic, young Scottish sailor, she had begun to get cold feet about committing herself to marriage and the complete change in her circumstances it would afford – namely a life in Scotland, which felt to her like a foreign land, away from her family and friends. Although she had been welcomed by Ralston's mother and father into their family home, young and experienced though she was, Daphne was sharp enough to realise no one would ever be good

enough for Mrs Wyllie when it came to the girl her precious elder son married.

Back aboard the *Argonaut* in Plymouth after a flying visit, George confesses in his diary that he is 'still worried', and refers to the fact that he keeps reading and re-reading her previous letter in which Daph tells him she is 'breaking it'. Later that day, he goes 'ashore to meet Daph and her mum' who have travelled five hours by train on the so-called *Cornish Riviera Express* to discuss the wedding situation. It's clear from all these intense talks between Daphne and her family and Ralston that the Watts had become fond of the young Scotsman who had sailed into their lives with such verve. At the same time, they were trying their best to help Daphne make the right decision: what would be the biggest one of her young life. The next night, George confesses he is 'pretty worried' but that he sat down to 'write "manly" letter and post it with last night's efforts'. One can only imagine his joy – and relief – when he receives a wire from Daph the next day and she is sounding much more positive. 'I phone her – ALL'S WELL again and the date is Sat 16th. Git "me" trousseau ready and write to Daph. Turn in latish.'

The next morning, 11 September, George can't concentrate on anything else but getting ready for his wedding in just five days' time. Having wired his folks in Glasgow to tell them the news, his fortnight's worth of leave begins later that evening when he takes off for a flying visit to Scotland before returning to Gosport for the wedding at the end of the week. His diary entry for 13 September, gives a real insight into the emotional and physical whirlwind of his life during this period. 'Arr Padd 7.5 exact. To Euston and in canteen meet O.M. and wire folks and try registry office. Shut. Meet P.O. bosses Catch 10am for Glasgow with O.M. Head down in morn. Arr Glasgow 7.20pm. So home (meet Daffy Taff). Barney with mum. Ooze about house and open swag etc. John Monachan here. Over to Whites (allies) Talk to Mrs Stevenson on phone (ally). To bed latish.'

The 'barney with mum' statement speaks volumes about Harry's reaction to all the on/off activity surrounding the wedding. Her Ralston could have any girl, and here he was being given the runaround by a slip of a girl. And an English girl at that, who might take her boy off to live far away for good. By the time Ralston reached Glasgow, all his family, friends and neighbours knew about the wedding fiasco. His mention of 'allies' in his diary attests to this fact. George doesn't record what his father thought of him getting married, but Andy was generally of a much more forgiving disposition than Harry and it could be that he was quietly nudging his wife in the direction of acceptance behind the scenes. Whatever reservations Harry had, the union between her bright-eyed, blue-eyed boy, George Ralston Wyllie, and Daphne Winifred Watts took place on Saturday, 16 September 1944.

George travelled down from Scotland with Banks, who was his best man. For whatever reason – disapproval, or not being able to take time off work to travel all the way to the south of England – his parents did not attend. In keeping with tradition, the bride and groom didn't see each other the night before the wedding. George spent his last evening as a bachelor at the home of Daph's brother and sister's joint mother-in-law Mrs Telford, not far from Brockhurst Road. The wedding took place in the Mission Church, a little tin-roofed building in Forton, a suburb of Gosport. George looked dapper in what was referred to in the Navy as a 'tiddly suit'; the navy-blue dress naval uniform worn by someone of his rank (Petty Officer). Despite wartime rationing of clothing, Daphne had managed to find a beautiful, floor-length, long-sleeved, white organza dress with clinched waist, full skirt and sweetheart neckline. Her lace-trimmed net veil was held in place by a white floral diadem, and round her neck she wore a simple rope of pearls. Her bouquet was a heart-shaped arrangement of roses and trailing foliage. In their wedding photograph, both look relaxed and happy, relieved, perhaps, to have made this big step after having

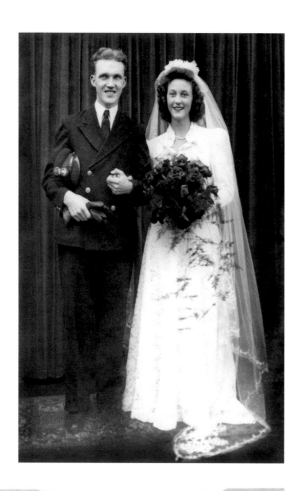

talked about it – and fallen out about it – for so long. The reception was held back at Daph's family home in Brockhurst Road. In his diary entry for 16 September 1944, which is book-ended by two wee hand-drawn doodles of bells, George writes: 'DING DONG! Me wedding day. Up 9'ish. Breakfast & prepare for the occasion . . . Banks as best man troops off to Gosport. Taxis early at 1.30pm & so to church a wee bit adrift. – GIT ME MARRIED – to Daphne then to photographers and so to Henriville for reception. Got changed etc & Daph and I taxi to F'ham and catch 5.40 for Reading. Eventually get fixed up at small place and so to bed together . . .

The happy couple had planned to spend a few days in London, but on their wedding day the Germans started to drop buzz bombs on the capital. These deadly V-1 flying bombs, also known as doodlebugs, were designed specifically with the terror bombing of London in mind and the first ones had been launched some three months earlier. At the peak of a summer of intense bombardment and terror for the people of south-east England, which lasted until the end of October 1944, more than one hundred V-1s a day were fired; 9,521 in total. The newly-weds decided at the last minute to head to Reading and find a hotel there but unfortunately, the town had been taken over by American soldiers and there was no room at any of the inns. At the end of his tether, George dragged Daphne into a pub with the word 'hotel' in its name and asked if they had a room. The landlady told him it was a pub which happened to have hotel in the name and wasn't really an inn, but a woman at the bar overheard, and spotting a source of ready income, piped up, 'I'll do bed and breakfast for you.'

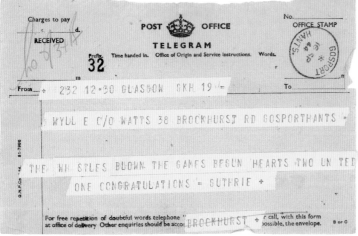

Top: George and Daphne got married on 16 September 1944 in the Mission Church, a tin-roofed church in Forton, a suburb of Gosport. **Below:** *A telegram sent to the happy couple.*

She told the couple to go and stand in the street outside until the bar emptied and she would come to fetch them. So out George and Daphne went, to hang around beside what was known as a 'baffle wall'. This wartime phenomenon was a temporary structure made of corrugated sheeting built up in front of an entrance to stop bomb blasts going any further. The woman finally bowled out of the pub at closing time and took them back to her cold, dark house with its sticky congoleum (linoleum without the fabric backing), heavy furniture and general air of neglect. Even worse, the bedroom with its cold, damp bed was the most unromantic place imaginable. It wasn't the romantic start to married life the couple had fondly imagined. Early the next morning, desperate to escape, the newly-weds hopped on a train to London and caught the first train to Scotland from King's Cross Station. George had often talked to Daph about how beautiful Edinburgh was, with its fortress-like castle high on a rock above the main thoroughfare of Princes Street, the historic Royal Mile, its parks and gardens and posh shops. So off they sped, up through the east counties, glancing skywards to see aeroplanes flying over their head towing gliders. They didn't know it at the time, but these planes, piloted by RAF officers, were heading to Holland to drop paratroopers ahead of the Battle of Arnhem, as the airborne invasion of The Netherlands became known in the annals of the Second World War.

Things started to look less bleak for the young couple when they stepped off the train at 9.30 p.m. that night in Waverley Station to discover it was the first night of the relaxed blackout. As the might of the Luftwaffe

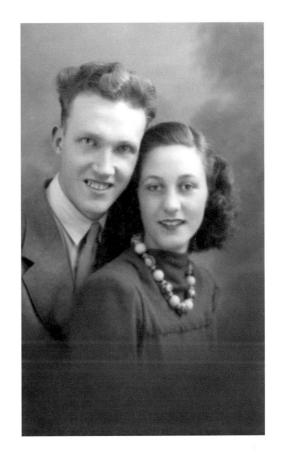

Above: The couple in a studio shot at the beginning of their courtship.

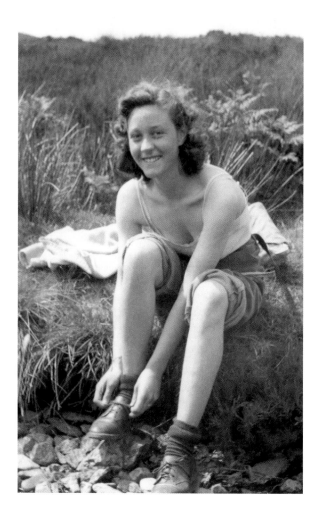

waned and the possibility of widespread bombing became less of a threat, a 'dim-out' was introduced on 17 September 1944 across the UK (apart from coastal areas). This little chink of light – literally – meant that car headlamps could be used and shop windows could be lit up. For many, it signalled the beginning of the end of the war. Edinburgh certainly presented itself in a cheerful light to George and Daphne as they climbed the steep Waverley Steps up to Princes Street. It was dark by then – the clocks had gone back one hour earlier that day – but thanks to the relaxed blackout conditions they were able to find a hotel fairly easily as they walked east towards Calton Hill. The hotel was the appropriately titled Darlings Hotel and happily, this time, there was room at the inn. Forgetting the trials of the previous evening, the couple finally relaxed and started to enjoy precious time together before George had to rejoin his ship.

For the next four days, they took in the sights and sounds of Edinburgh: by day strolling around Princes Street Gardens, taking a tram out to Portobello, where they went to the shows and had ice cream on the beach, as well as visiting the Palace of Holyroodhouse with its surrounding parkland, Edinburgh Castle and the city's zoo and aquarium. By night, they sampled the best entertainment wartime Edinburgh had to offer; including a trip to the Palais de Danse in Fountainbridge, famous for its revolving stage which allowed two bands to play in unison and change over seamlessly, and a night at the Theatre Royal, where they saw top Scots comic Jack Radcliffe perform. The honeymoon continued over on the west coast when they went to visit George's folks at Crookston Road. Harry had softened enough by this stage for George and Daph to have collected a present

Above: Daphne, captured on camera by her new husband, during their brief honeymoon in Scotland in September 1944.

Arrivals and Sailings

from her and Andy in Edinburgh's famous department store, Jenner's.

The honeymoon was all too brief. After a sociable few days in Glasgow, which included a trip down to the Meigle with Banks and a barn dance at night, the pair were heading south again by 24 September. In his diary entry for 25 September, George writes: 'Arr. Euston bout 7am and to Waterloo, Breakfast and catch 8.45 to Pompey. To Daph's place 11am and see wedding proofs and Jerome's photos etc. All well with Daph's folks – very well. Daph and I shopping etc then off for tea to Mrs Telford's blether and then very nice farewell to my darling wife – and so catch 11.45pm for Eastleigh.'

Hitting the Trail

The next day, George was back aboard the *Argonaut* and on the move again: 'Seems we're hitting the trail.' This statement was all too true. The *Argonaut* was bound for the Aegean Sea and into the great blue yonder. George wouldn't see his darling Daph for almost two whole years.

As the war in Europe headed swiftly towards its conclusion, the *Argonaut* was required in the Aegean to assist in the liberation of Greece. En route, there were stopovers in Malta and Alexandria, before pressing on to her first face-to-face encounter with the enemy. By this stage of the war, German forces were retreating from the islands in the Aegean to the mainland. A stark diary entry in George's Collin's Engineer's diary on 16 October, reads: 'Sink enemy armed vessel about 7am. Pick up survivors etc. Not much doing in morn – oil at sea etc.' In a scene which can be envisaged rolling out in a black-and-white war film, a small fleet of *caïque* – traditional Greek fishing boats – overloaded with around 200 German troops emerged from behind a large Ailsa Craig-style rock and opened fire on the *Argonaut*. She quickly unleashed the might of her firepower and sank all the fishing boats. All the German military personnel – which included one woman – went overboard. In line with the Geneva Convention, the *Argonaut* slowed down to a halt, a move deemed dangerous but necessary by its skipper, and proceeded to pick up survivors.

George and various crew members went down the ships' rigged scrambling nets and hauled people on board. At one point, he recalled many years later, he had a German soldier by the hand, trying to pull him up onto the rope ladder, while hanging on with his other hand. Just at that point, the ship started moving forwards. The threat of being a target for submarine or another enemy vessel was too great to remain static so Captain Longley-Cook gave the order to start up the engines again. Unable to hold the man, who was shouting at him in German, as the ship speeded up, George's grip loosened. He watched as the unknown soldier drifted backwards, flailing in the water, his guttural cries becoming fainter and fainter. This experience, although barely rating a mention in George's diary, remained with him until the end of his life, when he talked about it often. But at the time, in the middle of an active war fighting an aggressive enemy, George moved swiftly on; he did his job on various watches, 'oozed around the mess', wrote to Daph and played his uke. The ship also moved on, sailing up to Salonica, then to the island of Kos, where they dropped off their temporary human cargo at detention quarters. The ship's log for the period records that on being picked up the surviving German soldiers were assembled on the top deck where they were fed and given something to drink. The female POW was sent below decks to the pay commander's cabin to repair his socks.

From there, the *Argonaut* carried on, becoming involved in shore bombardments in the Aegean, patrolling between islands in the Dodecanese group such as Kos, Leros and Skiathos. On 20 October, George writes: 'Ashore Skiathos – barter etc.'

There was also time for some recreation on board. Nearly three weeks later, as the ship steamed towards the ancient city of Salonika on the Greek mainland, George reported that he was putting his double bass to good use by 'playing in quartet for soldiers aboard the ship'. The *Argonaut* was at the head of a twelve-mile convoy of ships detailed to take part in the relief of Salonika. The city's bay had been heavily mined by the German forces and the *Argonaut* headed into the area behind a minesweeper. To the horror of everyone on board, every now and then a mine would explode with the *Argonaut* just a few yards behind. After leaving Salonika, the ship headed back down the Mediterranean to Alexandria.

The sights and sounds of Greece and Egypt made a big impact on the young Glaswegian sailor. Although it felt like a completely alien culture in this new continent – it was the first time George and many of his shipmates had seen ox wagons or had encountered Arabs – he loved haggling with the market traders and bought various gifts for Daph and his mother, such as leather handbags and shoes. While there, George and some of the other sailors visited the Pyramids. Much of the imagery he absorbed from this period, not to mention tales of the ancients, would find its way into a stage play he wrote almost four decades later called *A Day Down a Goldmine*, a surreal two-handed fusion of prose, song and philosophy which asked big questions of how the world uses money.

On 14 November, George notes in his diary: 'Very bad news about our future whereabouts', which indicates the crew had been given details about their next tour of duty. The *Argonaut* had been ordered to set sail for Trincomalee, a major port on what was then called

Above: George aboard HMS Argonaut *during a Mediterranean tour of duty in 1944.*

Ceylon (now Sri Lanka). She was to form part of the British Pacific Fleet, the largest fleet ever assembled in this region, consisting of 336 ships and 300 aircraft. From there, she was assigned escort duties, and got involved in the bombardment of Palembang oil fields in Sumatra. Again and again, the *Argonaut* proved to be a lucky ship: during that period she was attacked several times by kamikaze aircraft, sustaining only minor damages. In January 1945, the *Argonaut* was ordered to Sydney, to join the Pacific Fleet. The following month, she took part in the shelling of Sakishima (the diversion operation from the main American operation in Okinawa).

Life on board a ship like the *Argonaut* could be claustrophobic. Most of George's diary entries from this period begin with the somewhat weary words, 'Usual routine'. As well as being on watch duty during extended periods at sea, his job was to make sure all the ships' electrics, such as torpedoes, were kept in battle-ready condition. The torpedoes had little gyroscopes on them and George kept these important pieces of engineering from wiggling when they entered the water. The crew had to find their own ways of passing the time and the down-time could be monotonous. Many a diary entry contains the phrase 'ooze about mess etc'. George wrote to Daph every day as well as penning letters to family and friends. He also read a lot, drew cartoons, did some woodwork, sang with the ship's choir and played his double bass and uke. There was a mini-cinema on board too, which was a popular way to pass time, and he often makes a reference to listening to the news on the wireless. George could be argumentative, which sometimes caused him to rub his shipmates up the wrong way. He often mentions having a 'barney' with some crew member or another. Navy regulations allowed the crew to complain, but they had to take their complaint to the officer in charge at the time and do it properly. George regularly found himself

griping about the food. Once, the ship's chief engine room artificer (ERA) said to him, 'Wyllie, why don't you start swimming with the tide instead of swimming against it? I think you'll find life much better in the Navy if you did.' George decided to swim with the tide. Up to a point . . . (This was a piece of advice he would offer his elder daughter on a regular basis when she was a similar age).

Swimming With the Tide

At the end of November, the *Argonaut* headed from Alexandria to Port Said, through the Suez Canal (with a short stay in Aden), before heading in the direction of the Indian Ocean, bound for the port of Colombo in Ceylon. From there, she sailed around to the east side of the island to Trincomalee. This busy port was temporary home to the Headquarters of South East Asia Command and the East Indies Fleet under Admiral Lord Louis Mountbatten. This was a staging exercise for the British Pacific Fleet for later operations in the Pacific against Japan.

The highlight of George's week was the arrival on board the *Argonaut* of mail from home. He was an ardent correspondent – not just to Daphne – but to his folks back in Glasgow, as well as a wide circle of friends and family. He even got the odd letter, sent via his parents, from his old Scout troop back in Cardonald.

From the time George set sail in September 1944 until his return to Britain in May 1946, the couple exchanged between 400 postcards and almost 700 letters. George sent 361 letters in total to Daphne and 253 to his parents in the twenty months he was at sea.

Daphne and her family, like most residents of the Portsmouth area in wartime, were under siege. Between 1940 and 1944, sixty-seven air raids pummeled the city. Long after German bombing campaigns had moved on from other parts of the country, Portsmouth and the

surrounding area continued to be a target. It was still under siege as late as July 1944, when the last bomb of the Second World War fell on the city, killing fourteen people.

It must have been hard for the young newly-weds to be parted so soon after their marriage, but Daphne's life didn't change much in the immediate aftermath of her wedding. Her job as a fire warden kept her busy at all hours of the day, and she also travelled out to her job in Hillsea, where she worked as a secretary. She had a wide circle of friends and was never short of company to chum her to dances or the cinema.

Throughout 1944 and 1945 there was a lot of discussion via the blue gossamer-thin air mail letters that volleyed back and forth between the young couple about Daphne's imminent move to Scotland. Although he didn't much care for the life of a Post Office engineer, George planned to return to his old job when the war ended. His position had been kept for him, and it was expected that Daphne would up sticks and move north. (She eventually moved to Scotland in early 1946 after George and his parents managed to secure a small flat in Penilee, near Hillington.)

At Trincomalee, the *Argonaut* joined the 4th Cruiser Squadron and was assigned escort duties for Operation Outflank and Meridian, which involved bombardment of oil installations in Sumatra. These former Dutch-owned oil refineries had been captured by the Japanese in 1942. The large Pladjoe refinery, a few miles north of Palembang, was capable of refining 45,000 barrels every day. Its speciality was high-octane aviation gasoline production, so halting this supply was a vital component of the war in the Pacific. It was hot,

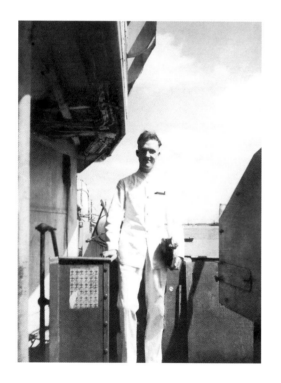

Above: *George in his tropical white uniform aboard HMS* Argonaut. *The ship was in the Pacific from early 1945 to 1 April 1946.*

Arrivals and Sailings

sweaty and dangerous work for everyone involved, and the seas were rough and high. George, unused to the heat, often complained about the high temperatures in his diary, especially during 'action stations'. On 20 December, he writes: 'Act. stations all day till about 7pm. Lousy conditions, act. missing the aircraft from carriers bomb Medan at airfield on Sumatra from Malacca Straits. NO opposition as far as we're concerned I'm pleased to say. Ooze around mess at night. Weary & chokker & turn in earlyish.' All in all, the fleet lost fifteen aircraft in these operations. George and his shipmates also got their first terrifying taster of suicide planes from Japan. Hovering on what they believed to be divine wind sent from heaven to protect them from their enemies, young Japanese pilots deliberately crashed onto several Allied ships. The *Argonaut* was lucky once again and avoided a direct hit. On 4 January, she was part of Rear Admiral Philip Vian's British Task Force 63, which took part in Operation Lentil, in what turned out to be a successful air strike on the Pangkalan Brandan refinery.

In January 1945 Captain Longley-Cook left the *Argonaut* after being promoted to Vice-Admiral. The new skipper was a qualified pilot called Captain W.P. McCarthy RN, which gave an indication of the new air-based dimension that the war in the Pacific was taking on. In mid-January, Captain McCarthy gave the command for the ship to set sail from the base at Trincomalee for Australia, where she would be part of the British Pacific Fleet. It wasn't all plain sailing as the *Argonaut* still had work to do in Sumatra. En route to Australia, just after crossing the equator, on 24 January George writes: 'To Act St – & another strike – quite successful, & a big one at that.' The ship was part of a mighty force raiding Japanese oil supplies at Palembang in Sumatra, as part of Operation Meridian One, followed up by Operation Meridian Two. These two attacks on Palembang were the largest strikes by the Royal Navy's Fleet Air Arm during the Second World War. After the

attacks, the refineries were completely out of action for two months and remained at a much reduced capacity for the remainder of the war. On 29 January, George writes: 'Act. Stat 6am. Raid Sumatra again extensively and accurately. Jap planes attack – several brought down.'

The *Argonaut* reached Fremantle in western Australia on 4 February and then sailed on to Sydney Harbour, to the headquarters of the vast British Pacific Fleet. On the way there, with time to think, George wondered 'when I will be with my darling wife again'. There was a real sense of occasion as the *Argonaut* sailed into Sydney, with the ship's band playing 'Waltzing Matilda'. George was delighted at the avalanche of letters he discovered waiting for him: thirteen from Daph, seven from his parents, three from Banks, one from his friend George Calder, and a postal order from his employers, the GPO. The Australians welcomed the British fleet with open arms, and George and his shipmates enjoyed their shore leave in this home-from-home in the sunshine. There was no shortage of food in Australia. The sailors' two-egg breakfast was the equivalent of two months' egg ration at home. George lapped it all up. He was even introduced to smoked cheese, which started up a lifelong love affair . . .

In a publication called *Thank You Australia*, produced after the war by the Naval Information Liaison Division in Sydney, the scene which met British sailors was described in glowing terms: 'As they stepped ashore for the first time, our men found a home from home, and a welcome unequalled in any of the world's ports where British ships have called. The men in the streets shook hands, the girls smiled pleasantly. The men in the pubs bought beer, scarce though that homely refreshment was.

Thank you Australia

NEW PROBLEMS OF WAR

. . . To the ships came hundreds of invitations to dinners and parties, to spend leave in Australian homes and on the sheep stations. The sun shone, the shops were full of good things, food was plentiful and excellent. It was a grand place and a grand welcome.

While British sailors wondered at and enjoyed this smiling land of sunshine and comparative plenty (their two breakfast eggs were equivalent to two months' egg ration at home), they also had to prepare their ships for the new warfare. Pacific war presented new problems to the Royal Navy, so accustomed to operations in the narrow waters of Europe. With Sydney the main base, fighting would be 4,000 miles away. So the first aim was to establish a base.

On shore, Monabs men assembled and serviced aircraft which are then flown to the carriers.

An early development was the establishment of Mobile Operational Naval Air Bases (Monabs), where aircraft could be assembled, serviced and flown to the carriers.

In Australia's ports administration offices were set up, stores and warehouses opened, and, soon, ordnance and engineering shops were noisy with work for the ships. The distractions of life ashore were only for the men off duty or on leave. The others worked at full stretch on guns and torpedo tubes, engines and boilers, radar sets and signalling apparatus, making certain all would be in order for Britain's new offensive. Helping the Navy were thousands of civilians, girl clerks and typists in the offices, storekeepers, riveters, welders and dockers. To cope with the rush of work, additional dockyard installations were made. The mightiest of these was the Captain Cook graving dock, at Garden Island, Sydney, completed in time for most of the major units of the Fleet to receive attention there.

But the greatest problem of all was how to keep the Fleet at sea for the extended periods necessary if it was to operate continuously against the Japanese.

Captain Cook graving dock, built by Australian workmen. H.M.S. *Anson* being serviced.

Workers admire, and supply come men to the ships, prepared the Fleet for the new offensive.

Fleet Air Arm ratings in the carriers prepare bomb loads for Avenger raids against Japan.

Civil Constructional Corps workers who built Sydney's graving dock for use by ships of B.P.F.

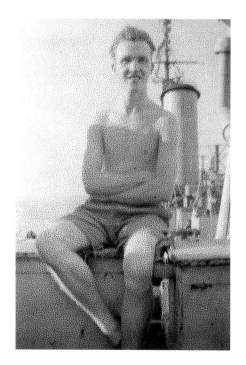

Motorists pulled up at street corners, invited the sailors to their homes.'

On his first day ashore in Sydney, George writes in his diary, he went to the pictures, followed by a party and to a 'Chink restaurant'. (Political correctness had not been invented in 1945 . . .) Like the entire British Pacific Fleet, George and the *Argonaut* crew had a high old time in Sydney, but by 28 February, they were on the move again; this time bound for what was called a 'forward' operating base on Manus, a small island with deep surrounding waters in the Admiralty Islands, to the north of New Guinea. The crew were impressed by the facilities there. It was also the base for the American Fleet, and it had hot showers, ice-cream parlours and a PX store (this US military retail outlet resembled a department store and was much envied by Allied forces).

On 18 March, the Fleet left Manus bound for Operation Iceberg, its first action in the Pacific. It signalled the beginning of a two-month-long attack on the Sakishima Gunto, a forward Japanese airbase, while warships shelled Sakishima. At the same time, American forces were attacking nearby Okinawa. Again, the *Argonaut* was threatened by kamikaze planes, not by enemy ships. Although the *Argonaut* fired at these Japanese planes, they never retaliated. They had bigger fish to fry, in the shape of the large Allied Fleet carriers. Seven British planes were hit in this operation. The crew heard reports that some of the Japanese pilots wore ceremonial funeral robes. Adrift and far away from her base for fuel and stores, the *Argonaut* crew came up with the ingenious 'Fleet Train' method of transferring

Opposite: A publication called Thank you Australia, *produced by the Naval Information Division in Sydney, was given to all Royal Naval personnel.*

supplies between vessels. This involved oil hoses hanging from warship to tanker in order to transfer ammunition, food, mail and general stores. This meant new skills had to be acquired quickly, and mistakes were made. One *Argonaut* crew member slipped overboard into the shark-infested waters below while supplies were being transferred. The cry of 'man overboard' went up and after a tense few minutes a destroyer came to his rescue. He was later transferred to the *Argonaut* by breeches buoy.

After Sakishima, the ship sailed to Leyte Bay in the Philippines where the crew were allowed to take a walk around the markets in the port area to stretch their legs. The only form of exercise in this hot and sticky climate while at sea was swimming, so the crew were encouraged to take time out ashore. It was while the ship was based off Leyte that the news came through on 8 May that peace had been declared in Europe. 'BBC confirm that this is V-E Day,' George writes in his diary. 'Bottle out in mess. Churchill's speech etc. And so turn in.' Outside, the ever-expressive Americans sent up rockets to celebrate, but on the *Argonaut* there was more of a sardonic belt-and-braces approach when one crew member went out onto the top deck with a box of matches and ceremoniously struck them one at a time before throwing them in the air.

All Ashore

The announcement of peace in Europe was swiftly followed by the news that the *Argonaut* was heading back to Australia for a major refit. She sailed back into Sydney Harbour on 11 May for a two-month-long refit and an extended period of shore leave. In George's case, a large portion of this period was taken up with sick leave, when he was hospitalised with a sore finger and then signed off for a fortnight's sick leave.

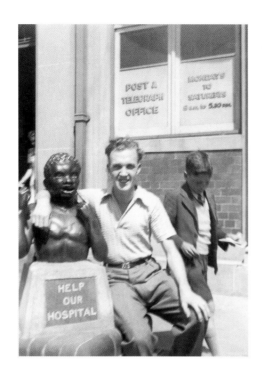

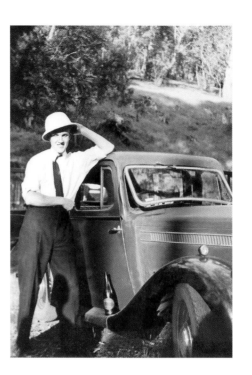

During this period, he headed to Melbourne to visit family friends called the Lochiels, who looked after him like a son, feeding him well and making him feel completely at home. While there, he did a lot of sightseeing to beauty spots such as the beach resort of St Kilda. He also took the opportunity to do some shopping for presents to take home. He bought a new camera, and from that point on he mentions frequently in his diary that he is taking photographs. Later, back on board the *Argonaut*, he talks about printing photographs too, almost taking on the role of unofficial ship photographer.

This halcyon stay Down Under ended on 7 July when the *Argonaut* sailed out of Sydney bound for Manus again. She stopped at Papua New Guinea, where they experienced a mighty tropical typhoon. Such was its power, the entire fleet was stood down, but in his diary George plays it all down by writing on 1 August, 'Pretty big swell. Dodge cyclone. Ooze around mess. Turn in for unsettled night.' By this stage, the war in the Pacific was coasting towards its conclusion. American and British ships were now bombing Japan and the *Argonaut*'s role was as a guard ship, stationed some thirty to forty miles ahead of the main Fleet, with a destroyer escort. Her job was to rescue Fleet Air Arm pilots who had ditched on their return from bombing missions. With her superior radio-based detection and tracking systems, the *Argonaut* had to signal the Main Fleet, advising of enemy planes infiltrating with Allied forces on their return to the Fleet. This meant being in an exposed position without the protection of the Main Fleet. Later, the crew learned that America had thirty-three ships on guard duties in their sector. Six were sunk. At dusk,

Opposite: George had plenty of time to 'ooze around' in Australia, which he and his shipmates regarded as the Land of Plenty after the privations of living in wartime Blighty.

the *Argonaut* would return to the Main Fleet, which withdrew into the ocean and cruised up and down in the darkness until dawn.

The ship had a close shave one night while she was sailing at the rear of the Fleet. All the ships were darkened with not even a navigation light in sight. Suddenly, it was realised she was on a collision course with the entire Fleet. A 180-degree turn had been ordered, but the *Argonaut* had not received the signal. All the ships in the Fleet switched on their navigation lights so she could weave her way out of trouble.

Hiroshima

The news which finally signalled the end of the war in the Pacific came through to the *Argonaut* as she sailed off the coast of the island of Leyte in the Philippines in early August 1945. George and his messmates were lazing in their hammocks at the time – playing cards and half listening to the radio – when they heard that a uranium-filled bomb known as 'Little Boy' had been dropped on the city of Hiroshima in the south west of Japan at 8.15 a.m. that morning. George knew instantly that this action signalled the end of the war. Three days later, on 9 August 1945, a plutonium-filled bomb – 'Fat Man' – was dropped on Nagasaki. On 10 August, George writes in his diary, 'skipper pipes about peace news – kinda celebrate in mess & so turn in, in hammock'.

After a short spell ashore in Leyte, the *Argonaut* was dispatched to Northern China to help liberate legions of emaciated, swollen-bellied serviceman from POW camps. They also went to Keelung in Formosa where they took prisoners of war on board and then handed them over to a British navy minesweeper, a fast ship, which took them on down to Hong Kong and back to Britain. They were all in need of urgent medical care. Their skeletal bodies spoke volumes about the torture

they had endured. The Japanese were notoriously cruel to their prisoners and, apart from witnessing the POWs' physical state, George had heard many stories from the men about the horrific living conditions in the camps. These accounts stayed with George for a lifetime.

Shanghai was a bustling port with an eclectic mix of people and an exciting place for the young sailors to spend a few days 'oozing about'. George bought a good German Welta camera for 1s.6d. There was nothing else to spend money on, and with his growing interest in photography he was keen to test it out. The port was full of German prostitutes and Chinese sing-song girls, whom George and his shipmates naively thought sang to you for a few bob. Young and silly, they ran away when they realised their game. Later in his life, George described an encounter with a fellow Scottish sailor, a belligerent Glaswegian who tried to pick a fight with him. Generally though, the ship's company enjoyed their stay in Shanghai. A high point after months of monotonous hard graft at sea took place when the crew arranged a party for a hundred children who had been kept prisoner at an internment camp in the city. For one afternoon only, the *Argonaut* turned into a fairground; the top-deck was transformed with flags, swings suspended from the gun barrels and slides down the gun decks. There were even makeshift coconut shies and cable seats on a pulley from the bridge to the fo'csle – all this activity was followed by ice cream and buns. As a member of the ship's concert party, George was also involved in a concert that took place in downtown Shanghai for released internees, helping to return a sense of normality after their years of deprivation.

Above: *George always found time to make music on board the ship. He picked up his 'erhu' (Chinese violin) during his travels.*

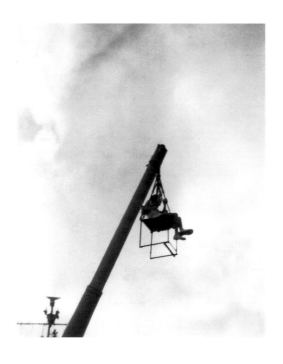

The ship then left Shanghai and sailed to Hong Kong, dodging the odd floating mine on the Yangtze River. After relief work in Hong Kong, the *Argonaut* returned to Sydney and from there travelled to Port Lincoln in South Australia. By 9 January 1946, with George having celebrated his twenty-fourth birthday in Hong Kong, the ship headed to Yokohama in Japan for two weeks in harbour. The *Argonaut* was the first British ship to sail into a Japanese harbour after the war and the ship's company encountered some shocking sights. The Japanese were disoriented, deprived of dignity, crippled and impoverished – a broken people. Despite this, there was no sympathy among the ranks for the plight of the Japanese people. George told his family in later years about one incident where a guard, who was picked out as being particularly brutal, was then loaded up with weighty boxes which the sailors let collapse in on him and crush him to death. Cruelty begets cruelty was the consensus on board.

While on shore leave, the crew heard of an opportunity to visit Hiroshima. Only three took this up and went on a day trip: a Yorkshireman, a Northerner and George. The three sailors took a train from Yokohama around the inland sea, seeing sunken Japanese boats on one side and terraces of manicured fields on the other. When they arrived at Hiroshima Station, which for some strange reason reminded George of Paisley Gilmour Street Station back home, there was no roof, just a few pillars left standing. On peering through them, the three men saw all that was left of a devastated city; and this appeared on first inspection to be the grid system on which it had been built. Every tree

Above: While docked in Shanghai in September 1945, the crew from HMS Argonaut *organised a party for a hundred children and their families who had been interned by the Japanese. Ingenious party tricks including swings from gun barrels.*

was black and charred, and the granite stone used in building had shattered and turned to dust. George was struck by a granite balustrade going up a staircase, which he crumbled through his hands. Stone had disintegrated and glass had melted. They walked in silence among the ruins, through what until just five months earlier had been bustling streets. They picked up molten glass and pulverised stone. Despite his newfound passion for photography, George only took two photographs. He recalled later that he was simply so shocked that it was all he could do just to take in the scene. They even saw some forgotten POWs who were hard at work cleaning up the streets. The residents of Hiroshima who had been spared wandered around the ruined city, still shell-shocked, scarred and covered in scabs. Children played among the dust. Between 60,000 and 80,000 people had died instantly in Hiroshima when the atom bomb was dropped. Many simply vanished in the explosion, such was the intense heat. The final death toll was calculated at 135,000 because so many subsequently died of long-term radiation sickness. No one thought about radiation sickness at the time, and George always wondered why he suffered no lasting effects after being so exposed to the fall-out from Hiroshima.

Back on board and after a lot of reflection, George recorded the visit in mundane terms: 'Usual routine. To Hiroshima. Very interesting. Back aboard – real hungry. Do enlargements.' Despite the matter-of-fact tone, he couldn't put the images and stories he absorbed in Japan to bed. Not long after this, the crew visited the city of Kure, which is close to Hiroshima. It too had been badly hit by the bomb. The crew also had a four-

Opposite: While on shore leave in Yokohama, George and his shipmates took several day trips, including one to Hiroshima. Despite being a keen photographer, he only took two photographs.

day visit to the city of Nagoya before making a return visit to Hiroshima and Yokohama. There was even a visit to a Japanese brothel, from which George in time-honoured fashion 'made his excuses and left', feeling nothing but pity for the starving girls forced by poverty into prostitution. His 'Original Earth Guarantee' in *A Day Down a Goldmine* was a manifesto on mankind's duty of care for Planet Earth. He also created an installation in 1995 at Glasgow's George Square called *The Difference*, to mark the fiftieth anniversary of V-J (Victory over Japan) Day. It was marked out by stark charcoal-like stumps of tree trunks on a criss-cross grid-like system.

From Yokohama, the ship headed to Tokyo. Shore leave was given to the sailors who went to visit the Emperor's Temple and other tourist sites, but none of these finer cultural points of Japan could eradicate the images of Hiroshima from George's mind. His experiences of fighting in the Pacific, meeting and talking to POWs and visiting Japan were to stay with him for ever. He had frequent nightmares throughout his life where he kicked Daph in bed thinking she was a 'Jap'. He wouldn't ever buy Japanese goods and had a very public run-in with a Japanese restaurant owner decades later in London while taking his daughter Louise out for a meal.

After leaving Japan in late March 1946, the *Argonaut* returned to Hong Kong where the crew boarded the *Strathmore*, a huge P&O liner. On 1 April, while waiting to board the trooper ship, George sent a telegram to Daphne, who had moved to Glasgow at the beginning of 1946 in preparation for his return: 'EXPECT TO BE HOME SOON. DON'T WRITE FURTHER. KISSES. FONDEST LOVE DARLING. RALSTON.'

It took just over three weeks to sail back to Britain via Singapore, Colombo, Aden, Malta and Gibraltar. In contrast to the previous voyages made by the crew of the *Argonaut*, it offered George and his shipmates some much needed rest and recuperation. George lists

in his diary the books he read – *The Scarlet Pimpernel* and *I, Claudius*, among others – and many instances of music-making, sing-songs and watching films. The *Strathmore* finally docked in Southampton on 30 April, and although George and all his mates were champing at the bit to be allowed to see their loved ones, they had to go through a long demob process at Devonport before being allowed to formally leave the Royal Navy. On 10 May, George writes: 'Last day in Nautical Regiment.' The next day, he travelled to Glasgow. 'Then to wee house to see wee wife and it seems as tho' I've never left her – lovely loving welcome. Up in clouds all day.'

George – or Ralston as he would always be to his nearest and dearest – was finally back on home soil. The next chapter of his life was about to unfold . . .

Above: During shore leave in Tokyo, George and the Argonaut *crew visited several tourist sites, including temples. George is circled in this picture.* **Right:** *After leaving Japan, the ship headed to Hong Kong and boarded RMS* Strathmore, *which took three weeks to sail back to Great Britain. George sent a customised note to Daphne in advance.*

Arrivals and Sailings

SOUVENIR

FROM

R. M. S.
STRATHMORE

1946

ROYAL NAVY

———

SOUVENIR OF THEIR
HOMEWARD BOUND
VOYAGE
FROM
HONG KONG
TO
SOUTHAMPTON
9596 MILES.

———

FROM 3RD APRIL 1946
TO
30TH APRIL 1946.

ANNOUCEMENT
OF
ARRIVAL.

———

Dearest *Daphne*

Arrived at Southampton
and expect to be home

on *just as soon
as I possibly can be!*

Signed *Robstan*

(Your own ever-loving husband)

———

HAPPY TO MEET
SORRY TO PART
HAPPY TO MEET AGAIN.

VERY (X)(X)(X)(X)(X)

4 Home Sweat Home

George and Daphne's first home as a married couple was at 4 Penilee Terrace in the southwestern suburbs of Glasgow. The Wyllie family's habit was to refer to their abode as 'Home Sweat Home' – just on eof the idiosyncratic Wyllie-isms which Daphne would have to get used to in her new life with George. The three-bedroom terraced house was situated on a large council estate, built to accommodate the influx of workers to the nearby Hillington Industrial Estate. Building work on the houses hadn't stopped during the war years, as accommodation was required for those who worked at the numerous factories on the estate. Before George returned home in 1946, Daphne moved up to Scotland to set up home. For a short while, she had a job with an importing company on the estate while Harry worked for MacDonald's Biscuits. The two women used to travel together in the morning to Hillington. Penilee Terrace was a depressing sort of place for Daphne. It lacked the sense of community other housing estates had built up over the years. Her family home in Gosport was a beautiful Victorian villa, with exotic cacti in its front garden and quince, damson and greengage bushes in the back garden.There was a real sense of warmth there as family and friends came and went. Daphne's parents lived there until they died. It must have been a terrible wrench for Daphne to leave her family in the south of England, which had a warm dry climate in contrast to the dampness of the west of

Top: It would be some several years into their married life before the young couple could afford to take on a mortgage, but it was always on George's mind. When they bought their own home in Gourock in the early 1960s, he made this sampler-style artwork and hung it on the wall to remind him of the effort involved in being a homeowner. ***Below:*** *At the end of 1947, George and Daphne were living in a flat in Penilee, Glasgow. George had joined the Customs & Excise Department. He is pictured here in his uniform, outside the flat, leaning against his Customs Car.*

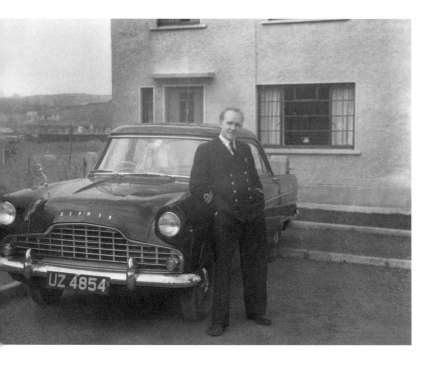

Scotland. George had sublet the house at a distance while he was still at sea and Daphne had moved to Glasgow while he was still in the Pacific. The house was owned by a man who gave the upper part of the house to his son and his new wife. He rented out the furnished ground floor to George and Daphne. Although at first both were giddy at just being together after such a long separation, gradually both George and Daphne began to feel it wasn't the house they were meant to live in. This point was hammered home when they thought they would spend their first Christmas together as man and wife in the house, sharing dinner with the couple upstairs. It was a disastrously damp squib of a dinner, with the four of them sitting miserably poking at their turkey and Brussels sprouts in silence. By the start of 1947, Daphne was increasingly feeling miserable. Not only was she living hundreds of miles apart from her family and close friends in a land which often felt unfamiliar, her sense of loneliness wasn't helped by George being out several nights a week playing at gigs with various local bands – for enjoyment's sake as much as to bring in extra money. Keen for Daphne to feel at home in Scotland, George suggested they move down the coast to be closer to his parents, who not long after the war ended had moved to Wemyss Bay, on the Clyde Coast. This would offer a network of support when it came to raising children, he reasoned. Daphne agreed, although she often felt she could do nothing right in George's mother's eyes. Both George's grandpas died during 1947, and it could be that there was a little money directed George and Daph's way as a result, which made it easier to move. Andy was executor of his father's estate, and it's noted in the family archive that George Ralston Wyllie senior left £221.7.5 (just over £8,000 in today's money).

Nothing to Declare

After the war, George returned to his job in the GPO's engineering power section, in which he worked on electric light, motor and power installations, but he was always on the lookout for alternative employment that would pay more and suit him better than this dull and safe job. Eventually, at South Lodge in Wemyss Bay, George and Daph found their first true family home. A year after leaving the Royal Navy, in the autumn of 1947, he sat a Civil Service Commission examination for an 'appointment as Male Assistant Preventive Officer in the Waterguard Service of the Customs and Excise Department'. As 1947 drew to a close, he received a formal document listing the results of the 'Fifth Reconstruction Examination'. The ninety-four successful candidates were listed in order of merit, and of that number only two had not been in the services. A further eighty-eight were unsuccessful. George was ranked number thirty-one out of the ninety-four success stories. The timing couldn't have been better. He was to be based between Glasgow, Prestwick and subsequently Greenock, which was closer to Wemyss Bay. The position required him to patrol and police the ships that docked in Greenock and Glasgow. George was delighted at being back at sea, albeit as a landlubber.

At this time, Greenock was a bustling port, which played host to all sorts of shipping traffic, including bulk sugar boats from Australia and the West Indies, banana boats from the West Indies, tramp boats from all over the world, and timber ships from West Africa, as well as yachts and returning Royal Navy vessels. It was *the* place for learning the skills required of a trainee waterguard and George embraced his new role wholeheartedly, fired up at being reconnected to the sea.

South Lodge was perched on the sea wall at Wemyss Bay, a village renowned to generations of holiday-bound Glaswegians as the departure point for the ferry to Rothesay. A small, detached traditional sandstone gate lodge with crow-stepped gabling, it sat on Shore Road, a private road at the main entrance to the Duke of Argyll's estate. With its panoramic views out across the Firth of Clyde and beyond to the hills of Arran, Rothesay and

Dunoon, it was a complete contrast to Penilee, and George and Daph loved their first real home together. It was here too, that George's mother finally achieved her ambition of opening a shop; first at nearby Woodside and then at Stonefield, which sat at the pierhead in Wemyss Bay. Almost overnight, Daph's life changed as she found herself at the very heart of family – and village life.

Baby, It's You

They had only been living in Wemyss Bay a year when Daph fell pregnant. Louise, their first child, was born in Greenock's Rankin Memorial Maternity and Children's Hospital on 28 July 1950, while her father was playing double bass at the nearby Greenock Palladium. It was not an era for hands-on dads, but not long after Daph returned home to South Lodge with Louise, George found himself left holding the baby when Daph was rushed into a nursing home for emergency treatment following birth-related medical issues. They had also acquired, as a gift, a lively spaniel puppy called Chippy. George had difficulty managing the baby, and he was caught by the local midwife trying to feed her with a baby bottle in which the powdered milk had formed into the consistency of wallpaper paste. Their second child Elaine was born at home four years later, and the family enjoyed happy days spent in the orchard that was their garden and on the beach and shore roads that wound their way around the duke's estate. Unfortunately, Chippy had to go as he proved just too much for Daph to handle in a little house with two young children.

Above: In 1948, George and Daphne moved to Wemyss Bay where Harry and Andy lived and ran a general store (pictured) called Wyllie's. Pictured (top), left to right: Robert Stevens (their lodger, known as Stevie) who worked in the store, Harry and Andy at the local railway station.

Arrivals and Sailings

As was the norm in the 1950s, Daphne was now a stay-at-home mother. George worked in Customs and Excise by day and at night he still played his jazz for enjoyment and the extra income. This didn't stop him finding time for fun with his girls though; George liked nothing better than making carts, constructing shops and wee houses, and conjuring up from his imagination seasonal flying witches, fairies and Santa Clauses that flew across the outer walls and windows in a series of handmade contraptions which proved all too believable for two innocent girls. Banks moved to Wemyss Bay around this time and took up residency at Kelly Mains Farm with his new wife Beryl MacAlpine, whom he'd married in 1948. They went on to have two children: Gillian, born in 1953, and Alistair, in 1956. Banks and Beryl also moved onto the Duke of Argyll's estate, and their home was in the courtyard buildings of the castle itself. Beryl would help out in the shop when she could. George's cousin Nan and niece Morag also moved down from Glasgow, and Nan took a job working in the kitchen of one of the big houses called Cardell. Harry and Andy couldn't have been happier. As far as they were concerned, family came first, and to be surrounded by their sons and their children in this idyllic seaside location was just perfect.

Woodside was the first of Harry's shops in Wemyss Bay. It was further up the hill from Daphne and George's house and was next door to a chapel. It had been a large semi-detached house with a large front window which became the shopfront. Harry made her money supplying the duke's estate with groceries delivered on a daily basis. As the business grew, taking

Top: South Lodge, perched on the sea wall at Wemyss Bay, was George and Daphne's first family home. A small, detached traditional sandstone gate lodge with crow-stepped gabling, it sat on Shore Road, a private road at the main entrance to the Duke of Argyll's estate. ***Below:*** The staff of Wyllie's are pictured here inside the store.

over much of the house, she then moved to a new home in Skelmorlie and bought the large double-fronted shop at Stonefield, on Wemyss Bay pierhead. She turned this into a general store, which was a mix of self-service and deli counter; an enterprising retail model years ahead of its time, it offered a delivery service to the outlying rural areas of Inverkip, Wemyss Bay and Skelmorlie. It also met the needs of travellers, as Wemyss Bay was a busy train and ferry terminal for coastal towns and islands on both sides of the Clyde. This was the era of steam trains and paddle steamers, a time when places like Glasgow would empty during the 'Fair Fortnight' and holidaymakers would make their way 'doon the watter' in their thousands to Rothesay, Millport and Arran. All these islands were serviced by Caledonian MacBrayne steamers. Harry's enterprising ways found a place at Wemyss Bay, and would provide the family with security and stability in the coming years.

Harry still had a touch of wanderlust though. Around the same time she and Andy bought a property called Stroove Cottage, Harry discovered a small newly built bungalow on Eglinton Terrace in Skelmorlie and decided she couldn't live without it. So they moved again, a pattern which Harry would follow to her death. It was also around this time that a man called Robert Stevens (known as Stevie) took up lodgings with Harry and Andy in this detached bungalow, which they again called 'Ralbank', after both sons. The bungalow was Harry's idea of the perfect home, with its lace curtains and roses round the windows. Stevie and his wife had

Above: Harry and Andy's bungalow (called 'Ralbank' after their two sons) in Skelmorlie where they lived with lodger Stevie for most of the 1950s. In 1956, George and Daphne and the girls moved to Northern Ireland, but they still had the seaside of the County Down coast within driving distance. A great spot for family picnics with family and friends The Bowdens.

been good friends of Harry and Andy in their Glasgow days, but his wife had died suddenly and Harry stepped into the breach by offering solace, and importantly, a place to stay at Ralbank. Once Stevie moved in, he never moved out. Andy continued working in Glasgow until he retired in 1955. He was also busy with masonic duties. By the time of his retirement, he had achieved the position of Right Worshipful Master at Lodge Progress, Glasgow No. 873. In this post, he led and conducted all business in the Lodge and would have been an expert on its rituals. (As George recalled in his later years, his father persuaded him to join the Inverkip branch of the masons, but it was not an association destined to last, as George didn't like the ritualistic nature of freemasonry.)

Stevie worked hard in the shop with Harry. He appeared to customers to be the model grocer, with his slicked-back hair and immaculate white coat. Back at Ralbank, they raised chickens and sold the eggs locally. They worked hard at the business, and all three enjoyed a good lifestyle, which saw them go to see shows in Largs, buy a brand-new car every year and have a warm and comfortable home. They all went to church every Sunday, an integral part of the week. Both Andy and Harry enjoyed singing and would burst into song at a moment's notice. Andy particularly enjoyed composing and reciting ditties and often published them in the local press.

My Wife by Andy Wyllie

Harriet is my darling, my darling, my darling
Harriet is my darling, she's been a guid dear to me
It's well over forty years we're wed, I never do regret
I picture her in Inverkip, that happy day we met
I've heard it said that if I return to live another life
God make it so and send me back with Harriet my wife.

A great day out with the Wyllie family was always connected to the sea – either picnicking on Shore Road or heading off on the paddle steamer on a trip to Arran with a high tea on board. From the age of four years old, Louise travelled daily on the bus along the shore road from Wemyss Bay to Largs, where she attended a small private school run by a lady called Mrs Murray, who operated a rather free-spirited establishment from the comfort of her front room. Her small charges sat around a very large round table, and Louise recalls Mrs Murray being possessed of a huge pair of knees on to which she and her fellow pupils routinely clambered.

Escape to Ireland

At this stage, George travelled back and forward from Glasgow to Greenock in his role as an Assistant Preventive Officer (APO) with HM Customs and Excise. He enjoyed it, but was always looking to the next move. For his parents, happy with their boys and the grandchildren around them, it must have come as a shock when he told them in 1956 that he had been successful in applying for a promoted Customs and Excise post in Northern Ireland. It was a step-up to Preventive Officer (PO), he told them, and an opportunity not to be passed over. On passing the exam from APO to PO, one had to look around the UK for a vacancy. The advantage of securing a post on the Land Boundary in Northern Ireland was that after a three-year stint, you had priority in securing a vacancy elsewhere. The gatehouse at South Lodge, by then stacked to the rafters with possessions he had accumulated in their eight years in residence (George could never throw anything away), had to be emptied before Daph and the girls could move to Newry to be with him.

In the meantime, George and another Customs and Excise Officer, Alasdair Currie, set sail on board *The Royal Scotsman* from the Broomielaw in Glasgow, en route for Belfast in the autumn of 1956. They were to serve on the Northern Ireland Land Boundary between

the North of Ireland and the Republic of Ireland. Until 1951, the border had been the responsibility of the Royal Ulster Constabulary Customs Patrol, but now it was under the control of HM Customs and Excise. In Belfast, George and Alasdair were joined by three other young APOs who had also been appointed to the Land Boundary: Ralph Solomon, Noel Butler and David Hadfield. There, the four men undertook training, mainly in the art of border driving. Some of the officers, like Alasdair, couldn't drive at all while some were experienced. None were prepared for driving the many winding and often single-track roads that wove across the borders and were invariably lined with high hedges. The police gave them lectures on 'cornering', imparting the wisdom that 'no corner was straightforward unless you could see round it'.

One of Ralph Solomon's early memories of George was when Ralph was designated 'wheelman' and ended up colliding with a lorry, which took up the entire road on one of those tight bends. A colleague called Jack Hyde ended up in George's lap, but George, although plastered against the windscreen, praised Ralph for his quick thinking. The driving training school was known as 'Mick Mulqueeny's Circus' and all the officers spent four weeks in Mick's company before being allowed to move down to their border bases. Mick Mulqueeny had trained at police college as an instructor examiner, and all the drivers were trained to a high standard. Mick was also allowed to certify officers with a Certificate of Competence, awarded to his own students and those Customs officers in the Waterguard Training Unit. The formal driving test as we know it, compulsory on the mainland since 1934, didn't exist in Northern Ireland in the 1950s. There were no driving tests in Northern Ireland until 1957. Until that point, licences were bought over the counter. Cars were vital to the patrol; every crew was assigned one. The smugglers preferred old American V8s with 30hp side-valve engines, which gave them considerable acceleration to around 70mph.

In 1951, Customs and Excise inherited various elderly RUC vehicles, such as an Austin A16, an A16 Hereford and several Ford Consuls, until the new Ford Zephyr Mk 1 was introduced in 1952. The Zephyr proved problematic as it had a distinctive single Notek Blue Spot driving lamp, which made it visible in undercover operations. Customs vehicles were exempt from lighting and speeding laws so the officers could go about their business combating smuggling. Cars were adapted so that tail lights could be switched off separately. Drivers had to be proficient at driving in the dark with no lights, and often practised on the road from Strabane to Scraghy. They also had the use of walkie-talkies.

The mobile patrols were responsible for policing frontier posts along the border, which was almost 300 miles long and crossed by sixteen approved routes and numerous unapproved roads. Known as the demarcation line between Northern Ireland and the Republic of Ireland, and legal as it was, there were no physical markings along its path. In some cases, the border went through villages, roads, farmland and houses. Not all the crossings were managed by Waterguard officers, as some were under the control of Land Preventive Men, or even joint initiatives such as at Killeen and Goraghwood. The Waterguard officers were stationed at Newry, Armagh, Aughnacloy, Enniskillen, Castlederg, Strabane and Londonderry.

George, Alasdair and Ralph were posted to Newry. The crew reporting line started at the bottom with the APOs, of which there were two or three, a PO and then the Chief PO. George was a PO with his team of three men, Alasdair, Ralph and Noel, who were all stationed at an office on Hill Street, Newry. This was base camp for twenty to thirty Waterguard officers. Border patrols were carried out from Hill Street, as well as visits to the Killen Road post, examinations of Goraghwood rail station, and the boarding of cargo vessels at the Port of Newry.

Cowboys and Indians

George served as a PO from 1956 until 1960. His work involved catching smugglers who were moving contraband such as cigarettes, tobacco, watches, butter and electrical goods across the border from south to north. In the other direction, items such as razors, artificial fertilisers and soap substitutes were smuggled. There were different categories of smugglers. Petty smugglers generally operated for their own consumption, or for friends and family. They would attempt to smuggle through frontier posts and used the authorised routes to avoid wrecking the undercarriage of their cars on unauthorised roads. Organised professional smugglers preferred more ingenious tactics. In the main, this illicit transfer of goods took place across the Newry and Auchnacloy borders. A car could be packed with 100,000 cigarettes, fourteen pounds of tobacco and half a ton of butter. Smuggling routes over the borders around Newry and Auchnacloy were the most popular, as these lay across the Dublin–Belfast roads and were most profitable.

The frontier posts opened from 8 a.m. to midnight in the summer and 8 a.m. to 9 p.m. or 10 p.m. in winter. They were recognised as authorised routes during those hours, but when closed they became unauthorised and were patrolled by the mobile crews. Ralph Solomon recalls George making a point of developing contacts

Above: The IRA were active along the Border which George patrolled in his role as a Customs & Excise Officer. This shows a bombed-out land boundary post at Killeen. *Below:* Louise and Elaine were six and two respectively when the Wyllies arrived in Lisdrumgullion. The television set in the corner was a new addition to their lives and their father used the opportunity of his girls sitting still for long periods watching TV to paint them.

who might give him a bit of information. On one occasion, he orchestrated a scheme by which two crews were dropped off in the middle of the night to climb the side of Flagstaff Mountain in total silence with no lights to help them get into position. This resulted in Ralph and the others jumping over walls at the sound of George's whistle and capturing a convoy of bicycles loaded with 80,000 cigarettes, while the riders disappeared into the night like frightened rabbits.

There was also the story of a man with a wooden leg being apprehended at the border crossing and being found to have his artificial limb packed with cigarettes. Smugglers were always looking to turn a quick profit and the merchandise could be anything from cars to cattle, so officers had to think on their feet. Smugglers were often apprehended by placing obstacles on the road, such as road blockades or cars positioned broadside, and then being blocked in from the rear, so they couldn't make a reverse escape. If this was successful then invariably the smugglers would make a run for it and a chase would ensue. Most smugglers tried to escape, as they often had criminal records. The large list of charges incurred at the blockade made for hefty fines and/or imprisonment.

There was one incident that caused quite a stir among the ranks. George and his APOs were heading southwards on traffic patrol because the roads were busy. As they came into Jonesborough, County Armagh, they clocked men driving off slowly from a shop owned by one John Rice. An elderly gentleman, Rice flagged down the Customs men and explained that armed masked men had robbed his car. The car windows were down and machine-guns pointed outwards. The five robbers saw the Customs officers and suddenly jumped out, abandoning the car and fleeing across the border 150 yards away over stone dykes, still brandishing their weapons. They were dressed in semi-military uniform with trousers tucked into gaiters. Wheelman Noel Butler did a seventy-five-yard reverse at speed ensuring the

unarmed officers were not in any danger. This move was commended by George in his incident report and caused some laughs socially as it was recorded as the fastest-ever record of a Zephyr in reverse. The Customs team then travelled the 500 yards to Jonesborough Post Office call-box and made a 999 call to report the incident to the Garda and drove on to the Killeen frontier post to warn officers there. The rumour was that it was believed to have been the prelude to an IRA attack on Forkhill RUC station. Troops and police rushed into action as a result, but the men were never apprehended. It was later established that fourteen men in all made their escape into Eire that night.

One of George's first jobs on arriving in Northern Ireland had been to find suitable accommodation for the family to join him. It wasn't long before he found a semi-detached newly built house at the end of a cul-de-sac on Carbane Road in a small district just outside Newry known as Lisdrumgullion. The rented house was modest, but George reckoned it would be a fine family home for Daphne, Louise and Elaine, who were six and two respectively when they moved to Ireland. Furnished with utility furniture, the sea was never very far away, in the form of bunk beds straight off a ship, which were in the girls' bedroom. The house was situated on a corner plot and had a huge garden. George was later to build his daughters their own log cabin in which to play, and Daphne grew lots of vegetables. The house was flanked by a Protestant family on one side, the Browns; on the other, a Catholic family, the Hannas. Both families had numerous children with whom Louise and Elaine played. It was an idyllic rural lifestyle, with the buttermilk lorry arriving once a week with milk for making soda bread and the ice-cream van playing merry tunes. The children were free to play along the nearby river and canal banks that ran parallel to Carbane Road. Louise continued her primary schooling at Newry Model School, with Elaine later joining in 1957. It was a mile-long walk to school accompanied by the neighbours'

children and local farm children. Days off were spent sailing on Carlingford Lough, collecting crab apples from the hedgerows and swimming among the numerous seahorses in the sea at Omeath. Daphne became good friends with Mary Bowden, wife of another PO, Bob Bowden, and many away-days were spent picnicking and walking in the countryside with their daughters.

Yachts in the Kitchen and Other Stories . . .

For George, these were exciting times at home and at work. He built his first dinghy, a Heron, in the kitchen of their house, and Louise remembers having friends round for her birthday tea with them all wedged round it, plates of birthday-party food on the sides. Daphne negotiated some sort of fee for the disruption the boat-building caused in her kitchen with wood shavings everywhere – not to mention the removal of a window to get the boat out. This caused much hilarity among the neighbours. George and the upside-down yacht featured in the *Newry Telegraph* on 18 April 1959 under the heading 'Even Yachts in the Kitchen'. Sailing was now one of George's great loves and he spent down-time at Warrenpoint and on Carlingford Lough in the shadow of the Mourne mountains. He also built another one of a series of rowing boats called *Dorty*. Louise attended Mrs Shannon's dance classes dressed in costumes made by her father, who made her lie on top of the fabric on the floor and cut around her for his patterns. This love of cutting also extended to the girls' extremely short haircuts.

Right: While living in Lisdrumgullion, George built his first dinghy in the kitchen of their small terraced house. It was captured for posterity in the local newspaper.

6 THE NEWRY TELEGRAPH :: SATURDAY, APRIL 18, 1959

EVEN YACHTS IN THE KITCHEN

All through the winter preparations have been made by the Carlingford Lough Yacht Club to get sailing under way this summer.

Members of the Club are working hard in their spare time preparing a Boat Park on the portion of the foreshore which the Club have leased at Rostrevor. Some are even building yachts in their homes.

At present three sailing dinghies are being constructed by Club members, namely: Brian Bradley, George Wylie and Mr. Williams.

The largest class of sailing Dinghy in the Club will be the yachting world G.P. 14 footer designed by Jack Holt, followed by the Heron Class, which are 11 foot sailing Dinghies.

One of the Club members, Mr. George McBurney, has purchased a 17 foot yacht of the Silhouette Robert Tucker for offshore racing

and which, incidentally, may be the first boat of this Class to appear in Ireland.

During the sailing season, weekly races will be held around a marked course in Carlingford Lough. These races will be based on a points system, points being allocated at the end of each race to individual boats in order of merit. At the end of the season the boat earning the highest number of points will qualify for a valuable prize.

The Yacht Club have arranged to hold a Regatta early in August and it is hoped that other Yacht Clubs will take part.

Queen's University Sailing Club have already offered to send a team to compete against members of the C.L.Y.C. at a date to be arranged.

Particulars of the Club's activities may be obtained from the Club Secretary, Roger Hall, Esq., "Rosetta," Warrenpoint.

His APOs, Noel and Ralph, remember what they called 'the tractor event', another of George's money-making schemes. Ralph recalls: 'He hit on the idea of importing used tractors from Scotland to Ulster where he would sell them on to local farmers and bring in some bunce. Where he got them and to whom he sold them – we never found out, but, as usual, Noel and I became involved, thanks to George's powers of persuasion, and the offer of a fiver each if we went to Belfast with him and drove the tractors back to Newry!

'Arriving at the docks in Belfast to collect said tractors, George showed his Scottish thrift by saying we would save a lot of fuel if one tractor towed another, so off Noel and I went with me as the tug and Noel, on the end of twenty feet of rope, as the tow, with George and another twit taking the other pair. Hilarious scenes followed as it was rush-hour in Belfast, and every time I wound my tractor up to ten miles an hour, cars and buses were cutting in between us as they did not realise Noel was attached to me by a long 'umbilical cord'. You can imagine the noise his nibs made each time! Anyway, we left Belfast in pouring rain and no cover on these primitive tractors as we chugged along at a stately fifteen miles per hour towards Banbridge; half way to Newry.

'Commander Wyllie called a halt to change drivers and, with his usual cackle, asked us if we were enjoying ourselves. I give no details of our joint response. Eventually the four tractors arrived at Newry in the late evening, but I cannot remember where we left them. At least George honoured his promise and gave us a fiver each. No more importations of knackered farm machinery occurred.'

George embraced his work as a preventive officer with gusto and came up with many imaginative ideas on how to achieve their aims. He loved the work and the people with a passion. Their tongue-in-cheek satire and love of absurdities made Northern Ireland a metaphysical place for him. The surreal situations he found himself in would influence his later life's work as an artist and writer when he turned to the work of philosophers such as Alfred Jarry and Voltaire for inspiration and instruction.

Alasdair Currie remembers being amazed at George's energy and his resourcefulness. Ralph Solomon recalls George as an honest man with a fine mind – an exuberant character who always exhibited a positive attitude with an accompanying dry wit and cackling laugh, often at the expense of others. Ralph remembers: 'one late moonlit night when a walkie-talkie crew had to cross a large field to get into position, he [George] made Noel and myself imitate a pantomime horse, with Noel in front and me as the arse-end, and both joined together by our arms with the walkie-talkie dangling down between us like a giant wotsit! George certainly enjoyed it more than us!' With his engaging personality he quickly established good working relationships with the locals, enhanced by his love of music playing in local céilidh and dance bands, many of which toured the Catholic clubs, both north and south of the border. When playing in the North, they weren't allowed to wind up the evening playing 'The Soldier's Song', which was seen as an anthem for the southern Catholic Irish, so they always played it as the second-last dance. And everyone saluted to that in what was in itself one of those Irish absurdities which George loved so much. Once he asked a band to play at the Customs dance and to play some more modern tunes as well. They were happy to do this but felt they couldn't play 'God Save The Queen'. George announced that if this was the case he couldn't possibly play 'The Soldier's Song'. An agreement was reached, amid great hilarity. Ralph also recalls George's love of naval terminology and remembers a nautical expression he used on the car radio: 'Belay that last pipe.' When George left the Northern Ireland Light Orchestra, with whom he

played for the duration of his spell there, he received a music box as a gift. It played 'The Isle Of Innisfree', and ironically could only be bought south of the border. This absurdity tickled George knowing that he, as a Customs officer, had received smuggled goods as a gift.

George was the unofficial Customs and Excise social secretary, arranging numerous staff events to entertain the officers and their families in an attempt to keep morale buoyant. Alasdair recalls George always putting in a lot of work to these events, with meticulous attention to detail: from dressing the tables with gifts for the wives, through to the music played. Alasdair enjoyed and learned so much from his time organising these events with George that he continues to do similar work for Customs to this day. His fellow officers were not surprised when George turned to art later in life, as there were signs of a consistently creative mind at work during this period they worked closely together. George not only played double bass with the Northern Ireland Light Orchestra, he was also part of an Irish céilidh band. George recalled in later life that one of the most surreal moments in these capers was always Christmas Day, when both smugglers and Customs' staff would have the day off and drink in the same establishment. At times, as the crew sat in their patrol car having been awake all night, they would watch the sun rise and George would comment how sad he was that he hadn't brought his watercolours and brushes to paint the scene.

The years between 1956 and 1961 saw many troubles erupt on the Land Boundary. In 1955, the Customs post at Killeen was bombed. Gone were the days of cowboys and Indians, of cat and mouse in one big game; it became a war with guns and bombs and the surfacing of what had been the underground Irish Republican Army. Customs posts such as Killeen and Auchnacloy were blown up and, as a family man, George finally decided to uproot the family again and head back to Scotland. While the Northern Ireland years were among the most special times in his life, George always said

he wasn't prepared to die for it. After serving in Ireland for four years, he was now eligible to apply for jobs on the UK mainland. So, he successfully applied for a job in Greenock. The family were on the move again – this time to Gourock, just a few miles up the coast from Wemyss Bay.

George would revisit Ireland some forty years later in the 1990s, when he created a sculptural installation called *32 Spires for Hibernia*. For this artwork he collected a stone and forked branches from all thirty-two counties in Ireland. He then made an installation of spires that crossed the border both north and south, all woven together to symbolise the uniting of Ireland. The name had no barriers, he would say when people enquired about its origins. He would ask the people of Ireland on his travels that if trees and stones can live together, why can't people? He was tickled by the comment from one person at the site of the installation who questioned whether the stream had been consulted in being a part of the border. George's good friend Murray Grigor filmed this project for posterity.

There had been frequent visits back to Scotland from Ireland to see Harry and Andy in the time the family lived there. The children were sent home on their own, flying over to stay with Gran and Grandpa Wyllie. The whole family was required to attend the huge, Harry-driven Christmas dinner for all her extended family. There were also annual summer holidays in the south coast of England to Gosport where Daphne's parents and family still lived. George's obsession with old bangers meant he was always buying cars, doing them up and selling them to make some money. One of his favourite schemes was to buy old Post Office vans and then do them up as estates. George would drive Daphne and the children to Gosport and he would sell it there. He would then leave them for the summer school holidays and return to pick them up in another car, which he'd sell before they all headed home by train. The journey from Scotland to Gosport was a long one

in those days, in an old shooting-brake. Pit-stops were frequent and included the option of camping overnight in Gretna, Dumfries and Galloway, or staying in a B&B in Wetherby or Catterick in the north of England. Occasionally they slept in the back of the car. There was also the inevitable breakdown going over Shap in Cumbria when the engine would overheat and the radiator blow its steam – as did George, the driver . . .

Back on Scottish Soil

On their return from Ireland in 1960, George and Daphne rented 12A Ashton Road in Gourock. It was an upper flat in a block of older houses divided up into two floors. The flat was flush to the road across from the Promenade and overlooked Loch Long and the Holy Loch. The Royal Gourock Yacht Club was 200 yards down the road and George couldn't wait to join it. It was an ideal situation for the family; Gourock was a small coastal town with a good local school and all the amenities one needed to bring up a young family. The flat was spacious, but the floors sloped and the house was cold in winter. Louise and Elaine settled into Gourock Primary School and normal family life resumed, with visits to Andy and Harry at Ralbank. Harry was busy at this stage in her life painting crockery in her spare time, but she saw it as her duty to teach her grandchildren how to dance and to draw – just as she'd taught their dads before them. Louise recalls being taught all the Charleston dance steps while holding on to the edge of a Singer sewing machine and endless happy hours collecting, painting and drawing leaves and flowers with Gran Wyllie.

As a newly appointed PO in Greenock, George and Daphne enjoyed friendships with new Customs and Excise officers and their wives, and carried on existing friendships with the likes of Alasdair and June Curry, who had also returned from Northern Ireland and

were now living in Greenock. They would remain lifelong family friends. George played his bass at any opportunity and enjoyed these evenings of making music until he was in his eighties at the Hasties Social Club in Greenock and at the town's RAF Jazz Club. He also played at Greenock Arts Guild Theatre and other light orchestral events. His love of music and playing with friends encouraged him to form a band locally. One of his old friends from his early days in Wemyss Bay was Bill Duncan, who played drums. Bill was slightly younger than George and worked at local daily newspaper the *Greenock Telegraph*, initially as a compositor and then in the advertising department. He ended up as a senior director with the paper, known as 'The Tully' in the Inverclyde area. The two men decided they would create a band for events such as weddings and hotel dinner dances. They formed a trio by recruiting a keyboard player called Charlie Erskine and the Clubmen were formed. This bought chaos to the Wyllie home, as rehearsals operated out of the front room of an evening. Later, to Daphne's relief, they based themselves at the Bay Hotel, located on Gourock's pierhead. There, they became the hotel's resident house band, playing every Saturday night – though it wasn't unusual for George to be called away on Customs business if one of the big ships docked in Greenock.

Bill Duncan and his wife Doreen were great supporters of George and his artistic aspirations, especially in the early days. They would often purchase works of art from his exhibitions, never expecting to be given the work as a gift. They bought several early works by George dating from the late 1960s to the early 1970s. They bought a work from Frank Lynch, who was Billy Connolly's manager at the time, called *Bird in Flight*. Apparently Lynch's second wife didn't appreciate the sculpture, which was above their bed. Bill got to hear about this on the grapevine and bought it for his wife, who loved George's bird artworks. George and Daph were friendly with Connolly and his first

wife Iris, around the time Connolly was becoming well known. George gave him a big outdoor barbecue he'd made complete with tractor seats. Connolly in turn gave George some drawings he'd done. Daph was taken aback a few years later when Connolly's second wife Pamela Stephenson phoned to ask for the drawings back.

'The Folks Who Live on the Hill'

Not long after arriving back in Scotland, George decided he and Daph should buy their own property. He heard on the grapevine that a few new houses were to be built by a Glasgow-based builder called P. Houston on the highest point in Gourock. The site was originally a farm road up to the famous Tower Hill and up until the early 1960s was free parkland. The houses were stepped down the road on one side overlooking the Clyde, and on the other, slightly higher up, overlooking these adjacent houses and out to the Clyde. George went up and down the road on numerous occasions with the sole purpose of choosing the correct plot for the best view. Having finally decided on a plot on what was to be called McPherson Drive, his next tactic was to harass the builder into letting him have the house without an interior finish or a landscaped garden. He could only afford so much each month, but at last his dream of home ownership was realised. This home on the hill was to become a reality with the help of friends and family who rallied round, digging the garden and making flooring or plastering walls.

Above: *The family moved to 9 McPherson Drive Gourock in 1962. A new-build, it was the first and only house George and Daphne owned. It was sold after George's death.*

In 1962, the family moved into 9 McPherson Drive. Completely lacking in furnishings and fittings, bit by bit George fashioned every aspect of it by himself. Daphne loved the house too, although there were regular arguments about what to put where, not to mention the fabrics and style of the place. One end of the room had short curtains and the other long as a result. Daphne was a keen gardener and George bought her a Daphne Bush, a plant which has beautiful little purple-pink flowers with a sweet fragrance. This bush thrived in the garden until, inexplicably, it withered and died when Daphne died in 2004. Daphne was no pushover and had learned to manage George's domineering personality. She kept the family on an even keel and her man's feet on the ground, which was to prove crucial when George entered the next phase of his life. She represented equilibrium in the family, and towards the end of her life when she became ill, George made a sculpture dedicated to her – a portable spire in a box called *The Happy Compass*. In the mid-1960s, when George finally made time for art and embarked on what he called a Ten Object Plan, the first sculpture he made was called *Mortgage Climbing the Wall*, an intricate piece of metalwork which appeared to represent a creeping presence. People would ask him how he had managed to make it feel so tactile and intricate. He replied that it was really about the tools and materials he could afford at the time he'd made it.

Despite the ongoing financial pressures which face most family men, life was good for George Ralston Wyllie as the 1960s started to swing into action. He had a new job, a new car in the shape of a pale blue Anglia, a new house and a new Dayboat dinghy – not to mention

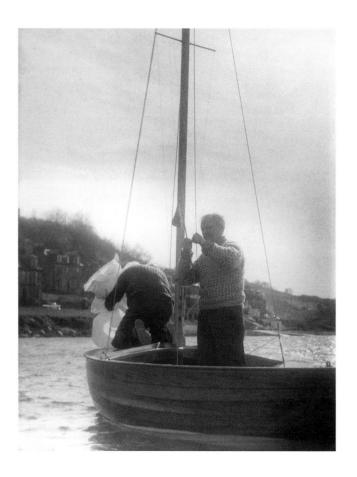

Left: *Once settled back in Scotland, George joined the Royal Gourock Yacht Club. This shows him with his crew in his dayboat dinghy,* Daybreak, *at mooring.*

Arrivals and Sailings

a coveted membership of the Royal Gourock Yacht Club and regular holidays to England's south coast. By then, the addition of a Dayboat meant that each summer the family headed for Brixham, on the Isle of Wight, or to France for holidays and yacht racing.

George's career allowed him to meet people from all over the world: passengers and crew from the American depot ships he examined, not to mention the grand Cunard and Canadian Pacific liners sailing between Canada and Greenock carrying emigrants across the world. He also regularly visited the nuclear submarines based at Faslane on Loch Long, with their military and merchant navy crews from all over the world. For his young family, it made for a cosmopolitan social life, with various ships' captains coming for dinner at the house or taking them on days out. Louise would board ships with her father and learn about people from around the world and their lives. George would experiment on the family by shutting himself away in his new kitchen and preparing an exotic recipe he'd learned from a ship's chef. The hatch between the dining room and the kitchen would fly open and a flaming hot curry would find its way to the table for the family dinner amid fits of laughter when George regaled them with tales of smuggled monkeys and contraband.

George's parents were a constant presence. Although the creative side of his nature probably came from his mother, George took after his father in many ways. They shared a love of making people laugh and of music and making up songs. After he retired from the Machine Tool Company in Govan at the age of sixty-five, Andy's time was mostly taken up with his work for the Masons and in looking after the grandchildren. He was always whistling and playing games, while Harry worked away in the shop in Skelmorlie. Louise remembers a song Andy sang to them called 'Wee Jimmy Stodger' about a boy who burst because he ate too much, which always had the children in stitches. He had sung this to Ralston and Banks when they were wee boys

There was a sense of moving on in the Wyllie family when Andy died in 1965, aged seventy-five. He was always a reassuring presence in the family, kind and patient and loved by everyone who knew him. He used to tell people he'd come back as a robin after he died because it was such a cheerful and cheeky wee bird. (Robins would become a recurring motif in George's work.) Such was George's dedication to these birds that more than twenty years later, in December 1988, together with five unemployed youngsters from Greenock, he made 250 robins out of logs cut up on a local estate, added steel wire and roofing felt, painted them and placed them in front of the Assembly Rooms in Edinburgh's George Street. A speaker made a chirping sound all day. It was a fittingly paternal reference as George got a lot out of working with these young lads. Afterwards, George and the boys from Greenock sold the robins off for £2.50 each. That way, George said, the 'Famous Five' each got a bonus.

At the Bottom of the Garden

George was always happy when engaged in the art of making. He collected driftwood and discarded items from the beach and mounted them in sculptural form back in the house. He was so taken with the view of the ever-changing skies, the mountains, the sea and its traffic, he decided to return to sketching and drawing, which he'd last done seriously on the *Argonaut* during the war. This grew into oil paintings of the view, of houses and of docks, a new foray into the world of visual art.

One day, after George had amassed a small collection of paintings which depicted the view from McPherson Drive, he asked a friend with some experience of painting what he thought of his work. The friend replied that, in his honest opinion, they didn't work as landscape paintings because he'd made the classic

mistake of piling garden, sea, mountains and sky on top of each other – 'like a striped rugby jersey'.

These 'rugby jersey striped paintings', as George subsequently referred to them, could often be found down at the bottom of the garden, where they had been hurled off the balcony in a fit of temper. Frustrated with what he perceived as his lack of ability, he decided that making sculptures instead of paintings might be more up his street. He was influenced by an art exhibition of work by the Italian Arte Povera movement he went to see at Kelvingrove in Glasgow. In this exhibition, he saw how artists had made work out of old farm implements and other everyday objects through semi-engineering. Yes, he could do that, he told himself.

He promptly signed up for welding classes at evening school in Greenock's James Watt College and became a frequent visitor to the scrapyard in Gourock. He started welding outside the house on a good day, and under it, in his large basement, on a bad day. George's penchant for hoarding things (never far from the surface) was to return with a vengeance as the basement rooms slowly filled up with oddities from the scrapyard, the shipyard, the beach, the dump and anywhere else he could procure materials of interest.

After some minor successes, he decided it was TIME FOR ART. Daphne simply rolled her eyes and went with the flow. That was just the way it was for the Wyllies . . .

Opposite: George and Daphne in their first house in Gourock. It was an upper flat that looked out over the Firth of Clyde.

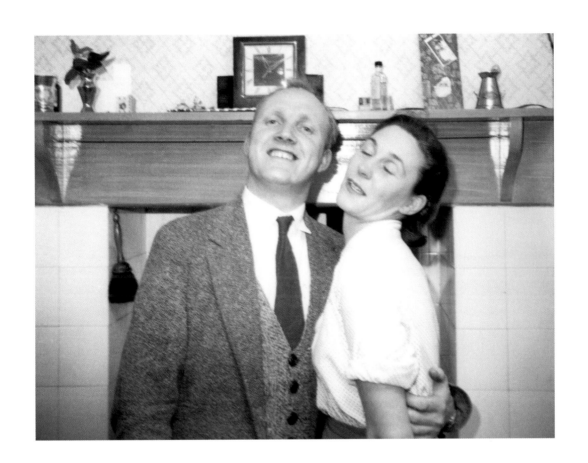

5 Time for Art

As the house George and Daphne owned was set high up on the Tower Hill, George could time exactly when a ship would berth at Greenock as it headed round the tail of the bank. On nightshifts George would go to the Customs Office in Greenock, settle down on a mattress and sleep until his alarm clock rang in his ear to indicate a ship was due to berth. This habit gave George extra time in his welding workshop, however combining being a Waterguard officer and a sculptor still proved difficult.

He was growing increasingly frustrated with the job. His Customs role had been a varied and diverse one, mainly involving boarding ships from all around the world and meeting their crews, but that was all to change, in January 1969, when Greenock became a busy freight terminal. The new £2.5m operation worked round the clock, and gone were the days of the very personal journey of people emigrating to the other side of the world. Now, it was vast anonymous containers of whisky being shipped to the USA. To add to George's frustration, on 1 January 1973 the UK joined the European Economic Community (EEC), and as a result his role changed significantly. He had to deal with mountains of tax-related paperwork and search no further than the inside of the dreary grey containers stacked up in the terminal. This was a far cry from George's beloved seafaring lifestyle.

Into the World of Art

George's first foray into the world of art was facilitated through an unusual channel. In 1967 George became very friendly with a young up-and-coming interior

Opposite: Together with footballer turned architect Ron McKinven, George started making quirky sculptures for interiors. This included a huge peacock for Motherwell United Services Club.

designer who worked for an architect in Edinburgh. Ex-footballer Ron McKinven had an exclusive client list and an eye for the unusual, and George was able to supply his quirky sculptures and sculptural-designed interiors to meet Ron's brief.

Alloa-born Ron was no ordinary footballer. While playing as an amateur with Glasgow-based side Queen's Park in the early 1950s he studied architecture at the Glasgow School of Art. It was there, based in the Charles Rennie Mackintosh-designed 'Mac' building that he developed a lifelong passion for both Mackintosh and interior design.

He played for Stirling Albion for a short while before returning to Queen's Park, ending his career as captain of Perth-based St Johnstone in 1966 at the age of thirty. By that stage, he had made over 250 appearances in the Scottish Football League and even represented Great Britain in the 1960 Olympics. His football career came to an end following a disagreement with St Johnstone's manager over underpaying youth players. A lesser known footnote in Scottish footballing history records that as club captain of St Johnstone during the 1960s McKinven gave a player called Alex Ferguson the chance to fill in during a clash with Rangers FC. Ferguson scored a hat-trick and went on to become one of the most successful managers of all time.

During his playing days, McKinven had been asked to take on a couple of interior design projects through contacts he had made off the pitch, and this, in turn, led him to the door of Edinburgh-based architect Schomberg Scott. Scott, who was in his mid-fifties by the time the two men met, came from a wealthy aristocratic background. The working-class, charismatic McKinven and the upper-class Scott presented an unlikely meeting of minds.

At the time, working from his practice in Forres Street, Edinburgh, Scott was the go-to architect for all work connected to Scotland's historic buildings. In 1965, not long before McKinven became involved with the practice, Scott had been retained by the National

Trust for Scotland (NTS). He had sat on the Trust's Architectural and Artistic Advisory Panel since 1953, and went on to be its Adviser on Architecture and Furnishings, Architect and Design Consultant, and finally Consultant for Architecture, Design and Furnishings. By the time McKinven encountered him, Scott's work for the NTS was taking up a substantial portion of his working time and despite repeated entreaties to join its staff, he doggedly retained his own practice. Scott had a bohemian streak that drew him to McKinven, not to mention a shared love of detail and craftwork.

In 1967 McKinven became a partner in Scott's practice, and its name was changed to Schomberg Scott & Ronald McKinven. This partnership lasted until 1974. McKinven brought a touch of heady 1960s glamour to the practice, specialising as he did in the design of commercial premises such as shops and nightclubs.

He met George at an exhibition in Glasgow, and the two men hit it off immediately. There was a surreal touch to McKinven's aesthetic sensibility; and he, in turn, introduced George to Schomberg Scott.

In 1967 Scott bought a crucifix which George had designed as part of his Ten Object Plan. The artwork, which George later described as one of his 'crusty objects', had been accepted for display at the Royal Scottish Academy in Edinburgh, and Scott bought it to place in Saint Matthew's, a new church he had designed in Barrow-in-Furness, Cumbria.

The handsome McKinven family – Ron, Ruby and their son Zak – soon became regular visitors to McPherson Drive. George was even chosen to be Zak's godfather. It was therefore a complete surprise when Ron seemed to disappear. He moved to Qatar and set up an architectural design business there. Many years later, in 2012, Louise was to track Ron down to Gloucestershire: Ron and Zak were helpful in recalling some of their collaborations with George. They installed a huge peacock and a Scottish pipe-band in Motherwell United Services Club, and created the interiors of the Birds and Bees pub in Stirling, La Bonne Auberge in Glasgow and many other restaurants, bars and clubs throughout Scotland.

Ken McCulloch, a self-made man and the entrepreneurial brain behind luxury Glasgow hotel and restaurant One Devonshire Gardens, the Malmaison boutique hotel chain and Dakota Hotels, was another influence. McCulloch first became a fan of George's work in 1975 when he commissioned some for his first venture, La Bonne Auberge wine bar, where it remains today. This was followed in 1976 by his ultra-stylish Charlie Parker's Piano Bar in Royal Exchange Square, Glasgow, where George created a large-scale Charlie Parker's band. This support was to give George some credence in Scotland; the connection and the subsequent commissions from McCulloch gave him a great deal of satisfaction and also a feeling that he was a proper working artist.

A thrusting young aesthete from the Edinburgh art scene during that era would also become a major influence in George's life. Although a decade younger than George, Richard Demarco was already an established figure in the Scottish arts scene by the time the two men met in the late 1960s. Edinburgh-born of Italian parentage, Demarco co-founded the influential Traverse Theatre in 1963, before going on to set up the Richard Demarco Gallery in 1966, which helped to introduce major European artists such as Joseph Beuys to the Scottish arts scene. By the time the two men met in Demarco's Melville Street gallery, George was slowly gaining a toehold in the Edinburgh art world, thanks to his work being accepted by the RSA and through his connections to Ron McKinven and Schomberg Scott.

George showed his Ten Object-style work in a couple of early group exhibitions at the Melville Street gallery, and the two men became friends – or perhaps more accurately, sparring partners. Their mutual friend, artist Dawson Murray, describes them as 'oil and water', but from the outset there was an acknowledgement by

both men that they could feed off one another's mutual interest in art as a vehicle for changing the ways in which society viewed itself.

One of the watershed moments in George's development as an artist was attending Demarco's palindromic *Strategy: Get Arts* exhibition at Edinburgh College of Art for the Edinburgh Festival in 1970. German artist Joseph Beuys, viewed by many as the father of contemporary conceptual art, took part in this exhibition at the behest of Demarco, and returned to Scotland a further seven times after taking part in it.

Pauline and the Clubmen

Throughout the 1960s, George had been developing another strand of his creativity. Now settled in Greenock and playing bass at Hasties Social Club, George decided that forming a trio might be the way forward. He was very friendly with Ewan Williamson, his landlord at his first rented property in Gourock, and Ewan also owned the large art deco Bay Hotel which sat on the pierhead at Gourock. The Bay Hotel played host to many 1960s bands who played at the Greenock Palladium and the Gourock Gragburn. Louise remembers the fun she and her friend Peekie Peacock had visiting the Bay Hotel to collect autographs from people like the Applejacks, the Hollies and many others.

George was to make the three large sculptural fish for the Bay Hotel bar that year. The fish were known as bumper fish, as they were made out of a job lot of

Above: *In late 1981, George and Daphne travelled to Düsseldorf to stay with Joseph Beuys. This picture was taken by the influential art gallery owner Richard Demarco, who introduced them. A sketch of Joseph Beuys by George shows the artists in his trademark fishing vest and felt hat.*

chrome car bumpers from the scrapyard in Gourock. In 1962, George, Bill Duncan and Charlie Erskine formed a trio known as the Clubmen. Ewan was eager to attract customers to the hotel and decided that wining and dining at the hotel was the way forward. He came up with the idea of the trio playing weekly dinner dances on Saturday evenings as well as for special occasions such as weddings. The Clubmen then recruited a twenty-two-year-old vocalist called Pauline Hair and changed their name to Pauline and the Clubmen. Pauline was a soprano, and George with his theatrical experience spent endless rehearsals trying to get her to loosen up and belt out numbers like 'Big Spender'. The Bay Hotel was to advertise the wining-and-dining experience as a distinctive Spanish evening with soft lights, sweet music and a three-course dinner served with all the trimmings, concluding with a bill for fifteen shillings at the end of the evening. In 1963 the 'stars' – as they were referred to – supported the local Boys' Brigade band at a fundraising concert in Cragburn, and of course the Clubmen were in there with ballad singer David Hughes from the TV series *Make Mine Music* who was currently appearing at the *Five Past Eight Show* in Glasgow's Alhambra Theatre.

George loved playing in the band, although the circuit, which included the Bay Hotel, took in other west of Scotland hotels and was demanding on all the members and their families. The live music scene was changing as the demise of the shipyards resulted in a lot of the social clubs closing down (including Hasties). The Bay Hotel was also to change hands as Ewan sold up and moved south. The building was eventually demolished in the 1990s but not before it hosted bands like Manic Street Preachers and Blur in their early days.

Above: George and Daphne's neighbours in McPherson Drive grew accustomed to seeing strange sights such as this large dolphin made of bumpers being loaded into a van.

Sneaking Things into Galleries

In the 1970s George went on to produce artworks that attracted large audiences, partly due to his satirical approach, which was often seen as humorous. However, he was in danger at the time of being almost too whimsical and 'playing to the gallery', as he had done in his youth with music and performance. Today, these works are often seen as a form of knockabout humour as he strove to find his place in the art world. His portable palms set on their own beds of sand trolleys and pulled along by heavy chains (*Portable Palms*, 1972), later exhibited at the Serpentine Gallery in London and the Royal Botanic Garden in Edinburgh in the early 1980s, were examples of this humour.

George's first real arts project was to embark on his self-declared Ten Object Plan. He insisted on complete creative freedom for himself in the making of these artworks. There were enough other restrictions to the form of his equipment, tools and materials. The objects included *Mortgage Climbing the Wall*, *A Dancing Lamppost*, *Bishop Rock* and *A Canary with Its Foot Stuck in a Girder* (attributed to Daphne and her frequent visits to the hospital with broken fingers and toes, due to dropping heavy sculptures). In those days George's artworks were made of mild steel and some were painted, which meant he could work at home. (He had created a welding workshop and store beneath the house.) The steel was often supplemented with odd shapes and cut-offs from anything metal and thus visits to the local scrapyard became an integral part of his life. He would be pleased to know that seven tons of this material was recycled back to the scrapyard from whence it had come when his daughters and their friends cleared out the workshops at his house. He collected tools over the years, as he did he every nail and nut. Often installations were recycled after an exhibition. Nothing was wasted.

His initiative was to pay off. The last of the ten objects he made was *Crucifixion*, which was accepted by the prestigious Royal Scottish Academy in 1967 into their annual exhibition. It was then purchased by Schomberg Scott, who had it mounted in a church in Barrow-in-Furness that he was working on at the time. The other objects, although not all formally exhibited, found a home whether sold or given away. It was from then on in that George learned the importance of creating his own destiny. He had a need for self-belief and confidence in oneself, even, as he put it, to have been 'a successful failure'. He always appreciated a little scribble by London cartoonist Noel Coleman, of a woman on the phone with the caption, 'He hasn't let failure go to his head'.

By the end of the 1960s George had enjoyed participating in a group exhibition at the newly opened Richard Demarco's Gallery, in 1966, a solo exhibition in the Arts Centre, Irvine, in 1968, and had made numerous sculptures such as his *Crucifixion*, *Bumper Fish*, *Electra*, Motherwell United Services Club crest and *Agnus Dei*.

With renewed confidence in the 1970s, he embarked on a prolific schedule of creating art. His welding flashes on the hill could be seen from all around, including from ships sailing up the Clyde – some which hooted their acknowledgement. In 1991, Cordelia Oliver, his friend and the *Guardian*'s influential art critic, reflected on his work at this time. She wrote:

> George Wyllie's lively and imaginative intelligence seems to generate ideas like soap bubbles from a small boy's clay pipe, some astonishingly substantial amid a lively multitude of iridescent froth . . .
>
> Where another artist equally given to spawning morsels of social comment or visual satire might take pen and paper to create a pointed image or linear fantasy (of such are Saul Steinbergs and Rowland Emmetts made) Wyllie would descend into the workshop he secretes in the undercroft of his home on a Gourock hillside, select a few items from

the clutter of iron, steel and other oddments, don his Ned Kelly headgear and proceed to materialise his concept in three dimensions by welding together an object that might extend to several feet in all directions.

One of George's closest friends from the art world was the Glasgow School of Art-trained painter Dawson Murray, who was working as an art teacher when they first met in 1974. The two men would go on to collaborate on a major public artwork in 1999 inside Glasgow's Buchanan Street Galleries (see page 129)

Although George was the elder by some twenty-five years, Murray recalls that as George began to feel his way in the art world, he would regularly turn to him for down-to-earth advice. Both men were friendly with Richard Demarco, who recognised a spark in them which was pushing against the grain of traditional approaches to making art.

'George's friendship with Ricky Demarco changed as George became more confident in his own abilities,' Murray explains. 'Ricky initially called him George Douanier Wyllie, after the famous French primitive painter, Douanier Rousseau, who was also a customs officer. I think George enjoyed that at first, but not later on! I was always piggy-in-the-middle with the two of them. There was always a bit of point scoring to be done when it came to the way they both worked.

'Later, as George became well known, I became his history of art resource. He would often phone me up and say, "I'm on Radio Scotland tomorrow – what do you know about such and such?" It was quite a laugh because George had made such progress in the world of art without having a formal background in the history of art. He knew the bits he liked, such as Dadaism and Surrealism, but was very shaky on some of the other major movements in art!'

Cutlery Goes Missing

He became renowned locally, and with thankfully understanding neighbours, George went on to produce work he felt confident enough to put on public view. Louise Wyllie remembers awkward times when friends and particular boyfriends came to visit the house and her father would emerge from the cellar looking like Rab C. Nesbitt on a bad day, clothing peppered with holes from the welding torches. There would be a giant knife and fork on the living-room wall and a crocodile in the corner chomping on wine glasses. There was either loads of conversation or none. Daphne went to lay the table for her guests on one occasion only to find all the knives and forks missing – gone into a sculpture earlier in the day!

Family life had changed for ever. Gone were the days of sailing and racing his fourteen-foot dinghy up and down the Clyde every other night. The boat was sold, and Daphne didn't bother too much, after many soakings at sea while crewing for him. Neither did his daughters, who earned their pocket money sanding it down every season. He announced one day that he was a Surrealist, and after Louise accompanied him to a meeting of artists at Dawson Murray's house, she was concerned about what exactly this meant for them all as a family. After life in an orderly traditional household, to be told it was okay to shout out and to break rules – which is what she embarrassedly had to do at Dawson's – made her feel, for the first time, that she'd lost her dad to art.

In the 1970s his love of all things transport-related and nautical burst onto the scene with steamboats, yachts, planes, tram cars and trains of all descriptions, and in all possible places, scenarios and situations. These too could be seen as overly emotional or indeed still whimsical, but every now and then a sculpture would emerge that hit the target. One such sculpture was a tram car winging its way to the 'great terminus in the

sky'. Glasgow Corporation Tramways were formerly one of the largest urban tramway systems in Europe; by 1922 around 1,000 trams served the city over one hundred route miles. On 4 September 1962, George was not the only emotional witness to see the last tram in Glasgow make its final journey. Some 250,000 people turned out to see many of the trams paraded through the streets of Glasgow and the sight affected him deeply. *Towards The Great Terminus* was purchased by the Transport Museum of Glasgow for their collection in 1970.

George applied for Scottish Arts Council funding in 1976 for a show at the Third Eye Centre, but he was refused. Still struggling as an outsider in the art world, he managed to secure an exhibition at the Collins Exhibition Hall in Glasgow's Royal Technical College, ironically reflecting its founder John Anderson's aim to provide inclusive education, regardless of students' backgrounds or formal qualifications. Mounted in 1976, a full three years before he became a full-time artist, this was the event that gave first sight of his signatory reinterpretation of the question mark, ultimately moved to its rightful place at the 'centre of everything'. This first exhibition was called *Scul?ture* (he said he was never sure what sculpture was and so he took the P out and replaced it with a question mark). He liked to suggest that the question mark was placed in the centre of the word 'sculpture' as a means of tackling the question head-on rather than at the end of a word.

Page 112: George was always sketching out ideas – some like this 10 Locos series ended up as completed sculptures; some did not.

Page 113: An early sculpture called Promontory Point *was influenced by stories from George's boyhood of his uncle, Sidney Graysher, who made his fortune in America building railways.*

Page 114: Making annual trips to George Rickey's Hand Hollow Foundation in East Chatham, a hamlet in New York State during the mid-1980s, George drew inspiration from the cowboy and Indian films of his youth to make work such as this carved Indian head.

Page 114: In 1992, George made a 12ft high paper temple to celebrate Stirling-based Weir Products' third anniversary. It was placed in Princes Street Gardens in Edinburgh.

Page 115: George made a giant safety pin (Just in Case) for Glasgow arts festival Mayfest in 1996. It found a premanent home in 2004 at a site once occupied by Rottenrow Maternity Hospital, which is owned by the University of Strathclyde, ad was renamed Monument to Maternity.

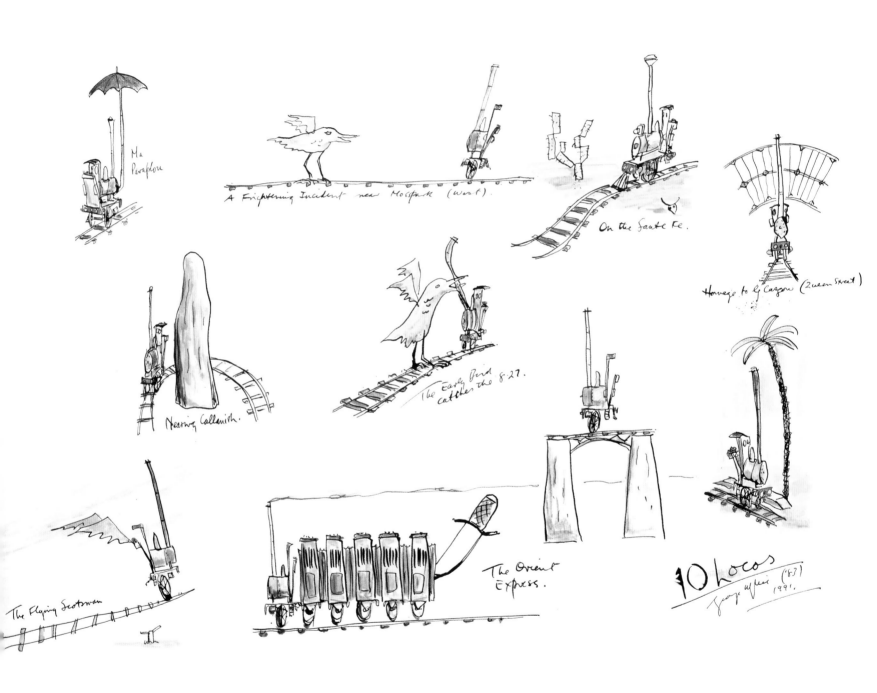

Ma Parapluie

A Frightening Incident near Mosspark (West).

On the Santa Fe.

Homage to Cy Capon (Queen Street)

Hearing Callanish.

The Early Bird catches the 8.27.

The Flying Scotsman

The Orient Express.

10 Locos ('83)
George Wyllie 1991.

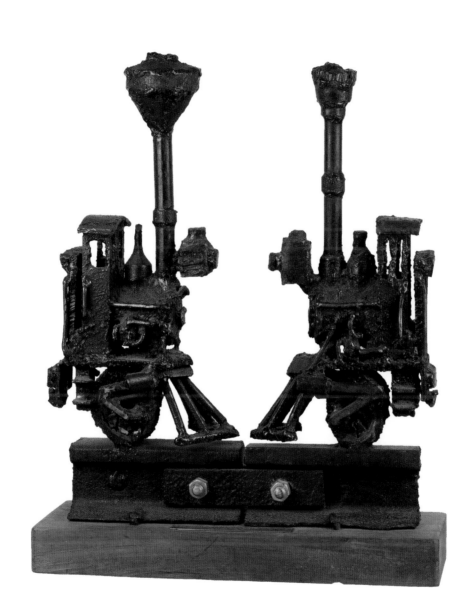

6 The Scul?ture Movement

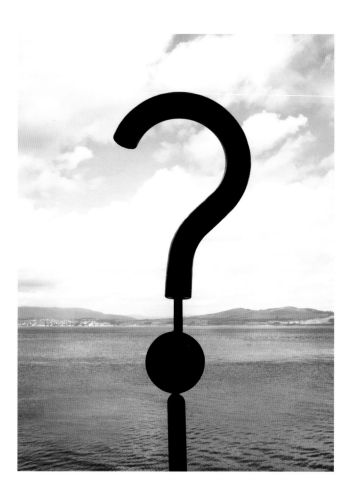

George was always ahead of the curve. So much so that the 1980s started for him on 4 May 1979. On that day, the political landscape of Britain changed completely when the Conservative Party gained a landslide victory over Labour in the General Election. From their eyrie-like home on Gourock's McPherson Drive overlooking the Firth of Clyde – the perfect platform for viewing Polaris nuclear submarines patrol the Holy Loch – George and Daphne watched the coverage of Margaret Thatcher's assent to power on television. On the steps of Number Ten, Thatcher, a grocer's daughter from Grantham in Lincolnshire, quoted Saint Francis of Assisi: 'Where there is discord, may we bring harmony. Where there is error, may we bring truth. Where there is doubt, may we bring faith. And where there is despair, may we bring hope.' For George, it was a call to arms. He would spend the best part of the next decade trying to highlight the shortcomings of Thatcher's hard-line right-wing policies. The heart of what would become known as Thatcherism was an unerring belief in a free market economy and a small state, not to mention the defence of her realm with nuclear weapons. As his working life as a civil servant ended, George knew instinctively he should make it his business to question the absurdities Thatcher and her government were about to unleash. With the question mark already firmly tucked into his armoury, not to mention his newly coined description of himself as a 'scul?tor' on his CV, George would make it his business to ask big questions of the powers-that-be through his art.

George officially retired on 31 October 1980, exactly two months shy of his fifty-ninth birthday. His pension of £4,291.68 per annum (roughly £16,000 in today's

Left: The question mark became an integrated part of George's work – a trademark – and popped up in various guises during the course of his late-flowering career.

money) would ensure a comfortable enough living for him and Daphne now that Louise and Elaine were getting on with their own lives and no longer needed financial support. The old guard of the Wyllie/Mills family was also moving on. In her latter years, George's mother suffered from dementia, which was a constant worry for her sons. She came to stay with George and Daphne for a while but the illness proved too difficult to manage as she became aggressive, particularly towards Daphne. Harry would sometimes escape from the house and be found miles away. Daphne was so stressed by the experience that her hair fell out. Harry died on 30 March 1979 at the age of eighty-four. George and Banks were the beneficiaries of her will and she left £38,000 (£190,000 in today's money) to be divided between her two sons. Banks took over her shop in Wemyss Bay as part of the settlement. George and Banks continued to look out for their mother's elder sister, Aunt Molly, who lived in a home in Largs until her death in her late nineties. George retired confident in the knowledge that he could get on with making art which didn't have to be about making money. His innate ebullience and his experience of being involved in artists' societies such as the Glasgow Group and the Society of Scottish Artists (SSA) had convinced him he could make a go of being a full-time artist. His connection to Richard Demarco had also led George into avant-garde art surroundings and he rather liked the lie of the land.

Although naturally gregarious, George swung between being completely at home in this world to feeling like an outsider due to his lack of formal art school training. Only Daphne and his closest friends got to hear about these flashes of self-doubt, as he proceeded to unleash a tornado of creative energy that often saw him juggling several projects at once. He sketched out his ideas compulsively on any piece of scrap paper to hand – although ever canny, like most people who had lived through the Depression and the war years, he used up

old notebooks and ledgers from Customs and Excise in the process. He carried a canvas satchel everywhere he went filled with a tiny tray of watercolours, sketchbooks, pencils and pens. Around the time he became a full-time artist he began to wear a bunnet (a flat cap), which became his trademark. He was never seen in public without a cap, which he wore until it was crusty, much to Daphne's horror. At one point, he picked up a couple of bales of Harris Tweed when working in Lewis, and had a gold-coloured tweed suit made from them. This, and an emerald-green jacket, became his outfit of choice when he wasn't forging away in his basement workshop. His family, particularly his daughters, used to tease him about his bad taste in clothes and would take him shopping. To no avail. He would wear his clothes until they fell apart. Although he would never admit to it, he was colour blind, which his daughters also felt went some way to explaining the green jacket. His idea of being stylish, which probably harked back to his Navy days, was anything blue. Daphne checked his socks before he went out because he always had holes in them from welding and she would be mortified to see him on a stage doing a talk with gaping holey socks on show to all and sundry. Daphne was always a loyal and willing first mate, albeit a long-suffering one. She welcomed a constant stream of visitors to McPherson Drive with tea and cake and went everywhere with him. In 1979, George managed to build a verandah and a patio to the rear of the house, but throughout the 1980s and 1990s he was on fire with ideas and literally never stopped making.

Everything he encountered found its way into his art. Music still played a huge part in his life and he played his double bass regularly at a couple of jazz clubs in Greenock. He was also playing gigs with the Glasgow School of Art Jazz Band by the start of the 1980s, often joking that it was the closest he ever got to going to art school.

Putting on a Show

As well as opening doors to prestigious exhibition spaces, George's association with Edinburgh gallery owner and one-man cultural dynamo Richard Demarco had opened his mind to new ways of making art. George described Ricky as a 'rocket without a stick' because of his ability to set off small fires that led to much bigger things. Because of Ricky's connections across all art forms, the association also introduced George to artists, actors and writers such as Paul Neagu and Dawson Murray. Ricky's *Strategy: Get Art*s event for the 1970 Edinburgh International Festival had been a watershed experience for George and for many of the people who saw it that summer. The title in itself was a cheeky (almost) palindrome designed to wind up the bureaucrats who ran cultural events at the Festival and beyond. It featured work by thirty-five artists from Düsseldorf, including Joseph Beuys and Gerhard Richter, and brought the full force of conceptual art to Edinburgh for all to behold and for many to condemn. George was particularly struck by Beuys' 1969 work *The Pack*, which consisted of twenty-four sledges resembling a pack of dogs tumbling from the back of a Volkswagen van. This was the first major exhibition of avant-garde German art since the war ended. For George, the former sailor, who three decades earlier had held on to a German soldier's hand and watched him disappear into the water as his ship moved on, it presented an almost Damascene vision of art as a means of bringing about social change through 'actions' and installations. This was art which appealed to George's innate sense of humanity and of 'putting on a show'. The Daddy of it all was Beuys, a former radio operator in the Luftwaffe who, like George, had been born in 1921. As well as being a renegade artist-philosopher with a penchant for weaving a fabulist tall tale or two, Beuys was a political animal and founding member of Germany's Green Party. As a mature artist, he became preoccupied with the idea of shamanism, an ancient practice which sees a spiritual leader figure invoking his followers to connect to nature and promote harmony within all creation. A key aspect of shamanic practice was journeying, ceremony and pilgrimages to places of power in nature. On his first visit to Scotland in 1970, Richard Demarco took Beuys to Rannoch Moor, a wild expanse of boggy moorland which Beuys declared was 'the last remaining wilderness in Europe'. This seminal trip inspired much of Beuys' thinking on Celtic mysticism. It also led George into a way of thinking about art that he was to refine and develop as the twentieth century – a troubled century if ever there was one – drew to a close.

Although he was aware of Beuys' work and increasingly influenced by his approach to using everyday 'found' materials in his art, George didn't actually meet Beuys until 1981. In August that year, Richard Demarco brought Beuys to Edinburgh to work on what became the *Poor House Door* installation. Ricky asked George and his friend, painter Dawson Murray, to assist Beuys in creating a sculptural work that saw them remove the dilapidated former Edinburgh Charity Workhouse doors from the Forrest Hill building and transfer them to Inverleith House in Edinburgh's Botanic Garden, which was then the home of the Scottish National Gallery of Modern Art. To the existing doors, Beuys added a red lightbulb underneath a small hole at the foot of the left-hand side of the double doors. George revealed years later that the

Opposite: In August 1981, Richard Demarco brought Joseph Beuys to Edinburgh to work on what became the Poor House Door *installation. George and his friend, painter Dawson Murray, assisted Beuys in creating this sculptural work.*

doors, now in the collection of the Municipal Museum of Mönchengladbach, were secretly signed in pencil on the back by himself and Dawson because they felt they had done so much work on them.

George and Daphne travelled to Düsseldorf in late 1981 to stay with Beuys at his home in the city, cementing a friendship forged in a shared view that art could facilitate social change. It was a friendship, which as young servicemen fighting on opposite sides during the Second World War, neither could have imagined would have been possible. When Beuys died at the age of sixty-five in 1986, George led a party of thirty people to Rannoch Moor, which included Ricky and their mutual friend, art critic Cordelia Oliver. There, George erected a spire made of wood and stone as a commemoration of Beuys' initial visit in 1970 and his attraction to this brooding and atmospheric wilderness.

In 1999, thirteen years after Beuys' death, George wrote this about his old comrade in arts, in the *Sunday Herald* newspaper:

> He was a constructive disturber of the peace, a raw but highly intelligent artist, a man for all good causes. The regeneration of human and planetary energies was central to his imagination. He proclaimed 'Everyone Is an Artist' – not advocating more and more paint brushes, but the adoption of the attitude of the artist for all trades, professions and vocations.

Above: Rannoch Moor, where George and friends erected a spire as a homage to Joseph Beuys. **Opposite:** *A robin in a cage refers to George's connection to the birds. His father had said that George would come back as a robin after he died. This work is also inspired by William Blake's poem 'Auguries of Innocence', which contains the line, 'A Robin Red breast in a cage, Puts all Heaven in a Rage'.*

A Way With the Birds

The liberation George felt at being able to pursue his art on a full-time basis led him to make connections and form firm friendships with many like-minded souls. He may have been in his sixties, but he had the energy of a man half his age. His gregarious nature helped, of course, not to mention his ability to get on with people of all ages from all sorts of backgrounds and cultures. In 1981, as well as his work with Beuys in Edinburgh, he exhibited with Dawson Murray at the Stirling Smith Museum and Art Gallery in a show called *Counterbalance*. For this thoughtful exhibition, George made sculpture in response to Dawson's paintings and vice versa. Years later, in 1999, George and Dawson revisited this idea of responding to one another's work with a monumental installation in Glasgow's brand new Buchanan Galleries shopping centre. In this work, *Divine Rythm*, George suspended a 400kg stone on a stainless-steel beam in front of Dawson's painting of the earth's strata. It was underpinned by a quotation from Hugh MacDiarmid's poem 'On a Raised Beach'.

In 1981, George also had another solo exhibition at Strathclyde University's Collins Gallery called *A Way with the Birds*, which travelled on to London's Serpentine Gallery, where it was a major attraction during the summer months. This was George's first big exhibition in London and it attracted press attention on an unparalleled scale, especially outside Scotland. This included an appearance on the BBC's popular early evening current affairs programme *Nationwide*. He started to receive fan letters and he made sure he answered each and every one of them. The exhibition's title was a nod to George's continuing fascination with making birds from steel – or 'burds', as he referred to them, in the Scots vernacular. *A Way with the Birds* featured several portrayals of birds, including *A Robin in a Cage*, a simple yet poignant little steel robin – with painted red breast – trapped in a cage.

George and Daphne always used to wonder if his attraction to creating birds or featuring them in his work had something to do with Andy's influence from beyond the grave. One of the most memorable feathered friends George made was his *Berlin Burd*. This gangly big bird was commissioned in 1988 by the City of Glasgow as part of the European Capital of Culture celebrations that year in Berlin. George sited it at the Berlin Wall at Reinickendorf where it peered over into what was then Communist East Berlin. He invited schoolchildren in West Berlin to participate by making their own birds for display alongside his own five-metre tall bird. Ironically, or perhaps prophetically, the wall came tumbling down just two months after George's *Burd* was planted on its lofty vantage point. The *Berlin Burd* combined an educational project with street theatre and art-with-a-message and George revelled in its surrealism. The planning powers-that-be in West Berlin were reluctant to allow him to install the *Berlin Burd* initially, but he reminded them that 'ein Vogel ist kein Stein' or 'a bird is not a stone' and that students would not be throwing it in demonstrations. He later wrote about the experience: 'I think the bird looking over the wall in Berlin was quite good. I said to this German, "This wall's a bit stupid really, because there's Germans on this side, Germans on that side, and we're all really together, except this wall's keeping us apart. It's an absurdity." "You're right," he said. "It takes one absurdity to question another."'

One of the biggest hits at George's *A Way with the Birds* exhibition was the Heath Robinson-esque *All British Slap and Tickle Machine*, a kooky contraption with a recycled bicycle seat for people to sit on, operating pedals, a welter of floppy leather hands and a somewhat risqué tickling finger. George told the media this machine was designed to prevent the loss of 'a sense of joy in things' during the Thatcher years. George's gift for making people laugh brought all sorts of visitors into galleries who had never visited one before. The Serpentine Gallery staff were amazed at the laughter ringing through the space during the exhibition's run in London. George knew, from his lifelong fascination with performance, that humour was a way to permeate people's hearts and minds.

Around this time, George met Barbara Grigor, a charismatic film and television producer as well as an art lover, who had set up an organisation called the Landmark Sculpture Trust, later the Scottish Sculpture Trust. At that point, together with her husband Murray, Barbara ran a film company called Viz. George didn't meet Murray until a few years later, but all three would go on to enjoy a fruitful and life-enhancing friendship. Murray recalls his late wife (Barbara died in 1994 at the age of just fifty), coming home from George's first solo show at the Collins Gallery in 1976 'completely bowled over by his work and his wry wit'. According to Murray, 'They really got on so well because Barbara shared George's attitude to the mandarins of Scottish art who seemed always to be obsessed with reshowing London exhibitions in Scotland. "Pioneering Old Hat," as Barbara called it. She invited George onto the board of the Scottish Sculpture Trust, which greatly livened up meetings.'

George also got to know jazz musician, art critic and fellow lover of Surrealism George Melly. The two men shared many interests and met up whenever they could. In September 1982, Melly sent George a letter headed 'Dear George the Pataphysician', which alluded to their shared passion for the work of surrealist French writer and philosopher Alfred Jarry. Jarry was the man responsible for coining the term 'pataphysics', meaning 'the science of imaginary solutions'. Referring to having just read George's *A Day Down a Goldmine* script, Melly writes: 'You're right about usury of course. You can't eat it, make love to it or take it with you and yet it runs, very badly, the world. All it's good for is to spend & I'm very proficient at that, hence the squirrels' wheel.'

Distant Horizons

At the tail end of 1980, Barbara introduced George to American kinetic artist George Rickey. Rickey was fourteen years older than George, but the two men struck up an instant friendship, each recognising in the other a kindred spirit. Although born in the USA, Rickey grew up in Helensburgh. His father's job as a senior executive with the Clydebank-based Singer Sewing Machine Company had taken his family to Scotland in 1912, when Rickey was just five years old. Like George, Rickey had worked as an engineer in the war, and his sculptural work combined engineering and mechanics to great effect. His kinetic sculptures were beautifully realised feats of engineering that relied on the elements to give them life, almost like giant mobiles responding to air currents. His work, a retrospective of which was mounted by Barbara Grigor along the banks of the River Clyde in 1982, resonated with George on many levels. The two men went on to form a friendship that lasted until Rickey's death in 2002 at the age of ninety-five.

Rickey invited George and Daphne to the USA in the summer of 1982. It was the first of several residencies George took up at Rickey's Foundation in East Chatham, New York, and it offered an invaluable and challenging opportunity to create work in direct response to a rural environment alongside other

Top: To celebrate Gruinard being declared germ-free by the Ministry of Defence, in April 1990, George travelled planted a spire on the along with his friend, Murray Grigor, who was filming it for his Why?s Man *documentary. This photograph shows (left to right), Murray Grigor, Daphne, George and Barbara Grigor.* **Bottom:** *In September 1988, George went to Berlin, taking with him a 5m-tall* Berlin Burd *made from stainless steel. It peered over the Berlin Wall. The following year on 9 November 1989 the wall was knocked down.*

international artists, including landscape architect
Jens Jensen. Other people whom George had got to
know in the art world obviously thought that his work
would travel well to the States. In a letter to George,
dated 7 January 1981, Edinburgh gallery director
Tom Wilson, who had exhibited George's work at
Henderson's Gallery (and later at the Open Eye Gallery
in Edinburgh), wrote to George to say that meeting
Rickey could prove a turning point in his career.

> It really is great news that you met George Rickey.
> I looked him up after you phoned. He is obviously
> one of the great American sculptors to emerge from
> the Second World War [. . .] with introductions into
> New York it should be marvellous [. . .] you really
> should take advantage of the connections for simple
> reasons that America would be the place for your
> work to really take off.

At East Chatham, George made two major installations:
A Church for an Invented God, in 1982, and one year
later, *A Temple of Fertility*. The *Temple* installation
was made to express George's increasing focus on
environmental issues and took the form of a 'grove'
of rusted steel trees on which were hung toilet rolls,
weathered to appear like the wood from which they had
evolved. The experience of working in the US made a
major impact on the way George approached his art.
He wrote about his work there: 'The two materials I like
best are for these reasons; one is an eternal material, and
one is as modern as one can get in a practical sense. The
first is stone, and the modern one is stainless steel.'

Right: *George's expeditions to America sealed a lifelong love
affair with American culture and provided a raft of inspiration
for a new body of humorous work, much of it – such as this
work – inspired by his boyhood hero, all-American movie
cowboy Tom Mix - 'the cleanest cowboy in the west'.*

Many elements from these two installations were reintroduced in subsequent artworks which George made when he returned home. George was very excited about the possibilities of working in stainless steel, and despite it being expensive, he went on to forge many large new works, outsourcing it to Greenock Welding Company, with whom he formed a close working relationship. He was making much bigger artworks by this stage, and around this period, the spire entered into his art. He went on to amass an expansive collection of kinetic spires, of all shapes and sizes, which responded to the natural world in a simple yet profound fashion. He sited them throughout the UK and abroad, and even made his own portable spire, which he slung over his shoulder like a gun in a leather pouch (which, of course, he'd made himself).

Over several summers, George and Edie Rickey introduced their new Scottish friends to their own friends, including Tom Freudenheim, then director of the Worcester Art Museum in Massachusetts. At the time, Freudenheim (who later went on to play leading roles in the Smithsonian in Washington DC and the Jüdisches Museum in Berlin), was a trustee of Rickey's Hand Hollow Foundation in East Chatham. He was immediately struck by the originality of George's work. Many years later, in an email to their mutual friend Murray Grigor, he observed that George's work had 'a sensibility that combined the aesthetic principles of earlier Dada artists with a unique imagination that wasn't limited to any single medium'. George, he said, 'absorbed visual messages from American Shaker traditions and cowboy movies, from Glaswegian

Left: Over several summers, George worked at George Rickey's Hand Hollow Foundation in East Chatham. Harking back to the America of his youth, a world of cowboys and Indians, this 1986 work Where Are The Indians *was sited at Hand Hollow.*

shipping and Scottish industry, as well as from a depth of understanding traditional western art, all the while embedding his ideas in a very personal artistic language.' Freudenheim, who bought several works from George, including a Shaker stove (which worked perfectly) offered him an exhibition at the Worcester Art Museum in 1984 and the exhibition, called *As Others See Us*, was well received by critics and visitors alike. Recalling this exhibition to Grigor, Freudenheim wrote: 'Here was a foreigner with a twinkle in his eye and great personal charisma whose art communicated directly with New England audiences (who are not always as open as New York art audiences).'

George's head was turned in more ways than one by his American adventures. At the age of sixty-two he found himself the subject of what Daphne described later to Louise as 'adulation' from one woman in particular whom he met on a solo trip to the US. The woman corresponded with George, and it became a bone of contention between Daphne and George for a while, causing friction in their otherwise harmonious marriage.

In terms of his art, George's expeditions to America sealed a lifelong love affair with American culture and provided a raft of inspiration for a new body of humorous work, including a limited edition comic book, featuring George's boyhood hero, the all-American movie cowboy Tom Mix. Always a 'clean fighter', he was represented by a soap-firing pistol, a holster filled with bars of soap, and a large white Stetson. He presented this work for Glasgow Arts Centre's touring exhibition *Americana* in 1986. After the exhibition, the work ended up in the upstairs bathroom at McPherson Drive, causing visitors to end up much longer in the bathroom than was customary.

Daphne was ploughing her own artistic furrow in the 1980s. She began to organise regular exhibitions at the Greenock Arts Guild, which George had done, with Daphne's help, for a while. As he got busier with his work, Daphne took over completely. She used to get annoyed when George tried to interfere because she regarded it as her own project and she was good at it. She gave many artists exposure over the years in these exhibitions, including a young woman from Gourock called Anne McKay. McKay, who is still making a living from working as a full-time artist, graduated from the Glasgow School of Art in 1987. She recalls Daphne as a 'lovely lady' who gave willingly of her time and energy, 'especially when it came to young artists'.

Excavating Down a Mine

George was always working on several projects at once, multitasking before the phrase had even been invented. In 1981, Chris Carrell, then director of pioneering Glasgow cultural hub the Third Eye Centre, invited George to mount an exhibition in July and August of the following year. According to a booklet published at the time of the exhibition, the original idea was that George would create 'a suite of sculptures or installation' consisting of 'humorous sculpture with a deeply serious vein running through it'. Taking a leaf out of Joseph Beuys' book, and building on his own passion for performing, George had the idea of augmenting the exhibition with a theatrical experience. Assisted by a Scottish Arts Council grant, he and Daphne decanted to the Greek island of Paros, where George wrote an early version of what would eventually become an award-winning play called *A Day Down a Goldmine*. The exhibition came first though, and the theme, fired up by George's increasing ire at Margaret Thatcher's economic policies, was mankind's never-ending pursuit of power through the accumulation of wealth.

George wrote the text in the form of a comic lecture, and his original plan was that he and an actor would perform it over two nights at the start of the exhibition. On its own, the exhibition was a riot of ideas and knockabout surreal humour. At the entrance to the *Goldmine*, visitors were met by a sign warning them to

'Be Suspicious!' George's assertion that money was the root of all evil was given a voice. His exhibits included: an alchemist's machine for turning base metal into gold; a telescope to view the earth through a slab of gorgonzola (made from rusty steel); a do-it-yourself *Machine for the Equal Distribution of Wealth* (with a spanner in its works); various rusty eagles (a nod to the emblem of several big banks); picks and shovels; and a monument to the 'greatest of the Greeks' invented gods, Trestacles'. This fictional Greek god was represented by three golden balls recumbent at the base of a phallic-style column, sited at 'Delos, Valhalla of Bank Clerks'. The performance aspect of the exhibition took place over two nights, 6 and 7 August 1982. The ticket price included a three-course supper and wine. Reviewing solely the visual art aspect of *A Day Down a Goldmine* in the *Glasgow Herald* on 3 August, its influential art critic Clare Henry wrote: 'The danger is that unless you pay sufficient attention and take this clowning seriously you will miss a lot. The ideas in the exhibition sometimes come too thick and fast, or are left unresolved.' It took the Brechtian-style clowning of George and Scots actor Russell Hunter to bring the show to life. In the performance, Hunter delivered the 'lecture' while George, in a cap, dungarees and huge gold-painted boots, indicated the exhibits in question.

A Day Down a Goldmine was George's first real attempt to counteract what he saw as an absurdity with another absurdity. 'An incorrect assumption leads to a false conclusion' was the play's refrain. In other words, if we fool ourselves with minor absurdities, what happens when there are really major issues to deal with.

Top: *Daphne and George in a scene from Murray Grigor's award-winning film for Channel 4,* The Why?s Man *(1990).* **Bottom:** *In 1985, at the Edinburgh Festival, Bill Paterson and George starred together in* A Day Down a Goldmine, *a two man play written by George which was a critique of the global banking system.*

Three years later, in 1985, with the script reworked and fine-tuned by acclaimed Scottish actor and director Kenny Ireland, George took *Goldmine* to the Edinburgh Fringe. The role of Goldbunnet was played by George, while Bill Paterson played The Guide. Tony Gorman, a schoolteacher and friend from George's jazz club in Greenock, provided an atmospheric soundtrack. George relied on friends from his jazz club, such as Tony Gorman and Willie 'Burd' O'Neill, who played saxophone. The play was a sell-out and won a coveted Fringe First Award. It went on to have a life of its own throughout the 1980s at various venues, including the ICA in London, and the Tramway in Glasgow in 1990. George always played Goldbunnet, although The Guide was played by various actors, including John Bett in the final production at Tramway. Bill Paterson reprised his role in Murray Grigor's 1990 film *The Why?s Man*, which took viewers on a surreal odyssey around George's whole approach to making art. In the film, George featured in many roles; he even played himself as a Customs officer and as a tourist talking to his Customs officer self. A highlight of the film is George playing his trusty ukulele singing 'The Bum Steer' song from *Goldmine*: 'When the enlightenment of the human race goes wrong, you're on a bum steer.'

Herculean Grandchildren

As George steered his career as an artist in all sorts of weird and wonderful directions, family life also ebbed and flowed. With the passing of both sets of parents, George and Daphne were now the old guard. A new

Opposite: George's play, A Day Down A Goldmine, *refined by director Kenny Ireland, was an award-winning hit during the 1985 Edinburgh Festival Fringe when he and Bill Paterson performed it at The Assembly Rooms in the city.*

generation, in the shape of their grandchildren, started to appear. Their first grandchild, Jennifer Louise, was born to Elaine and her husband Campbell Aitken on 22 April 1983. Later that same year, on 3 November, Louise gave birth to a son, Calvin Michael Ralston Gomes. Two years later, Louise and her then husband, Farley Gomes, had another son, Lewis Mercer Gomes.

George's three grandchildren have diverse memories of their grandfather. Jennifer grew up in Greenock, close to Daphne and George, and had more contact with them than Louise's children did. Louise's boys only visited in school holidays as they were born in Manchester and spent their formative years there. Jennifer recalls how as a shy youngster, her gregarious grandfather used to push her into taking part in activities such as elocution lessons or playing the piano and reading books.

I was never interested in those things. Now I'm older, I understand why he tried to encourage me to do things. He wanted us to find something we had a passion for. Sometimes it might not be what he wanted us to do, but he was still proud of us all whatever we did. He tried to bring out my artistic side by giving me a sketchbook to get down any ideas. Although I had the talent, I never had the imagination, so it was always difficult to impress him with my ideas. The thing I remember most are car journeys with him. Some were fun and educational; others would be very boring! Sometimes he would be looking for something very particular, such as a rock, and he would spend ages trying to find the perfect one. We were always roped in to helping him.

Louise's lads, Calvin and Lewis, who came to Gourock to stay with Grandma and Grandpa Wyllie in the school holidays, both recall getting their hands dirty with George. Calvin, who went on to study at Glasgow School of Art explains:

I remember one occasion being bored when visiting the family house in Gourock. I was curious to see what Grandpa was up to in the workshop downstairs so I went down to see him. It was fascinating to see him conjuring up all these things down there. There was plenty of effing and blinding when things weren't going his way. There would be sparks flying in all directions, and lot of grinding and welding. I was a bit jealous and I remember he noticed this and stopped work to invite me to 'think' about what I'd like to make as well. We ended up grabbing Lewis and making our own homemade skateboards from bits of scrap wood and casters. They ended up quite odd skateboards, but we took these up the drive and gave them a shot. They worked just fine for kids! It's always stayed with me that you can make anything you can think of.

Lewis remembers the warm welcome which greeted himself and Calvin when they arrived from Manchester at McPherson Drive after what seemed like an eternity in the car playing travel Scrabble.

Arriving was always great. There would be an exchange of brotherly high fives before Calvin and I walked carefully down the steps to the house as they were always a tad mossy. A warm welcome at the door from Grandma awaited and then a nice hug from Grandad. It struck me from a very young age that he clearly didn't have a nine-to-five office-type job, otherwise he would have shaved more often. His stubble used to be very scratchy on said hug. Grandpa would ask things like how our schooling was going, then tell us where the problem lay with our schools and our teachers. There was always a lot of asking how we were, then subsequently being told what our problem was.

Making art, and letting his grandchildren push themselves to make something original, was always on the menu at McPherson Drive. Lewis remembers being allowed by George to use his 'super special paper', which he used to make 'real art'. George would challenge the boys to create 'something new and something pure' which would be followed by twenty minutes of 'hard thinking' and lots of shouts from George asking, 'How you getting on over there?' 'We would try our best,' says Lewis, 'but rest assured you would get an honest critique. I didn't mind. I just loved those thick black ink pens and the feeling of pure joy using those gold and silver pens usually only reserved for Christmas present tags.' Another challenge which Grandpa Wyllie used to serve up to the boys was wood-chopping. 'Grandpa would ask, "How strong are you? Can you chop a log in half for the fire!" To this day I don't know if he had pre-sawed these humongous logs for the fire because as my brother and I karate-chopped them one by one, they all snapped in half. I felt like the Hercules character I was learning about in school.'

George also had an unusual approach to culinary matters, according to Lewis.

Grandpa thought outside the box when it came to cooking. He even made cups of tea in obscure ways. It wasn't just in his art that he took an unusual approach to making – it spilled over into his life. He'd pour boiling water on prawns to defrost them or use two teabags to make tea and add way too much milk as my brother and I looked on chuckling to ourselves! He even produced a special cheese he was very proud of, which had, he told us, been 'sweltering away' in a biscuit tin like some kind of Japanese delicacy. I didn't get it. But I liked his style. He could be as silly as he wanted to be and he was grown up.

Sometimes he'd come towards you as if giving you a firm pat on the shoulder and his hand would

go over the top of your back and sneak into your clavicle, where he would squeeze your shoulder, like some kind of SAS death grip. I don't think he knew quite how hard he did it sometimes, but it was always playful. We were always sad to be going home. The only thing to soften the blow would be the ten-pound note he slipped to you for being 'a good boy'. I liked that he thought I was a good boy. The money was nice, but you always left feeling richer: richer in life, richer as a person. A life lesson or two was always learned when we were with Grandpa. You left with your morals realigned. It was always a truly wonderful experience.

Grand Designs

A Day Down a Goldmine took George's talent for showmanship to another level. Various performances followed in its wake, including the *March of the Standing Stones* (1985) and the *March of the Missing Tourists* (1986), both of which formed part of the Edinburgh Festival Fringe and presented a serious subject in a humorous vein. In 'putting on a show' with his art, George was beginning to find his natural home as an artist. In 1986, he took up the presidency of the Society of Scottish Artists (SSA) and widened his horizons yet further within the art world. In the mid-1980s he also began to plot his most ambitious piece of street theatre, *Straw Locomotive*.

He started sketching his plans for the *Straw Loco*, as it came to be known, in late 1986 and was delighted

Left: Louise Wyllie's sons, Lewis (front) and Calvin, pose in their grandfather's Tweed Tram *during an exhibition at the Lillie Gallery in Milngavie in the early 1990s.*

when his idea to create a life-sized locomotive made of straw and hang it from the Finnieston Crane in Glasgow was selected as one of the winners of a competition organised by Television South West and South West Arts for nine major site-specific temporary artworks to be sited around the UK. He received funding to the tune of £6,000 to make the *Straw Loco*, but perhaps more importantly, it placed him in the company of artists such as David Mach and Antony Gormley, and awarded him recognition as one of the UK's leading environmental artists.

The *Straw Loco*, with its steel frame chassis covered with wire mesh stuffed with straw, took George two months to build in Scott's Store near Greenock's container terminal. As with previous projects, George worked with welders from the Greenock Welding and Fabrication Company to make the locomotive. Clyde Port Authority supplied a workshop big enough to house the sculpture before it was transported on 4 May 1987 to the huge hammer-head Finnieston Crane. An integral part of that year's annual arts festival, Mayfest, the loco dangled above the banks of the River Clyde for over six weeks, astonishing unsuspecting passers-by who looked up and thought it was a mirage. It was a project dear to George's heart, laced as it was with boyhood memories of seeing the locomotives transported from Springburn, past Allan Glen's School on their way to the docks and on to a distant land. For George, the *Straw Loco* was a symbol of Glasgow's creative spirit and capacity for world-class engineering and manufacturing at its best. In his lifetime, Glasgow had gone from a city which exported 18,000 locomotives to forty-three destinations worldwide to a city which no longer produced a single locomotive. Where did all these skills go? George was asking. It certainly struck a chord with the men left unemployed when the locomotive works closed. Many former workers were among the crowd who saw the loco being hoisted ceremonially into position. They were also in Springburn on 22 June, when it was taken to the site of the former North British engineering works. After George checked it over, removing a stray birds' nest, he set it alight. As a lone piper played a lament, the *Straw Locomotive* burned. It was a powerful visual image and when its burnt-out chassis revealed a question mark, many in the crowd wept at the sight. The last hours of the *Straw Loco* were filmed by Murray Grigor for posterity.

The *Straw Loco* lives on in the collective memory of everyone who saw it. The scenes in *The Why?s Man* film, alongside the ashes, which George kept at home in a tatty old cardboard box, were all that remained.

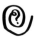

The *Straw Locomotive* changed many people's view of what public art was and what it was for. It really was art the public couldn't avoid, as George put it in one of his many press interviews at the time. Talking about it in 2012, Alan Cumming, then a young jobbing actor living in Glasgow, said, 'It was an act of whimsy, bravado and passion that connected on an emotional level with the Scottish people. It changed my view of what art could be.' Around this time, artist David Harding, founder of the environmental art course at Glasgow School of Art, invited George to work with students on his course to 'amplify' students' ideas on performance and installation. Together, they participated in a theatrical event based around the Berlin Wall and travelled to Rannoch Moor to erect the spire in remembrance of Joseph Beuys. Students he worked with included future contemporary art stars such as Douglas Gordon, Roderick Buchanan, Christine Borland and Ross Sinclair. George used to joke that he had to 'wallop them a bit hard for being too conceptual'.

Hundreds of people wrote to George to tell him how they felt about the *Straw Loco*, including leading Scottish Nationalist Party politician William Wolfe, who

in a letter dated 27 October 1987 told George: 'For me it epitomises the cataclysmic changes which have taken place in Scotland in the last forty years. I shall never forget the *Scotsman* and the *Glasgow Herald* on the day they announced the closure of the N.B. [North British] Loco. [sic] because on the same front pages the news included the closure of the Scottish shale oil industry. What a day for Scotland.'

In the *Straw Loco*, all George's skills coalesced: a flair for street theatre, design, engineering and sculpture, and the delivery of a message with simple and direct honesty. Crucially, by then, George knew he *had* a message – one that was important to his whole being as an artist. The following year, for the Glasgow Garden Festival, which took place on disused dockland opposite the Finnieston Crane, George produced several works, including one called *Arrivals and Sailings*, a series of eighteen funnels painted in the colours of the many shipping lines which once plied the Clyde, and a makeshift pier presided over by a spire-like structure on which a seagull perched. George had wanted to make a work called *The Lost Ships of the Clyde*, with the coloured funnels emerging and submerging in the centre of the river through flotation tanks, but despite support from Barbara Grigor, this idea didn't materialise. George was never down – or short of ideas – for long. In 1989, he launched another full-scale public art installation with a nod to Glasgow's lost industrial heritage in the shape of the world's biggest *Paper Boat*. Again, he used the Finnieston Crane, a talisman from his days working as a message boy in the docks, as his launch pad. George was becoming adept at securing funding for his big ideas, and this project, which was part of the city's Mayfest programme, received £30,000 worth of financial support from the Gulbenkian Foundation, an international charity which supports the arts.

Not What a Ship Used to Be

George's dismay at the virtual disappearance of Glasgow's once mighty shipbuilding industry drove his *Paper Boat*. Fusing engineering, street theatre, visual art, performance and music in one provocatively playful package, the boat had a steel frame clad in sheets of plastic and gauze Velcroed together, which opened to reveal a viewing platform. There was, naturally, an elevating question mark inside, but this time George wanted the simplistic beauty of the sculpture to be appreciated in equal measure to the political content. He was heavily influenced by French poet Arthur Rimbaud's 'Drunken Boat' poem, the first line of which describes a something or someone in a boat 'floating down unconcerned rivers' being 'steered by the Haulers'. The narrator describes gliding down calm rivers to tide water, and then for ten nights being tossed about by the tumultuous waters of the open sea. The experience is a joyful one, and at the end the speaker has a feeling of freedom and purification. The *Paper Boat* carried the initials 'Q.M.', but George admitted later that 'we were never sure what Q.M. stood for. It's always good not to know something about what you're doing. We had notions it might mean Queen Mary or Question Mark or Questioning Mind.' He made the boat in collaboration with Harry Finlay of the Greenock Welding Company. The two men worked together on *Straw Locomotive* but had enjoyed a fruitful relationship going back to the 1970s.

In order to be legally seaworthy, George tested the seventy-eight-foot-long *Paper Boat* at the Denny Tank in Dumbarton. This was the test facility where designs for the massive Clyde-built ships were undertaken. She was then certified with Lloyd's to complete the paperwork side. The launch of the pride of *The Origami Line* (with the letters Q.M. on her hull) took place on a beautiful sunny day on 6 May 1989 in front of a large crowd, and echoed the celebratory launches which once routinely took place on shipyards on the banks of the Clyde. (The title was a nod to the Japanese art of paper

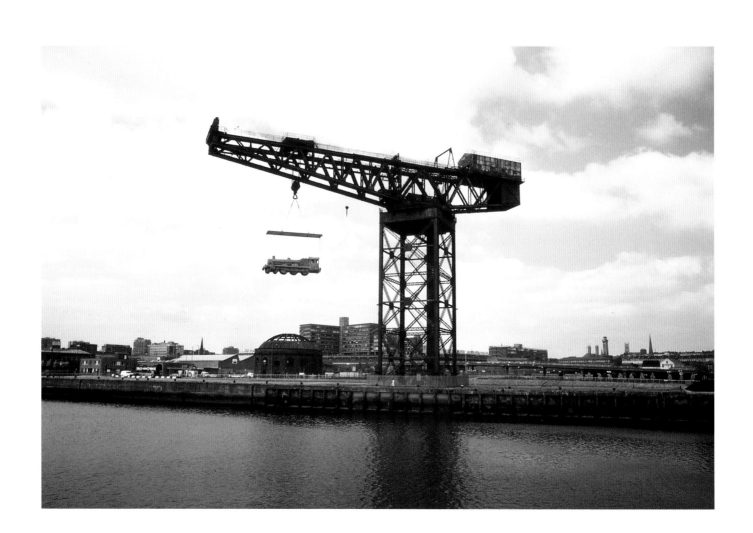

folding and a subliminal reference to the time he spent in Japan during the war.) There was even a blessing by industrial chaplain Revd Norman Orr and a naming ceremony by the writer Naomi Mitchison. Accompanied by the Da Capo Choir from Greenock, George, in his pristine white boiler suit and captain's hat, performed 'a corny wee tune, a paddle-steamer song' which he'd specially composed for the occasion. His first mate was his son-in-law, Campbell Aitken, who helped him off and on over the years with making and realising many of George's projects.

> So now that we're building a Paper Boat,
> A Paper Boat Paper Boat
> don't-be-surprised-at-the-way-we-vote.

> (We're going to build a big Paper Boat,
> A Paper Boat Paper Boat
> folded up carefully so it can float
> – but not what a ship used to be.

> We're going to work on a Paper Boat
> A Paper Boat Paper Boat
> having to put on a different coat
> – not the old dungarees

> We know the cost of a Paper Boat
> A Paper Boat Paper Boat
> Take it away for a Five Pound Note
> – it's not much use to me.

Previous spread: The Straw Locomotive *is one of George's best-known artworks. It hung from the Finnieston Crane in Glasgow for forty-eight days in 1987, from 4 May to 22 June. It was then taken to Springburn to a former locomotive works and given a Viking-style funeral. Once the flames had died down, its burnt-out chassis revealed a giant red question mark.*

> We're not all that proud of a Paper Boat
> A Paper Boat Paper Boat
> – you'd think that there never had been afloat
> a ship like the good old *QE*.

> We're all at sea in a Paper Boat,
> A Paper Boat Paper Boat
> The Rule of Britannia is very remote
> from what it used to be.

> So now that we're building a Paper Boat,
> A Paper Boat Paper Boat
> don't-be-surprised-at-the-way-we-vote.

George maintained that he wasn't nostalgic about shipbuilding, but rather for the skills and the spirit that went into it, and the transcending of the tough conditions of the shipyards. Where was this energy now? he asked, as his 'paper' boat travelled to London and made a splash there. In Murray Grigor's *The Why?s Man*, which also documented his *Paper Boat* project, he quipped that 'on paper' he was the only shipbuilder left on the Clyde. The idea of social sculpture, a concept mooted by his guru, Joseph Beuys, was the major driving force behind both *Straw Locomotive* and *Paper Boat*. *Paper Boat* referenced Joseph Beuys' idea of a journey, one that took it from Glasgow to Liverpool and on to London, New York, Antwerp, Dumfries and the east coast of Scotland.

In his art, which encompassed drawing, sculpture, painting and performance, Joseph Beuys wanted to take both himself and the audience on a literal and figurative journey which would transform their idea of society. There was also a strong aspect of the healing effect of art in all of his work. He often incorporated deeply personal motifs into his work, such as animal fat and felt, which had profound meaning to him. Both organic materials related to his wartime experience serving with the Luftwaffe, and it was his conviction that if he felt a profound connection, then the audience would feel it too. George, himself an ex-

serviceman – also profoundly affected by his time in the Royal Navy – espoused this idea wholeheartedly.

George received support for his *Paper Boat* events from Beck's Beer, who even produced limited edition *Paper Boat*-labelled bottles, part of a long-running Beck's Art Labels project, which started in 1987. The first to be featured in the series were Gilbert & George, and since then the list has grown to include names such as Tracey Emin, Damien Hirst, Jeff Koons and Andy Warhol.

In September 1989, *Paper Boat* travelled to London, and on Thames Day (9 September) it sailed under Tower Bridge to the Houses of Parliament. As a patriotic gesture, the question mark inside the *Paper Boat* this time was red, white and blue. George's prime aim in London was to draw attention to Thatcher's policies, including the privatisation of the shipbuilding industry. In order to ensure that Tower Bridge had to be opened, a tall mast was added, flying the Scottish Saltire. Traffic was stopped, the bridge was opened, and the *Paper Boat* sailed through and was moored opposite the Palace of Westminster. The questions, as well as the bridge, had been raised. But George was not happy. According to his friend and frequent helpmate Pete Searle, George cried when he discovered Thatcher was not there to see the boat opening up to reveal a giant question mark. As always, there was a little detail which kept the project grounded; George had borrowed the Union Jack flag which flew on the *Paper Boat* from the Inverkip Scouts. (His nephew Alistair, like his father Banks, was, and remains, a key figure in the scouting movement.)

The following summer, in July 1990, *Paper Boat* sailed up the Hudson and into the World Financial Center in New York accompanied, to George's delight, by the Duke Ellington Band. On docking, George sang the 'Paper Boat Song', accompanying himself on the ukulele, and then, as the question mark was revealed, four Scottish pipers played. He took a spire with him as he went ashore to celebrate the 'place in which it stood'. He then opened a golden suitcase and took out the

'ship's log'. The purpose of the *Paper Boat*, George told bystanders, was to make things 'plain; clear; open and visible', and added that he intended to do just that. The boat created a real splash by making it onto the front page of the *Wall Street Journal*. The headline on 16 July 1990 read: 'Laugh You May, but Remember It's Floating and the *Titanic* Isn't'. For its New York jaunt, George had included notations inside the boat from Scots economist Adam Smith's *The Theory of Moral Sentiments*. The newspaper wrote: 'Mr Wyllie says Wall Street has forgotten *The Theory of Moral Sentiments*, Mr Smith's companion [to *The Wealth of Nations*] treatise on conscience and morality.' George's timing was important as the bicentenary of Smith's classic text on capitalism, *Wealth of Nations*, was celebrated in 1990. He then read the first sentence from *Theory of Moral Sentiments*.

How selfish soever man may be supposed, there are evidently some principles in his nature, which interest him in the fortune of others, and render their happiness necessary to him, though he derives nothing from it except the pleasure of seeing it.

The boat was taken on many journeys, but eventually George sent it to a shipyard at Inverkeithing and had it broken up like a real liner. He recycled the material and made a giant goose, which he called 'Truce Goose', for another project in 1993 about a compromise between farmers and conservationists over the thousands of geese which consumed huge amounts of grass on the Hebridean island of Islay every year.

Next spread: *George 'sailed' the Paper Boat to several locations with rich maritime histories of their own making, including New York. This picture was taken while the Paper Boat was berthed at the New York Financial Center in July 1990. On the right hand page is a watercolour 'plan' painted by George.*

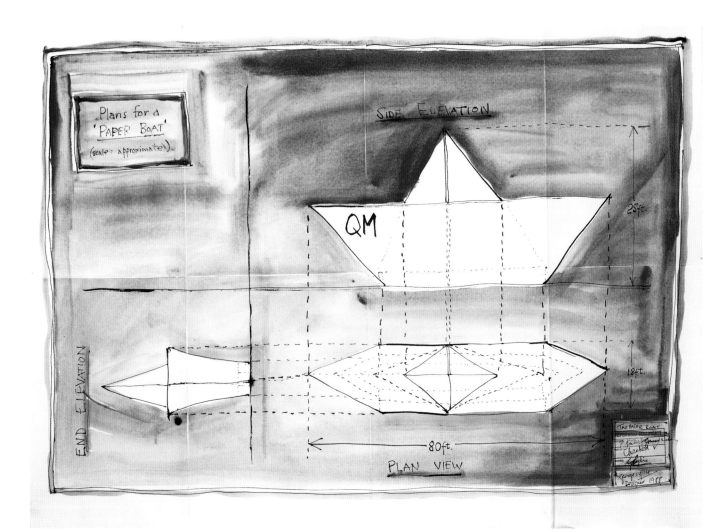

Plans for a
'PAPER BOAT'
(scale: approximate)

SIDE ELEVATION

QM

25ft

18ft

END ELEVATION

80ft.

PLAN VIEW

THE PAPER BOAT
Checked
George Utley
Designer 1988

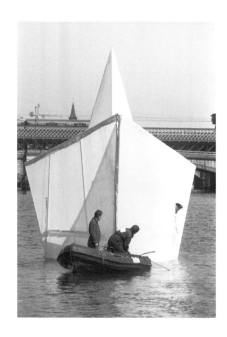

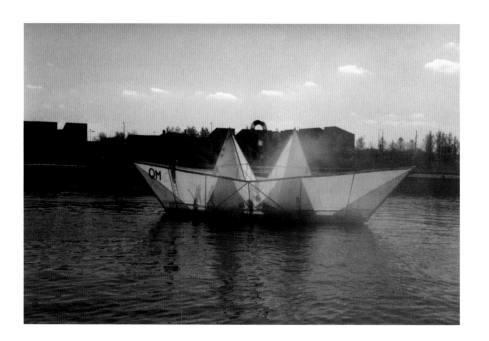

Burns, Beuys and Beyond

George was riding on a crest of a wave in 1990. As well as journeying with his *Paper Boat*, George got together with curator Joan Hughson and old sparring partner Richard Demarco to stage a conference called *Burns, Beuys and Beyond* as part of Glasgow's celebrations as European City of Culture.

A lifelong fan of the work of Robert Burns, George described the Bard as the 'great humanist from Scotland', while Beuys was 'the moderate, the contemporary humanist in the art world'. The 'beyond' aspect of this installation was, he declared, the question mark.

Speaking about the experience in the British Library Artists' Lives series of recordings, made in 2014, George explained: 'For this I made a cottage like a big tent, and covered it with felt, and I put the exhibits in there. So it was Burns the cottage and Beuys the felt.

'Kenneth White came over and delivered a lecture on it called "A Shaman Dancing on a Glacier". I don't think the lecture prompted geopoetics, but it was a beginning, and it reinforced attitudes. Ten years on, I feel I'm pushing along the geopoetical idea quite strongly myself.'

––––––––––––

Top row, from left: George, in his white boiler suit and naval cap, peeks round the bow of his Paper Boat, *just after she set sail on the River Clyde in Glasgow on 6 May 1990; the boat opened to reveal a giant brightly-coloured Question Mark; author Naomi Mitchison launched her and there was even room inside for George and Daphne to have a sing-song.*
Bottom row, from left: the Da Capo Choir *from Greenock accompanied by George on the ukulele, sang a song he'd composed for the occasion and the boat was blessed by industrial chaplain, Revd Norman Orr.*

Everything Real and/or Unreal

Murray Grigor was on hand in April 1990 to document a trip George made to the island of Gruinard on the west coast of Ross and Cromarty. Gruinard had been contaminated by anthrax spores in 1942 as an experiment in germ warfare. To celebrate its being officially declared germ-free by the Ministry of Defence, George travelled to the island to plant one of his spires. It is still there today. Beneath it, a plaque reads: 'For air, stone, and the equilibrium of understanding.' In smaller writing it states: 'Welcome Back Gruinard' and 'George Wyllie and Murray Grigor April 1990'. In a Buster Keaton-like turn of events, after offering the assembled media a dram, George's inflatable dinghy capsized as he sailed off the island. This was all captured on camera by Murray and can be seen in his award-winning film, originally screened on Channel 4, called *The Why?s Man*. Grigor digitally remastered the film in 2012 and released it as a DVD to coincide with the Whysman Festival, a year-long celebration of the work of his old friend. Sections of the film can be viewed online. (Grigor also made a film about a visit to Ireland that George undertook in 1994 – *32 Spires* – and it can be seen at georgewyllie.com.)

George turned seventy at the end of 1991 but showed no sign of slowing down. A major retrospective of his work called *George Wyllie: Scul?ture Jubilee 1966–1991* opened at Glasgow's Third Eye Centre in May of that year. It was the first time that the complete range of his work had been put on show, and it surprised many who just knew about his most recent work. *Scul?ture Jubilee* travelled to the Whitworth Gallery in Manchester and Gracefield Arts Centre in Dumfries before ending its run in the Crawford Arts Centre in St Andrews in January 1992. During the exhibition's run in Manchester, George exhibited alongside leading Young British Artist (YBA) Damien Hirst. George and Damien took part in a question-and-answer session during the exhibition, and it transpired that both men had a healthy respect

for one another's work. Louise Wyllie, then living in Manchester, also staged dance workshops using the work as a stimulus in the Whitworth during the show. In the exhibition catalogue, George's friend, supporter and occasional sparring partner, veteran art critic Cordelia Oliver wrote this in an expansive essay about George: 'When I first came to know him in the early 1970s my realisation that here was an individual of real potential was somewhat tempered by the feeling that here, too, was someone who still found it difficult to relate content with forms, to match an idea with its proper medium and no less important, scale.'

Oliver was at once George's greatest supporter and his fiercest critic. George would later say, after her death in 2010, that of all his friends who had died, he missed her the most. He knew that as an artist herself – she attended the Glasgow School of Art in the early 1940s – she cared deeply about art and wanted him to succeed in his attempts to make meaningful work.

Oliver, whose husband George photographed all George Wyllie's major works, regarded his *Straw Locomotive* as the work in which he came 'nearest to resolving the essential dichotomy of his creative urge'. She said of his *Paper Boat* that although it 'was almost identical in aim, the effect was different, less moving, somehow, if only because it was launched (from the same Finnieston Crane) in a musical comedy atmosphere and its purely decorative quality when afloat on the river in the city centre, not least as a luminous presence after dark, tended to nullify the concept's sombre meaning.' George told friends in later life that he

Above: George placed a spire on the island of Gruinard in April 1990 to mark the Ministry of Defence's declaration that it was officially anthrax-free. The island had deliberately been contaminated by the deadly spores in 1942 as an experiment in germ warfare.

more or less agreed with this summation of his two best-known works.

As the final decade of a tumultuous century gathered pace, George found plenty to keep him occupied, including, in the summer of 1994, a project that saw him returning to Ireland with a sculptor friend called Kenny Munro, whom he had first met on a Richard Demarco-led trip to Ireland in 1978. The two men shared a common view of life and art and reconnected in 1991 when George saw Kenny's sculpture, *A Place for Geddes*, at the Society of Scottish Artists (SSA) annual exhibition. Like many fellow artists, George was very taken with the philosophy of Sir Patrick Geddes (1854–1932). Geddes was a Scottish town planner who advocated a holistic approach to living and learning to improve communities. Kenny became a willing helpmate on various expeditions George undertook from then on; the two men worked together in Berlin, Montpellier and India.

As old age crept up on both George and Daphne (they celebrated their fiftieth wedding anniversary in September 1994), George began to revisit key periods in his life. His trip to Ireland that year with Kenny for the *32 Spires* project recalled his days during the 1950s as a Customs officer just before the onset of the Troubles in Northern Ireland. Just as the Berlin Wall had disappeared six years earlier when George's *Berlin Burd* keeked over it, within weeks, the road block that had lasted for more than seventy years was gone. For Murray Grigor, whom George had persuaded to come on board as the project's filmmaker, *32 Spires* was a revelation of how serious an artist George had become. 'He actually did go to all the thirty-two counties in Ireland to retrieve appropriate forked branches and rocks,' Murray recalled many years later. 'There were no half measures where George was concerned.' Facilitated by Richard Demarco, *32 Spires* transferred to Calton Hill in Edinburgh two years later during the Edinburgh Festival, where Murray filmed them as a sculptural statement on Ireland's

continuing Troubles. A sequence in the film shows George attempting to explain the concept behind the installation to a group of smiling (if baffled-looking) Japanese tourists.

The Difference

George confronted another demon in his past life in the summer of 1995 after being invited by Glasgow City Council to create an installation at the Cenotaph in the city's George Square. This was planned to commemorate the fiftieth anniversary of Victory over Japan Day (VJ-Day). For George, who had never fully exorcised his wartime memories of the war in the Pacific, especially those of the miserable prisoners of war, it was a big ask.

George thought long and hard about accepting the commission, but in the end he decided to do it. He was visibly upset when a member of the British Legion who attended a special ceremony on 15 August 1995 in George Square accused him of showing allegiance to the Japanese. George pulled his Burma Star medal from his pocket and retorted that he had been there. George approached this project, *From FERTILITY to STERILITY*, with compassion and humility. The installation was based on a collection of remembered images and impressions of the devastation he witnessed in Hiroshima. A Japanese girl made an origami bird, a crane, which symbolised hope and peace in Japan. Among the Japanese chrysanthemums and Scottish thistles, George laid an engraved plaque as a statement to peace in the centre of his VJ-Day installation. This was based on the grid system he had first seen in Hiroshima and was interspersed with charred trees, pulverised granite and globules of molten glass. The experience of making this artwork laid many ghosts to rest for George. His nightmares suddenly stopped and his family reported a shift in his attitude towards the Japanese people.

Catching Sight of the Cosmos

There was no 'going gentle into that good night' for George Wyllie. As the 1990s progressed, to the resignation of Daphne and his two daughters, George continued to make large-scale sculptural works, which required him to persuade many a friend or relative to wade in with muscle power and other forms of practical support. In 1996, for Glasgow's annual arts festival Mayfest, he made a twenty-one-foot-high stainless-steel safety pin (with regulation Burd perched atop) called *Just in Case*. It was eventually renamed *Monument to Maternity* when it was bought in 2004 by the University of Strathclyde and placed at the site of the old Rottonrow Maternity Hospital in Glasgow. Resembling a nappy pin and embodying simple engineering at its best, it was the perfect fit for an institution specialising in science and technology. (George received an honorary DLitt from the University of Strathclyde in 1990 and had been delighted by this pat on the back from the institution where he'd attended night classes as a young trainee engineer before it became a university.) Ever the philosopher, George insisted *Monument to Maternity*'s title should appear in Greek, in an acknowledgement that the earliest safety pins had been invented in antiquity.

At the end of 1996, George turned seventy-five. Two of his friends, Neil Baxter and Joan McAlpine, organised a birthday party in Princes Square shopping centre in Glasgow. It was a gathering of the great and the good of the Scottish art and media world. One of the highlights was when writer Liz Lochhead (currently Scotland's National Poet, or Makar), who had known George for several years, read out a poem written in his honour:

Opposite: To celebrate the 50th anniversary of VJ-Day, George created From Fertility to Sterility, *an installation at the Cenotaph in George Square, Glasgow.*

A Wee Multitude of Questions for George Wyllie

Who is the man
'it pleases as much to doubt
as to be certain'?

Whose faith
is in the questioned faith?

Which Great Scot
(pronouncedly Scottish) pronounces
Scul?ture
most Scotchly with a question mark and a
glottal stop?

Who puts a question mark at the centre of everything?

Who lives unbowed under the slant of Scottish
weather,
loves the white light of stones,
walks on wiry grass
and, feeling the electric earth beneath him,
turns his wide gaze to the open sea?

Who was the young sailor
who walked in a place of ash and char, fused glass,
bone?
Who saw that, aye, rocks do melt wi' the sun
and let pulverised granite run through his fingers
like the Sands of Time shall Run?
(The name of the place was
Hiroshima
and in the middle of the word
was the hugest question-mark.)

Who will surely
interpret for us the monograms of the stars?

Who is the man
whose name belies his nature?
(for 'wily' he is not; there is
craft in it, and art, but no guile. He is true
and straight, his strategy is honesty, and to ask –
in all innocence
in all experience –
the simplest, starkest, startling
questions.)

Who makes biting satire out of mild steel?

Who wishes to avoid Incorrect Assumptions leading to
False Conclusions? Wants us to question mark,
yen, buck, pound?

Who in A Day Down A Goldmine asked us to resist
the Golden Fleece, the Big 'I-con'
that would swizz us all to sell our souls?

Whose Berlin Burd
faced an absurd
obstacle?
(Which the bird keeked over
and The Wall keeled over.)

Who, one Christmas, made
gorgeous guano-free robins
cheep in George Street, Edinburgh,
more multitudinous
than were starlings once in Glasgow's George Square?

Which George is the Captain of The Question Mark
and Daphne his first mate?

Whose Jubilee
was happily misspelled Jubliee on page thirty-five
of his lovely, jubbly, jubilee catalogue?

Who decided a locomotive might descend a
staircase
and a tramcar might have wings?

Who made the out of order
Standing Stones walk?
Who made Holyrood into almost Holywood
for the Festival Fringe?

Whose spires inspire us,
unquestionably celebrate?

What the devil was the de'il
wha danced away wi the exciseman?
(Art did! Art is the very devil that danced
awa wi the exciseman.)

Who is the Mad Professor up all night in the attic
inventing The Great British Slap and Tickle
Machine?
Who is our ain
National Genius, wir true Caledonian McBrain?

Who speculates about what is
below the surface, douses, divines? Whose rod is
not a Y
but a why? Whittled to a ?
(His 'by hook, by crook' he advances with, slowly
over rough ground in his good grasp;
his shepherds crook;
his boat hook
hauling us aboard – hang on to your sou-westers,
shipmates, it'll likely be a bumpy ride . . .)

In the dark spaces of our heads
divers, multitudinous, unmarked, the questions float
 above a straw locomotive and a paper boat.

Another Glasgow landmark created by George was *The Running Clock* – a giant clock on a pair of stainless-steel running legs. It was installed outside the city's Buchanan Street Bus Station in 2000 after being commissioned by Radio Clyde. A humorous take on the hustle and bustle of city life and people coming and going to catch buses and trains, despite negative headlines at the time, the clock was subsequently taken to the city's heart. George never worked on these projects in isolation and for this project, he was assisted by friend and architectural historian Neil Baxter.

As the twenty-first century got into its stride, George found himself consumed by the idea of finding balance in nature, and how stones and air not only create equilibrium, but contain a message. In 2000, to mark the opening of the Scottish Parliament in Edinburgh, he made a permanent installation at Regent Road Park called 'The Stones of Scotland'. In the park, which overlooks the parliament, George worked again with sculptor Kenny Munro and artist Lesley-May Miller to install the thirty-two stones, one from each local authority in Scotland. The work forms a circle, within which is a tree and a stone centrepiece, on which is inscribed 'whose the tread that fits the mark' alongside a footprint in cement. This line of poetry comes from Tessa Ransford's 'Incantation 2000', written for the inauguration of the work on 31 December 2000 – George's seventy-ninth birthday. The work, said George, was 'a reminder to a new era of Scottish politics that the centre must involve and be legitimised by all that surrounds it'.

As he entered into his ninth decade, George began to slow down slightly, although he hated to admit it. He was a popular 'talking head', as the press refer to someone who can be relied upon to have an opinion on most subjects, and he made frequent appearances on television and radio. He also wrote for newspapers on a regular basis. Many of the journalists and media people he met along the way became good friends,

such as Gourock-born journalist (and now politician) Joan McAlpine and her former husband, the singer and writer Pat Kane. A new writing focus also came from producing a regular monthly essay for the Scottish periodical *ArtWork*, which George used as a platform to expand on his views and ideas. In 1997, publisher Bill Williams decided to do a small print run of these essays in a little red book called *MY WORDS: George Wyllie's Essays for ArtWork.* Williams wrote in the foreword: 'Wyllie has a winning way with words as well as images. They work for him just as powerfully as does his inspired line. In these essays the two can be seen acting together in perfect harmony.'

As his peers and family members of the same generation began to die off, almost everything George made and everything he wrote was based around a search for equilibrium. He had espoused the philosophy of geopoetics, a movement established by Scottish poet Kenneth White. White's teachings on geopoetics liken mankind's relationship to the earth with the opening of a world. With this in mind, a visit to the island of Kerrera on Scotland's west coast with his friend, poet and musician Donny O'Rourke, led George to discover a motif which he felt summed up his view of the world in the shape of a triangular window on the side of a stone byre. A sculpture called *Vent 2000* came out of this altered perspective. The small triangular window, he said, gave a clearer picture of reality than the computer programme Windows 2000. This smaller work developed into a major commission called *The Vent* for the Northlands Festival in Caithness. This was placed on a small headland near Thurso on the road to Scrabster. Made from Caithness stone and stainless steel, with assistance from a local dry stone dyke builder, George intended that this triangular structure should act as a link between the new Scottish Parliament and the ancient parliament of Iceland.

In the early years of the twenty-first century, George also became involved with a project to build a 'Crystal Ship' over the Clyde. It was a homage to the way in which crystal helped to power shipping and shipping lines. (The plan started off with bridging the Clyde, then changed to the River Kelvin.) This ambitious scheme aimed to place a glass ship – one hundred metres long, fifty metres high and twenty-five metres wide – on a dock area reached by a bridge. It was to become Glasgow's equivalent of the Eiffel Tower. This ship would not float itself, but be like a ship in the regenerated dock area, with water and plants around it, from which 'ideas floated'. Perhaps it was just too ambitious a plan for George at this advanced stage in his life. Despite backing from a development company and high-profile support from many quarters, funding was not secured and the project fell by the wayside.

———————

Opposite: *George created* The Running Clock, *a giant clockface on a pair of stainless-steel running legs, after being commissioned by local radio station Radio Clyde. It was installed outside Buchanan Street Bus Station in Glasgow in 2000.*

7 Time and Tide

New beginnings can only happen in the offing.
Joseph Beuys

Louise Wyllie, April 2016

When my mother had a stroke in January 2002 and was admitted to Inverclyde Royal Hospital, Greenock, it was a shock for all the family. It couldn't have come at a worse time. My sister Elaine's husband, Campbell Aitken, aged just forty-eight, had been rushed to the same hospital with blood poisoning a few days earlier. When I got the call, I had just returned from the Highlands back home to Manchester, where I lived at the time, and had to get straight back on the train to Scotland.

My father, who had just turned eighty, was in turmoil as two members of our family were in the same hospital at the same time and there was absolutely nothing he could do, despite his firm belief that anything was fixable. It was clear my mother had had a major stroke and there was to be no recovery. Asking us, as we gathered round the bed, if she had a 'tiger on her head', the family simply just didn't know how to respond and the only comment was from Dad who asked, 'Is it a hat?' Within a few days, she was assessed and moved to the Larkfield Unit in the Inverclyde Royal and then on to a long-term care ward in Ravenscraig Hospital. This was the place my grandmother Harry had gone in her final months suffering from severe dementia. It was where she subsequently died. The worst was still to come. George's son-in-law Campbell, who seemed chipper in the days following his initial admission to hospital (even going so far as visiting my mother), suddenly – and unexpectedly – died, just after my mother was transferred.

Left: Romantic poet, William Blake, was one of George's favourites. Bicycles were one of his metaphors for equilibrium and he created Blake's Bike, *in his hero's honour.*

Arrivals and Sailings

The Happy Compass

This was to prove a trigger for a downward spiral in our family as a whole. For the first time in his life, my perennially hale and hearty father was to find the pressure taking its toll on him physically as well as mentally. In a sense, it was a double bereavement, as my mother's stroke was so severe that communication was very difficult and frustrating for everyone concerned. This, combined with the death of my brother-in-law at such a young age, threw us all into confusion. My father made a decision to visit my mother twice a day – once during the day and then again at night to tuck her in. The only time he left her was for a brief overnight visit to London in February 2002 to honour an obligation to mount an exhibition called *Resurgam Revisited* in London with the Rebecca Hossack Gallery. He had been planning, as part of this, an installation which saw him releasing bags of Caithness 'fresh air' into the Capital. One of the pieces in this exhibition, which now had added poignancy for us all, was called *The Happy Compass*. He had made this as a sort of love letter to my mother. It was a reference to Daniel Defoe's Robinson Crusoe saying of his wife that she was 'the stay of all my affairs; the centre of my enterprises; the engine that, by her prudence, reduced me to that happy compass I was in'. It is one of my favourite artworks. A simple box-like structure, it has a lump of quartz for a needle, sitting above a Celtic spiral.

The Cosmic Voyage

Without Dad's devoted attention to my mother's care, she may not have lived a further eighteen months after her initial stroke. He made small welded gifts for her and brought her favourite foods to eat. We started to notice my father's devotion became almost fanatical at times, starting with major announcements in the press and followed by fantastical stories of their life together. We suspected he felt guilty, having always put himself first, especially when art become his first love. We weren't at all sure what was happening, but on a day-to-day basis I actually grew to dislike him, and my sister found it difficult to cope with his behaviour as she hobbled through coping with the loss of her husband while having a young daughter to care for. My father turned his full focus to my mother to the exclusion of all else. We all found ourselves in a dark place without the mainstay of our family. After two long years in hospital, unable to move or speak at the end, my mother died in 2004. The cause of death was pneumonia.

My father embarked on another art project, which was to become his last major exhibition. In 2005 – the same year he received an MBE from the Queen for his 'services to art' – he approached the Collins Art Gallery, as he wanted to mount an exhibition dedicated to my mother. He had always enjoyed a long and fruitful relationship with the gallery and with Laura Hamilton, its curator. She was only too happy to help; she knew it could be his last. Since his first major solo exhibition, *Scul?ture*, had been held there in 1976, it seemed only fitting. It was one big push from him and he embarked upon it with zest. It opened on 27 August 2005 and ran until 8 October 2005. Creating the work and making it happen took its toll on his health and he found it very hard going.

THE COSMIC VOYAGE by George Wyllie
COLLINS ART GALLERY 2005

'Scul?ture' was launched in the Collins Art Gallery in 1976. The question mark deliberately replaced the 'p' to signify doubt and apprehension within that movement. After random adventures in parts beyond the seas, its questionable strength became

central to my scul?tural aspirations. It now extends itself towards an essential consideration of wonder. A happy compass will set the uncertain course, and 'The Cosmic Voyage' will begin.

The above declaration is tentative, for I'm not sure at all of where it is taking me however, my aspirations urge me not to dodge uncertain adventures. I have a notion that the time has come for the earthbound human race to evolve beyond the evolution we have so far shakily achieved. It might be revealed in the fresh clarity of the cosmos. Here is my statement of intent.

Like good old Joseph Beuys, I'm aware that new beginnings can only happen in the offing. I reckon it's the way Columbus must have felt when he sailed due west over the horizon to see what lay beyond. Because of the uncharted nature of random destinations, it is worthwhile considering the ways of other cosmic adventures. I am particularly interested in sculptural explorers such as Constantine Brancusi and the contemplative simplicity of his 'Endless Column' suggesting infinitive upward directions to beyond ourselves. I am also intrigued by the 'Nine Catalytic Stations' of Paul Neagu, in particular his open-ended star that invites us to climb inside and metaphysically rummage for its mysteries.

The awkward business of ascending to the cosmos is probably best suggested by the dynamic Vikings who seemed intent on going anywhere and everywhere. Not unlike the Shaman 'World Tree', the Norsemen came up with the idea of the Yggdrasill tree. This was visualized as a ladder stretching upwards to heaven, and downwards to the underworld. Nowadays I cannot look at a solitary tree at the bottom of my garden without it making me aware that its roots are exploring the centre of the earth – whilst its high branches are striving to reach the heavens . . . And who can deny

that it isn't making an invisible cosmic connection – and from my garden too?

The relationship of the cosmos to earthbound trees is simple and believable. Consider the multiplicity of leaves, and understand that each one is a solar cell. They are busy – busy – busy collecting the radiated energy of the cosmos, then delivering it through the trunk and so into the roots, and then into the Earth. Thus, Earth and tree are nourished and energized. Then, the cycle of cosmic energy, hinged onto time, allows the tree to do it over and over again. This is simply known as 'growth'. It is perfectly natural – not just for trees, but for all vegetation, aye, even Ourselves, for it ensures the totality of all Being.

All of this theoretical talk is fine, but none of it suggests the implications of transporting the enterprising members of the human race to reach much further than the nearby moon. We can shoot scientific golf buggies into the ether and land them in planetary dust – and every now and again a failed high-tec astral device will lose its grip and return it to us, to land with a 'splat' in some awkward desert. I must hand it to the scientists, however, for they do try and seem to know that the cosmos has a lot to offer. I worry a bit about this, for on our own planet, the positive aspects of scientific ingenuity are not consistent, and can also go 'splat'.

The unpredictable nature of cosmic voyaging is very handy for films and TV – as Captain Kirk, galaxy hitchhikers and special effects departments well know. It is a strange human quirk that when we consider wonder, we are inclined to make fun of it. Is it because our power to imagine what lies beyond our orthodoxy is not fully developed? Is our intuition embarrassed by the excitement? . . . But, hey! Here is a job for the arts – and not least this 'Cosmic Voyage', – for even if it does not deliver the

elusive 'new beginnings', at least it's having a go. At best it will encourage me, and hopefully others, to regard the cosmos more seriously.

Consider now the ancient stones of Callanish. Positive-minded scientists have now figured out that these were arranged as an early lunar observatory – handy for the farmers and early astronomers. It's not a bad idea to reconsider so-called primitive and honest fundamentalism. It was uncluttered by Corporates and Arts Councils and therefore fairly free from human contaminations. Now, in our new age, wonder and confused appreciation is expressed theatrically with sandals and folksy merriment – ah, the contrived merry tinkle of Hebridean temple bells.

I happen to own a small meteorite that I regard as a visiting card from space. It arrived on our Planet via Russia in 1914, offering me assurance that tactile things are happening beyond our planet. My alien meteorite is probably not quite at home here, but its elsewhere presence is friendly enough to induce wonder from afar. I believe it once landed in Russia with a 'splat' – but I hope this does not happen to my 'Cosmic Voyage'. Nevertheless, undeterred and flying blind, I'm off to the offing.

For a few weeks now I've been searching in and around the offing, but to date, no new beginnings have revealed themselves. I wonder if that happened to anyone who climbed Brancusi's 'Endless Column' or entered Neagu's 'Open Ended Star', and returned with a greater knowledge of higher things? If my 'Cosmic Voyage' doesn't go 'splat' feel free to come on board and join me in the metaphysical search.

In the hope of detecting a glimmer of a signal for getting cosmic notions off the ground, I have reconsidered possible directions suggested from some of my earlier scul?tural meanderings. I therefore put on my 'Cosmic Cap' and jump into

the 'Boots of Icarus' – to takeoff to fly to some splat-free zone. I want to propel myself beyond mere metaphysics and into the Jarryesque realm of pataphysics. The wonder of Jarry's random philosophy will surely introduce me to the science of imaginary solutions, which, when pursued to excess, will provide the apprehensive answers we need.

The good old Vikings had a wonderful way for dodging reason when deciding course directions. Navigational decisions were left to the birds that they carried on their long boats. When one was released then later returned to the boat, there was obviously no land ahead. If it did not return they sailed on, confident in the belief that their feathery pilot had found somewhere to land. If the bird returned they sailed on and on into the offing with renewed hope – but remember, 'Hope is Hard'.

My navigational instruments are equally fundamental. The first simple device is a triangular 'Vent' inspired by a window in a byre on the island of Kerrera, through which the animals could see and enjoy all-round planetary perception. This was real reality as opposed to the sub-standard virtual stuff.

The next instrument is my faithful spire, dealing with 'air' – 'stone' – 'equilibrium' – that is, the broad concepts of our Planet. We breathe freedom of the air in balance with the energy of the stone, and are reminded of our human responsibility for maintaining that balance – known as . . . equilibrium.

Back now the good old Yggdrasill Tree – remember the Nordic idea of linking heaven and our earth. Now re-interpreted as my 'Cosmic Tree', the double helix within its branches allows the ancient two-directional spiral to suggest cosmic traffic upwards and downwards between the polarities of heaven and earth. The Shamans will

be pleased. The stone from which the tree arises is quartz, containing its own enlightening earth energy.

These then, are the three simple scul?tural indicators that are essential and central for the 'Cosmic Voyage'. There is now no excuse for not understanding that an awareness of these fundamentals is essential for this voyage. On this voyage we can revise and extend our potential for the future and positive aspects of evolution.
I look at the tree at the bottom of my garden and take my directions from there. Find your own tree . . .

Welcome Aboard!

Dad mounted a further two exhibitions at Rozelle House, Ayr, and then at the Hill House in Helensburgh, the Charles Rennie Mackintosh-designed house which had belonged to the Blackie publishing family. Following on from these events, he continued on what seemed like a downward spiral of frustration. He began to turn the house into a studio rather than a home and he moaned incessantly at my sister and myself to the effect that we had never met his expectations and that we were complete and utter failures (in his eyes). It came across as bitterness, and we found ourselves increasingly put out and offended with his insinuations and unsympathetic behaviour, to the point that we both distanced ourselves from him for a while. In the months and years following my mother's stroke, despite my sister's grief, she was expected to manage all the day-to-day affairs in Gourock relating to my parents. Not long after my mother took ill, I moved to the Highlands with my two sons and set myself up as a freelance events manager. As a result, I was always busy with work and my own family. I became aware that Elaine was starting to feel the pressure of dealing with Dad's increasing demands. She badly needed support as she was mired in the responsibility and negativity we now found ourselves living with on a daily basis.

Reaching for the Cosmos

In a bid to pull my father back on track, I managed to
acquire funding for a Highland Year of Culture 2007
celebratory event. It was to be mounted ultimately
at the Lecht Ski Centre on the autumn equinox (23
September). The event, Let There be Lecht, included
Moray primary schools taking part in an educational
programme on the art of making illuminated, animated,
large-scale sculptures though puppetry. This was done
over a term, and four schools participated. On that
evening of Let There be Lecht, the sculptures were
paraded up the mountain, and other light and fire
activity took place along with the unveiling of my dad's
landmark sculpture. *Cosmic Reach* was one of his
favourite sculptures and is one of his last installations.
It is sited at the Lecht Ski Centre, which is 2,920 feet
above sea level in the Eastern Cairngorms. It is a
contemporary work comprising a stainless-steel frame
to define its shape and a helix that suspends a piece of
natural stone. As Dad put it, it is 'a standing stone in
space'. Although the sculpture is not maybe as high as
it could have been, standing at thirty-three feet, it still
indicates the right direction. He had hoped to create
a series of these: a cosmic circle of standing stones
throughout Scotland. Alas, he only managed two.
Dad wrote about it this way:

> The Cosmic Reach follows on from the uncertain
> course set by my happy compass, a journey created
> from my exhibition *The Cosmic Voyage* in 2005.
> I have no certain idea of where it is taking me,

*Opposite: One of George's last major works was 'Cosmic Reach',
which is located at the Lecht Ski Centre in the Highlands. It was
made to celebrate the Highland Year of Culture, 2007.*

however aspirations urge me not to dodge uncertain
adventures and so let the voyage continue.
We are hooked on the physical side of art and often
forget the abstract. It is this unexplored cosmos that
I will explore in the next chapter of my life.

For him, it was about working again – albeit aided by
myself, my partner Hugh Clark, and James Mackintosh,
director at the Lecht. The plaque at the bottom of the
sculpture reads:

> The aspirational aspect of the work is to focus
> human attention on a space beyond ourselves. The
> height of the Lecht and the nature of the materials
> that form it are ideal for defining a 'launch pad' for
> ideas projected beyond earthbound constrictions. It
> helps humanity to break free from these and aspire
> to enlightened ideas that lie beyond.

Not long after the Cosmic Reach project was completed,
good friend Neil Baxter approached him with a request
from architects who were building a new university
student accommodation village in Aberdeen: to design a
sculpture within the village. He made the second of which
he hoped would be many sculptures creating a circle
of standing stones in space throughout Scotland. His
contribution to the cosmos was called *The Northern Light*.
During these years, and the years that followed,
several things started to happen to my father. He liked
– and disliked – people at the drop of a hat. He couldn't
concentrate. He craved attention, especially from
women. His misguided judgement allowed people to
enter the house whether he knew them or not. He would
give them a guided tour and then a piece of artwork
to go on their way. He acquired a lady friend, which
really upset my sister. This lady was kind and really just
wanted a companion, but she too was to be scared off
by my father's non-conformist behaviour. Elaine and I
discussed all this with close family friends and relations,

and there was a general assumption that as an artist he had licence to express himself any way he felt fit. He was, perhaps, just extremely egotistical; latterly, some family members thought him too big for his boots.

Life for my father in these days saw him on a diet of homemade chicken soup which he made from two chicken thighs with regularity (a favourite soup my mother made for him), coffee buns he bought from the local butchers, which his grandma and mother made for him when he was a child, and bags of sweeties he had never eaten before. Most nights he would head off to the Café Continental in Gourock, where the staff and customers tolerated his erratic behaviour with grace and kindness. Occasionally we'd go out for 'posh grub' in restaurants, a horrid experience for my sister and me due to my father's antics. He craved days out down memory lane with numerous trips to Inverkip and Wemyss Bay. His emotions always bubbled up close to the surface, and he had heartrending and intense moments every time we drove past the site where his father used to work in Glasgow. He sobbed at the loss of family and friends as they died or became infirm, but never empathised with those left behind to cope. This goes some way towards explaining how he reacted to my sister's grief following the sudden death of her husband, Campbell. He made me visit every house he'd lived in, and I'd sit and listen to tales of how life had been for him and his family when they lived there. As for art, he put it out of his head deliberately as he knew and accepted he could no longer design or make anything. It was an inadequacy he couldn't face. The workshop was left as if he had just walked away one day. These were difficult times for the family as little was known publicly about his illness. Old friends were often offended, as we had been, by his extreme actions and language. In 2009, his once much loved Royal Gourock Yacht Club asked him to leave on the back of a series of silly little mishaps as he didn't 'fit the mould' any more. He was summarily dismissed after a lengthy membership. The Greenock-based RAF Jazz Club, one of two jazz clubs he regularly attended, also told him not to come back, so the very passions, interests and loves that stimulated him and kept him going were pulled from underneath him. They thought him crazy and vulgar, which was hard for us all to accept. It is a stark reminder, especially with our ageing population, that people with neurological disorders should not have to struggle to 'fit in'. How much nicer it would have been if he had been asked to leave with a ceremony celebrating his longevity of involvement thus preserving his dignity. We could have accepted that, and as people live longer, this will continue to be a problem for social organisations such as yacht clubs and music clubs.

During this time, some people were incredibly kind and generous. In September 2007, a local hairdresser called Steven Quigley took Dad to the Connect Festival in the grounds of Inveraray Castle to see Icelandic singer Björk, a favourite performer of his. He loved her eccentricity, and as he ploughed across the field, eighty-six years old, young people shouted, 'Hi, old man, what you doing here?' It didn't bother him. He loved Björk's sense of performance, individuality and eccentricity. There was no such thing as an Individuals' Club he always said. Two lady friends from Dunoon regularly invited him on days out and they would trail across the countryside on buses using their free bus passes. He had many good friends who would come from all over Scotland and beyond to visit him in McPherson Drive, but ultimately, he missed my mother – his first mate.

Combined with an inability to get in and out of bed, resulting in numerous falls and, inevitably, tantrums, came an inability to write or draw. He still had ideas but he couldn't put them down on paper, which as someone who had always been a great communicator was incredibly frustrating. At this point, it was decided something had to be done. We visited his family doctor and told him of our concerns, and very quickly Dad received tests at the geriatric unit in Larkfield Hospital

between 2008 and 2009 to assess his situation. It was apparent he was in need of specialist care, which initially came in the form of a carer coming to the house three times a day. He loved this but felt he should have had more of it as he enjoyed the company.

My father had never really suffered from ill health in his later years, apart from the loss of sight in one eye due to diabetes. Even that disability didn't deter him from his life's work, but it certainly affected his driving. At this stage of his life, it was a brave person who accepted a lift from him, as he drove straight over raised roundabouts, brushed alongside cars when parking, forgot where he'd parked and crashed into the railings outside the local police station. It was a blessing in disguise as he then lost his licence legitimately!

He was diagnosed with frontal lobe dementia in 2009, seven years after my mother's stroke and five years after her death in 2004. In 2010, he had a really bad fall, and even he admitted he looked like a bruised prune. He was admitted to hospital for three months. Following this stay, we were advised that he was unable to care for himself at home and after much to-ing and fro-ing, he happily went into a lovely nursing home in Greenock called Balclutha. The family drew breath.

Frontal lobe dementia explained a lot of my father's neurological problems; old age and diabetes explained the physical ones. Ten per cent of people suffer from this rare form of dementia – a fact of which my father was quite proud! This illness causes the patient to have sudden changes of personality: an intransigent attitude, a complete lack of concern towards personal appearance and latterly incontinence. The values he had instilled in us from a young age were suddenly tossed aside. He was disinhibited and had problems with balance; he talked more; used obscene language; and suffered from diminished creativity and a lack of problem-solving skills. This made him unable to perform complicated tasks. The consultant explained that the illness had developed over many years, possibly from ten to twelve years prior to testing, and made sense of why we'd found it difficult to understand what had happened to the father we once knew. My sister, the grandchildren and myself almost felt relieved when we were given this diagnosis, although we were all left with a profound sense of guilt. At least we could go forward armed with knowledge of how to manage my father and his illness.

People still got in touch, with requests to submit drawings for public artworks, and they found it difficult to accept he could no longer do this. He still enjoyed the company of good friends and artists, many of whom came to Greenock to visit and take him out. He put up a good front, but lurking below the surface was a tired, frustrated and yet oddly compliant old man who considered his latter years as a preparation for death – or, as he put it, his Journey into the Cosmos.

The Cosmos played on his mind a lot towards the end. He commissioned a young local artist to paint a couple of pictures for his bedroom in the home. He saw them as the way forward on his Journey into the Cosmos. They were black holes based on what looked like centripetal circles pulling you into the centre of the painting. Each morning and every night, he would see these images and feel drawn to them. He had no fear of death, he said, and expressed the wish that he'd meet up with Daphne and his close family in his new life. His younger brother, Banks, died in 2010.

While he was very happy at Balclutha, it didn't last. It was a mixed-sex set-up, and a new companion in the form of a cat-owning lady resident, ironically called Daphne, gave my father a new lease of life. We were all happy about this, but Daphne wasn't keen when my father displayed signs of over-affection. It was recommended to us after various episodes that he be moved to an all-male home. The choices narrowed, but as my father considered himself an old sea dog at heart, he asked if he could go into the Sir Gabriel Wood's Mariners' Home. He moved there in 2010. He was eighty-nine years old.

The home and charity had been founded by Gabriel Wood, the son of a Greenock merchant, in 1767. Its doors opened in 1854 with a duty of care for the reception of 'fifty, aged and decayed Merchant Mariners and Merchant Seamen, natives of the area and all whom should have attained the age of fifty-five years'. Today, the home plays host to merchant mariners, deep-sea fishermen, naval personnel, lighthouse keepers and widows of all the above. It strikes me now as ironic that, like his great-great-grandfather, Antonio Charrette, my dad was now in the care of a mariners' charity. Back in the early nineteenth century, Antonio ended his life in the care of the Trinity Board, a charity that looked after the welfare of mariners. My dad always assumed everything would be 'tickety-boo' if the Navy were involved.

In my view, this Victorian building struggled to be homely. Its walls are adorned with seafaring pictures from down the ages and the small rooms are referred to as cabins. The care was good though, as was the food, but we did feel it lacked a woman's touch. It is now held in trust by the Sailors' Society and administered by a local volunteer company. We, as a family, are eternally grateful to them for taking in my father, warts and all, and caring for him.

To keep my father stimulated, my sister and I thought we might publicly celebrate his forthcoming ninetieth birthday year. Loosening the reins wasn't going to be easy. Despite his generous nature, my father always found it hard to share in 'matters of the art'. On the one hand, he wanted involvement from the family: on the other, he rebuffed it. At this stage of his life it was easier to take over those reins.

My sister Elaine and my niece Jennifer spent years looking after my father and his needs as they lived near to him both at home and in the care home. It was now my turn to take on some responsibility, and my skills offered us the chance to create a programme of events culminating under the umbrella of the Whysman

Festival. Many years spent in the events industry made this a manageable option for me, but I was in unfamiliar territory, having spent most of my life working out of Manchester. I needn't have worried. Glasgow opened its doors to me with such a welcome, I was humbled.

When I embarked on this mission, I visited several people I had heard my father talk about, and thankfully many offered their assistance. I had a wish list of things I wanted to achieve, although the main thrust was a retrospective exhibition which, having embarked on a cellar clear-out at the house on McPherson Drive, offered up more than I bargained for!

The first meeting of the 'Friends of George Wyllie' was held in the private dining room of Oran Mor in Glasgow on 24 March 2011. I asked for help from various people who gave me their continued support throughout the project. My niece, Jennifer Aitken, was drafted in as secretary, and I also approached visual arts writer Jan Patience, and a senior arts producer at the BBC, Andrew Lockyer. Various old friends and helpmates of my father were also drafted in, including Pete Searle, Murray Grigor, Liz Murray, Dawson Murray, Neil Baxter, Laura Hamilton and Kenny Munro. Auctioneer Paul Howard was also a Friend. Other friends came on board later, including Karen Cunningham, then head of Glasgow Libraries, MSP Joan McAlpine and BBC Scotland arts correspondent Pauline McLean. Everyone felt a close connection to my father, which was great. He was always roping people in to help him with projects, and they usually became friends. Pauline even told me about how Dad played double bass at her wedding some ten years earlier.

Starting up the Friends of George Wyllie also signalled the start of my firm friendship with this book's co-writer, Jan Patience. Jan's unstinting commitment to everything George Ralston Wyllie has made it possible for me to achieve all I set out to do. She first saw my dad's work when she was a young reporter working in Glasgow in 1987, and when I met her she told me she

recalled the impact of seeing it for the first time as if it were yesterday. Until then, she said, art for her was something you looked at in galleries. The *Loco* was 'out there among real people', she added. The group was later extended to include another stalwart and tenacious helper, curator Lynne Mackenzie. Others would join the group further down the line.

I set out with a wish list for Dad's work, which included: a retrospective exhibition as the main focus of the year; the launch of his archives at Strathclyde University; a BBC TV documentary on his work and life; the launch of a dedicated website; an opening launch event for the birthday celebrations; acceptance of an artwork into the collection of the National Galleries of Scotland; and one or more publications dedicated to Dad's work. As it turned out, we achieved a little bit of almost everything – and more. We decided to mount a festival and call it the Whysman Festival, with an appreciate nod to Murray Grigor's film, *The Why?s Man*.

We applied to Creative Scotland for funding, but in the meantime set about organising the first events of the festival. First up was the launch of a small book of Dad's poems, called *Some Serious, Some Not, Some Not Even That*, at the Aye Write! book festival in Glasgow. It was a joyous, packed-out affair featuring poetry, music and dance in Glasgow's Mitchell Library. It featured many old friends reading Dad's poems, including actor Bill Paterson, journalist Pauline McLean, comedian Fred MacAulay and singer Pat Kane. Actors Gavin Mitchell and Stuart Hepburn performed excerpts from *A Day Down a Goldmine*, and veteran musician Alastair McDonald did a couple of turns on the banjo, including a rendition of 'The Great Bum Steer' song from *A Day Down a Goldmine*. Dad would have loved every minute of it, but unfortunately he wasn't well enough to attend. It was a great reminder to everyone of his work and made the point that it wasn't just about making sculpture; it involved theatre, dance and a deep love of words.

The second event in the Whysman Festival calendar was the launch of an exhibition called *A Life Less Ordinary*. This show was curated by Dad's old friend Laura Hamilton, then curator of Strathclyde University's Collins Art Gallery. It was an archival exhibition celebrating the donation of his archives to the university. Dad had received several requests for his archival material, but we as a family had decided this option was the best based on his long-term relationship with the Collins Gallery. It was not only the last public exhibition of his work, but the last for Collins Gallery too, as the university closed it down when the exhibition ended – much to the dismay of many in the art world. It was a decision my father never knew about, and in a way it was a good thing he didn't, as he was in no position to do anything about it. He would have been extremely frustrated and sad, had he known. We took him from Greenock to Glasgow for the night to see the exhibition before the formal opening and he gasped, 'Did I really do ALL of this?' My thoughts exactly . . .

Just as the exhibition was closing, the Friends and I discovered we had been successful in our second attempt to secure funding from Creative Scotland. The £158,510 award from the Year of Creative Scotland 2012 would allow us to head off 'in pursuit of the question mark' in earnest and start working on my Wyllie wish list in earnest. On 12 May 2012, we took part in a press call at Elder Park in Govan, which involved us sailing wee paper boats around where Dad grew up. Together with Fiona Hyslop, Cabinet Secretary for Culture and External Affairs, I sailed some on the pond around Dad's 1998 sculpture *The Launch*, for the cameras.

Just one week after this press announcement about receiving funding to stage the Whysman Festival in celebration of his life and work, my father died painlessly and with dignity. It was if he knew his work was in safe hands and he could leave us. The date was 15 May 2012. He died with my sister Elaine and niece Jennifer by his side. He had contracted a chest

infection and been taken into Inverclyde Hospital from the Mariners' Home. There, his big strong heart simply failed him. There was no long, drawn-out death. It was a good way to go. The funeral, conducted by a Humanist celebrant, took place at Greenock Crematorium. He hadn't left specific instructions on how to conduct his funeral, but we felt, since he hadn't attended church since his early sculpture days, we could express more about him and his life that way.

It seemed a fitting way to give him a personal send-off. Accompanied by a lone saxophonist, he was carried into the crematorium by my sons, Calvin and Lewis, and our cousin, Alistair Wyllie. His coffin had its Shaman's arrow on top to guide him on his way to the Cosmos. Each family member placed a rose on the coffin, an acknowledgement to his love of Burns' poem, 'My Love is Like a Red Red Rose', which he often recited to my mother. He requested that we play Peggy Lee's song 'The Folks Who Live On The Hill' as a reminder of our family life at McPherson Drive, Gourock, where he was at his happiest.

The outpouring of affection for him which followed was quite overwhelming for us as a family. The Whysman Festival took on an added poignancy, and as the year progressed we managed to achieve a lot in his name. This included a Whysman website and a George Wyllie website (created by Lynne Mackenzie and Pete Rossi), as well as busy social media sites, appropriately titled 'For The Burds' (created and managed by Jan Patience), a pilot film for BBC Scotland and the re-issuing of Murray and Barbara Grigor's *The Why?s Man* film on DVD. Various friends, including Murray, artists David Harding and Roddy Buchanan, Neil Baxter and myself all took part in a Festival of Politics event at the Scottish Parliament in Edinburgh in 2012. Not far away, in the parliament's garden, a selection of Dad's sculptures were displayed during the summer months. Later, in 2014, the parliament bought a selection of work for its permanent collection, including a small sculpture of his *Berlin Burd* and another work called

Contemplace, which references the ancient Stone of Destiny and Charles Rennie Mackintosh, in whose Hill House the work was previously displayed. It was also Dad's take on a Scottish throne.

Other highlights of the Whysman Festival included the siting of several big question marks created by Greenock-born artist Alec Galloway. Alec placed giant question marks (made by him with help from community groups in Inverclyde) from the mudflats on the shore of Port Glasgow down to Langbank by the Clyde. He also hung one from the Finnieston Crane as a homage to my dad and his *Straw Locomotive*. There was also an inspiring and successful education initiative managed by Angela McEwan of Media Matters that saw thousands of schoolchildren across ten local authorities studying Dad's life and work. This ran in tandem with a major retrospective of his work called *In Pursuit of the Question Mark* at the Mitchell Library in Glasgow from November 2012 until February 2013. This epic exhibition was curated by me, together with Lynne Mackenzie and Jan Patience. It brought together, for the first time, the sheer scale of Dad's output as an artist, and people were amazed at the scope of it. To many people, he was the artist who created the *Straw Loco* and the *Paper Boat*. It showed the public there was so much more to his work and brought his art to a whole new generation of young people. The Festival won three awards: Creative Scotland Winner of Best Visual Art 2012; Winner of Fedrigoni Top Award for Corporate Publishing 2013; and Award International winner of A&AD In-Book Award 2013. By the end of the year, I was proud. And very, very tired!

The legacy of all this activity has led to the formation of the George Wyllie Foundation, set up with a substantial donation and grateful thanks to an anonymous benefactor. Through it, we aim to promote both my father's work and his over-arching art-for-all approach to art. We have also benefited from the stoic guidance of Peter Thierfeldt, our chairperson, who battles continuously and tirelessly to see my dad's legacy fulfilled.

The Wyllie name will be all but lost from his branch of the family. Dad had two daughters: myself and Elaine. We both married and had children, while brother Banks had a daughter, Gillian Linn (*née* Wyllie) who has one daughter, and a son Alistair, who hasn't had children. Sadly, George missed the birth on 21 June 2013 of his first great grandchild (and my first grandchild), when my son Lewis Gomes and his partner Ruth Taylor had a baby boy, Harry George Gomes. He carries two very familiar names found throughout the history of the Wyllie family.

In the first line of the Arthur Rimbaud poem 'The Drunken Boat', one of the inspirations behind Dad's famous *Paper Boat*, the narrator describes 'floating down unconcerned Rivers'. At the end of Rimbaud's old mariner's testament, it is as if his sailor experiences a feeling of freedom and purification. I like to think that is how my dad, a sailor to his bootstraps, lives on in the Cosmos.

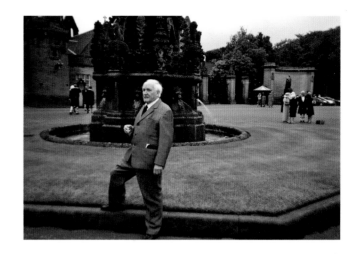

> I can no more, bathed in your langours, O waves,
> Sail in the wake of the carriers of cottons,
> Nor undergo the pride of the flags and pennants,
> Nor pull past the horrible eyes of the hulks.

George Ralston Wyllie's ship, *The Merry George*, had come in.

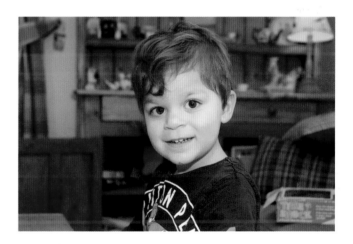

Above: George pictured in the grounds of the Palace of Holyroodhouse in Edinburgh after receiving an MBE from the Queen for 'services to art'. *Below:* George's first great grandchild, Harry George Gomes. *Next page:* George's Cosmic Arrow *from his last exhibition,* The Cosmic Voyage, *at the Collins Gallery in Glasgow, 2005.*

Acknowledgements

There are a few key people without whom this book would never have seen the light of day. We would like to thank our respective partners, Hugh Clark and David Mackay, for their forbearance. There have been times when Jan's husband, David, who never met George, was heard to mutter, 'I feel like I'm married to George Wyllie.'

We would like to thank our mutual friend, Fiona Black, who introduced us in 2010. At the time Louise was trying to set up a group called The Friends of George Wyllie, to help her father (by then living in a home in Greenock) feel like his work was not being forgotten. From this introduction, all sorts of sparks started to fly. Jan introduced Louise to a curator called Lynne Mackenzie, a Black Isle lass who keeps us all calm and carries on regardless. Thanks to support from Creative Scotland, we formed a small tight-knit group who launched a Whysman Festival to celebrate the life and legacy of George Ralston Wyllie.

We would like to extend our grateful thanks to Gordon Adams, Elaine Aitken, Jennifer Aitken, Aly Barr, Neil Baxter, Chris Bell, Mary Claire Boyce, Paula Brown, Karen Cunningham, Keith Bruce, Roger H Bullard, Alex Burns-Smith, Chris Carrell, Paul Cavill, Ruth Cranswick, Alan Cumming, Alisdair Curry, Richard Demarco, Norma Denny, Grace Dersborough, Karen Dick, Doreen Duncan, Marie Duncan, Julie Ellen, Drew Farrell, Morag Gay, Judy Gemmell, Calvin Gomes, Lewis Gomes, Muriel Gray, Murray Grigor, Laura Hamilton, Herald & Times Ltd Archive, David Harding, Sandy Howe, Fiona Hyslop, Liz Lochhead, Gillian Linn, Dominic Mackay, Sheila Mackay, Ciaran Mackay, Mia Mackay, Joan McAlpine, Andy McAvoy, Robert McDowell, Pauline McLean, Angela McEwan, Ron McKinven, Zac McKinven, John Messner (Glasgow Life), George Mills, Sarah Minney, Teresa Monachino, Margaret Morrison, Dawson Murray, Mark Osborne, Jamie Price, Dominic Quiqley, Peter Thierfeldt, Ken Ritchie, Marc Russell, Pete Searle, Ralph Solomon, Linda Sutherland, David Tanner, Kate Telford, Tenby Town Council, Cat Thomson, June Wells, Kay West, Margaret Wright, Stewart Wright, Alistair Wyllie and Jeanette Wyllie.

George left us to embark on a last Cosmic Journey on 15 May 2012, less than two weeks after we announced that there would be a year-long celebration of his work. He was ninety years old and as we all would come to realise, he had lived a life less ordinary.

The idea for this book was first mooted after a major retrospective exhibition took place at the Mitchell Library in Glasgow. Alongside the exhibition, an education project about his life and work captured the imaginations of many young eager minds. We both lost count of the number of times people said to us, 'I knew George Wyllie.' This was the original title of the book you are looking at now. Writing the book as a double act presented logistical and practical challenges; not least of all because we live 150 miles apart. But we have become – and remain – firm friends. The book we envisaged – people talking about the George Wyllie they knew – altered over time as Louise and her family started excavating in his personal 'goldmine' at the family home in Gourock. George didn't throw anything out. In his personal archive we found diaries kept as a schoolboy and as a young sailor, musical compositions he made in the late 1930s and early 1940s, postcards and letters sent during his wartime service, newspaper cuttings, lists, photographs and much, much more. We ended up writing a book about how Ralston Wyllie, a bright-eyed boy from Glasgow, became George Wyllie, engineer, sailor, husband, father, customs officer, and finally – artist. *The Arrivals and Sailings: The Making of George Wyllie* is the result. We hope you enjoy reading it.

Louise Wyllie and Jan Patience
March 2016

George Wyllie: Biography

Solo Exhibitions

1968 Irvine Arts Centre
1976 *Scul?ture*, Collins Exhibition Hall, University of Strathclyde
1977 *Sculpture*, Mac Robert Arts Centre, Stirling
 Sculpture, McLean Museum and Art Gallery, Greenock
1978 *Scul?ture*, Henderson Gallery, Edinburgh
 Scul?ture, Edinburgh Festival
1979 *Scul?ture*, The Workshop Gallery London
 The Call of the Sea, Talbot Rice Centre, University of Edinburgh
1980 *Counterbalance*, The Stirling Gallery
 Counterbalance, Henderson Gallery, Edinburgh
 Counterbalance, Spectro Arts Centre, Newcastle
1981 *A way with the Birds and other Scul?ture*, Collins Exhibition Hall, University of Strathclyde
 A Way with the Birds and other Scul?ture, Serpentine Gallery, London (Summer Show)
1982 *A Day Down a Goldmine*, Third Eye Centre, Glasgow
1983 *Scul?ture*, St Andrew's Festival Fife
 Scul?ture in Motion, Open Eye Gallery, Edinburgh
1984 *As Others See Us*, Worcester Art Museum, Massachusetts, USA
 Excavations from a Mine, Crawford Arts Centre, St Andrews
 Excavations from a Mine, Artspace, Aberdeen
 Christmas Day Down a Goldmine, Watermans Art Centre, Brentford, London
1985 *Friendship Paintings*, in collaboration with Berlin artist Jens Jenson, Goethe Institute, Glasgow
 Old Favourites, The People's Palace and Winter Gardens, Glasgow
1986 *Americana*, Glasgow Arts Centre, Glasgow
1987 *Americana*, An Lanntair, Stornoway, Isle of Lewis
 Americana, Richard Demarco Gallery, Edinburgh
 Old Favourites, Lyth Arts Centre, Caithness
 Paintings and Scul?ture at Sea, Open Eye Gallery, Edinburgh
 The Kleenex Sale, Richard Demarco Gallery, Edinburgh
1988 *Scul?ture at Sea*, Pittenweem Festival, Fife
 Scul?ture at Sea and Seven Spires for Lewis, An Lanntair, Stornoway, Isle of Lewis
1989 *Seven Spires for Lewis*, Richard Demarco Gallery, Edinburgh
 The Paper Boat, Glasgow
 The Paper Boat, Bluecoat Gallery, Liverpool
 The Paper Boat, installation and exhibition Royal Festival Hall, London
1990 *The Paper Boat*, installation and exhibition, World Financial Center, New York, USA
1991 *A Spire for Emily*, Ash Gallery, Edinburgh
1994 *Blake's Bike*, Rebecca Hossack Gallery, London
 Air and Stone, Rebecca Hossack Gallery, London
1999 *Retrospective*, Whitworth Art Gallery, Manchester
1999 *Rock the Boat*, Glasgow University Media Centre, Glasgow
 Bridges 1 & 2 (USA/Scottish/Irish)
2001 *Para Handy Re-visited Once Again & 7 Vital Sparks*, various venues, Argyll & Bute
2002 *Resurgam Revisited: 80th Birthday Exhibition*, Rebecca Hossack Gallery, London
2005 *The Cosmic Voyage*, Collins Gallery, University of Strathclyde, Glasgow, Bonhoga Gallery, Shetland, and UpFront Gallery, Penrith
2007 The Hill House, Helensburgh
2008 Rozelle Gallery, Ayr
2012 *George Wyllie: A Life less Ordinary* Collins Gallery, University of Strathclyde, Glasgow, RigArts, Greenock
 George Wyllie: A Retrospective In Pursuit of the Question Mark The Mitchell, Glasgow

Group Exhibitions 1966—1991

1966 Royal Glasgow Institute of the Fine Arts, Glasgow
 Richard Demarco Gallery, Edinburgh
1967 Royal Scottish Academy, Edinburgh
1968 Society of Scottish Artists Exhibition
1972 Glasgow Group Exhibition, Glasgow
1974 The Mall Gallery, London
1978 *Hang-ups* Greenock Arts Guild, Greenock
 MacRobert Arts Centre, Stirling
1980 Richard Demarco Gallery, Edinburgh
1981 *Art and the Sea* Third Eye Centre, Glasgow, Ceolfrith Gallery, Sunderland, Bluecoat Gallery, Liverpool, Mostyn Gallery, Llandudno, and Institute of Contemporary Arts, London
 Scottish Sculpture Open, Kildrummy, Aberdeenshire
1983 Portland Clifftop Sculpture Park, Portal, Dorset
 First Ten Years, Third Eye Centre Glasgow
1984 International Contemporary Art Fair, Barbican Centre, London
1985 *Sculptors' Drawings* Scottish Arts Council Touring Exhibition
1986 *Unique and Original* Glasgow Print Studio and touring
 The Eye of the Storm, Stirling Smith Museum and Art Gallery, Stirling, and McLean Museum and Art Gallery, Greenock
1987 *The State of the Nation*, Herbet Museum and Art Gallery, Coventry
 The Glasgow Group Norwegian Tour
1988 Spire installation in Sarajevo, Richard Demarco Yugoslavian Tour, Richard Demarco Gallery, Edinburgh
 Hugh MacDiarmid Exhibition, Galerie Redman, Berlin
 Ka Da We department store, Berlin
1989 *A Bird in the Hand*, Open Eye Gallery, Edinburgh
 For a' That, Ayr
 Togail Tir (Making Time), An Lanntair, Stornoway, Isle of Lewis
1990 *Glasgow's Glasgow*, The Arches, Glasgow
 The Sugared Imagination, People's Palace, Glasgow
 The Glasgow Fair, The People's Palace Glasgow

Plug In Sculpture, Buchanan Street, Glasgow
The Glasgow Girls, Glasgow Museum and Art Galleries, Glasgow
Estuary, Hillhead Library, Glasgow
Surrealist Tendencies, Hillhead Library, Glasgow
The Other Side of the Moon, Benjamin Rhodes Gallery, London

1991 *Scotland Creates*, McLellan Galleries, Glasgow
2012 Royal Glasgow Institute of the Fine Arts, The Mitchell, Glasgow
 (annual exhibition)

Events, Installations, Performances, Film and scul?tures

1967 Crucifixion, sculpture, St Matthew's Church, Barrow in Furness
 Bumper Fish, sculpture, Bay Hotel, Gourock
1968 Crucifix, sculpture, Monteviot Chapel, Jedburgh
 Electra, sculpture, Holland House Electrical Co., Glasgow
1969 Sculpture St Nicholas Chapel, Glasgow Cathedral, Glasgow
 Agnus Dei, sculpture St John's Kirk, Perth
 Club Crest, sculpture Motherwell United Servicemen's Club
1970 Sculpture, Mitchell Swire Factory, Greenock
1972 *Eagle*, sculpture, Vito's Restaurant, Edinburgh
 Eagle sculpture, St John's Episcopal Cathedral, Oban
 Crucifix, sculpture, Oratory, St Mary's Hospital, Lanark
 Sculpture, Cheshire County Hall
 The Clyde, sculptural panels, Clyde Bar, Queen Street Station,
 Glasgow
1973 *Locomotive Descending a Staircase,* Stirling University, Stirling
1974 Metal relief, The Talisman Catering Complex, Waverley Station,
 Edinburgh
 Dragon, sculpture, Bumpers Discotheque, Prestwick
1976 Invented the scul?ture movement
1979 Entrance sculpture, McLean Art Gallery, Greenock
 George Wyllie Hears, event, Talbot Rice Art Centre, Edinburgh
1981 *Bumper Eagle,* sculpture, Kilmarnock Arms public house, Kilmarnock
 American Eagle, sculpture, Harvey's American Bar & Diner, Glasgow
 Brass sculpture from Glasgow's Coat of Arms & Cathedral,
 Clydesdale Bank, St Rollox, Glasgow
 Sculpting from Scrap Iron, film BBC Scotland, with Campbell Barclay
 Dustbin Campaign against Nuclear Dumping at Dounreay,
 installation, George Square, Glasgow and Dounreay, Caithness
 Assisted Joseph Beuys with *Poorhouse Doors,* installation, Scottish
 National Gallery of Modern Art, Edinburgh
1982 *A Church for an Invented God,* East Chatham, New York
 A Day Down a Goldmine, performance In collaboration with
 Russell Hunter, Third Eye Centre, Glasgow
1982– Spires erected: Long Island; Manhattan, New York; East Chatham,
1990 New York state; Royalston Massachutess, Berlin; Kassel, West
 Germany; Amsterdam; Menorca; Sarajevo; Rannoch Moor,
 Joseph Beuys Tribute, 1986/7/8/9 and various UK sites
1983 *A Temple of Fertility,* scul?ture, East Chatham, New York
1984 *Excavating for a Mine,* performance, Crawford Centre for the
 Arts, St Andrews, Artspace, Aberdeen

Christmas Day Down a Goldmine, with Bill Paterson,
 performance, Waterman's Arts Centre, London
1985 *The March of the Standing Stones,* performance, Edinburgh
 Festival Fringe, Edinburgh
 A Day Down a Goldmine, with Bill Paterson and Tony Gorman,
 Assembly Rooms, Edinburgh
1986 *A Day Down a Goldmine & Americana,* performance with Bill
 Paterson & Tony Gorman, Institute of Contemporary Arts
 Theatre, London
 A Day Down a Goldmine, performance, Glasgow Arts Centre,
 Glasgow
 Stirling Smith Gallery & Museum, Stirling
 The March of the Missing Tourists, performance, Edinburgh
 Festival Fringe, Edinburgh
 On Corrupting the Young, lecture and performance, Glasgow
 School of Art, Glasgow
1987 *'and I' (Dance No.93 (b) 42')*, Glasgow School of Art, Glasgow
 A Day Down a Goldmine, performance with Tony Gorman, Third
 Eye Centre, Glasgow
 'Vigorous Vespers', lecture, Riverside Studios, London
 Middag-Dienst, performance, Viaams Cultureel Centrum, Amsterdam
 The Straw Locomotive, TSWA-3D, scul?ture, Finnieston Crane,
 Glasgow
 The May-Day Parade, event, Edinburgh Festival Fringe
 The Famous Grouse, Viaams Cultureel Centrum, De Braake
 Grond, Amsterdam
1988 *Circus Gold,* ten-hour installation, Ufa-Fabrik, Berlin
 Tavola installation, assisted Mario Merz, Demarco Gallery, Edinburgh
 Arrivals and Sailings, installation, five works for Glasgow Garden
 Festival, Glasgow
 The Berlin Burd, scul?ture, Berlin Wall at Reinickendorf, Germany
 The Paper Boat performance, Glasgow, London, New York,
 Antwerp, Greenock
1989 *The Paper Boat – A Patriotic Gesture*, Tramway, Glasgow
 The Peace Burd Peace Festival, Edinburgh
 Charlie Chaplin Slept Here, Edinburgh Filmhouse, Edinburgh Festival
 The Paper Boat, installation, River Clyde, Glasgow, River Thames,
 London
 The Glasgow Flourish, L'Europe des Createurs, Grand Palais,
 Paris, Museum of Transport, Glasgow, Scottish National Museum,
 Edinburgh
1990 *'Battering Fifty',* from *The Drunken Boat,* performance, St
Andrew's
 College of Education, St Andrews
 The Dumfries Mice, Gracefield Arts Centre, Dumfries
 The Dear Green Helicopter, installation with Arts is Magic,
 Finnieston Crane, Glasgow
 Arts is Magic, children's event, Glasgow
 The Paper Boat, River Hudson, New York
 The Paper Boat, River Schelde, Antwerp, Belgium (Stad ann de
 Stroom event)
 Burns, Beuys and Beyond: The Felt Cottage, exhibition and event,

Glasgow Museum and Art Galleries, Glasgow
A Day Down a Goldmine, performance with John Bett, Tramway, Glasgow
The Why?s Man, film, Murray Grigor, Channel 4
1991 *The Letterbox Project,* An Lanntair, Isle of Lewis
Life Cycle, workshops and children's event with Louise Wyllie
Robin, Mass Auction with Louise Wyllie, Manchester
Dustbin Demonstrator, event for Scotland Against Nuclear Dumping, Glasgow, Edinburgh and Caithness
Tour Cricket, Bicycle and *Spire,* events/lecture, British Council, India and Singapore
Life Cycle Scul?ture, Manchester
Life Cycle, installation, children's event for Global Forum Robin installation, Manchester
King Robin, scul?ture Manchester
Clean Sweep, scul?ture Manchester
1992 *Temple for a Tree,* event, Princes Street Gardens, Edinburgh
1994 *32 Spires for Hibernia,* installation, Irish border
1996 *32 Spires for Hibernia,* installation, Calton Hill, Edinburgh International Festival
The McGillivray Walk, event, Fochabers–Harris
Just in Case, installation, Mayfest, Glasgow, Portsmouth, Edinburgh
Voyage around a Safety Pin, performance, Citizens Theatre, Glasgow
The Kerrera Saga, performance, Glasgow University Theatre, Glasgow
1998 *The Launch,* scul?ture, Glasgow
1999 *A Bucket of Ice,* event, DCA, Dundee
Bye, Bye Blackbirds, event, Edinburgh International Festival, Edinburgh
Mobilisation, event, Whitworth Art Gallery, Manchester
The Millennium Garden Spire, installation, University of Strathclyde, Glasgow
2000 *The Monarch of Auchmountain Glen,* installation, Greenock
Running Clock, scul?ture, Glasgow
Salmon, scul?ture, Coleraine, Northern Ireland
Temple, installation, Rolls Royce, Hulme Park, Manchester
Temple Millennium, workshops with Louise Wyllie, Manchester
The 'Wee Hauf 'Puffer, installation, Islay Festival, Islay
2001 *Northland Vent,* installation, Caithness
Steeple Actions, event, Royston, Glasgow
2002 *The Bird and the Stone,* installation, Marie Curie Centre, Glasgow
A Hopeful Invasion, Aberdour
2003 *The Crystal Ship,* film, Scottish Television
2004 *A Monument to Maternity,* University of Strathclyde, Glasgow
2005 *The Cosmic Voyage,* film, produced by Martin Laycock and Laura Hamilton, Collins Gallery, Glasgow
Two Big Robins, installation and workshops(YES), Boat of Garten
2007 *Cosmic Reach,* scul?ture, The Lecht, Aberdeenshire
Let there be Lecht, school event with Louise Wyllie for Highland Year of Celebration
Scottish Water, educational film by Muckle Hen, Loch Katrine
2008 *Northern Light,* scul?ture 2008, University of Aberdeen, Aberdeen
2010 *Beautifully Crude,* film, Louise Wyllie and Helen Graham

Please note that is not the definitive list of artworks. George was a prolific artist and many works have gone out into the world unchartered. We continue to record them with the public's help.

Photographic Acknowledgements

Alan Dimmick (large Question Mark scul?ture) p vi; Wyllie Family Archive, p 6, p 9, p 9, p 11, p 11, p 13, p 14, p 14, p 16, p17, p 19, p19, p 26, p 28, p 29, p 31, p 31, p 34, p 35, p 35, p 36, p 39, p 45, p 46, p 48, p 48, p 50, p 51, p 53, p 54, p 57, p 57, p 61, p 64, p 64, p 65, p 66, p 68, p 70, p 72, p 72, p 72, p 74, p 74, p 74, p 76, p 77, p 77, p 78, p 78, p 80, p 81, p 86, p 86, p 87, p 88, p 88, p, 91, p 97, p 98 p 101; Mark Osborne, p 13, p 84, p 91, p 104, p 113, p 118, p 123, p 126, p154, p 166, Back cover (Greek Boat); *Daily Record* p 24; George Wyllie, p 26, p 133; Louise Wyllie, p 87, p 158, p 165; *The Newry Telegraph,* p 93; Richard Demarco Archive, p 107, p 121; George Wyllie Archive, p 107, p 108, p 112, p 141, p 146; Farley Gomes, p 114, p 142, p 142, p 143, p 143; *The Scotsman* p 114, p 142, *The Scotsman – Robert Perry,* p 115, *The Scotsman – Brian Stewart* p 125; Courtesy of George Wyllie, p 122, p 127, p 130, p 140, p 143; Sam Maynard, p 125; Murray Grigor, p129, p 145, p 146; George Oliver, p 136; Marius Alexander, p 137; Herald & Times Group – Martin Shields, p 151; Stewart Taylor p 165; Chris James – McTear's Auctioneers & Valuers, Back Cover (Seagull).

All scanning, restoring and retouching of photographs by Mark Osborne. Compilations by Lynne Mackenzie.

The End?

Arrivals and Sailings